Mary Drake McFeely

Lady Inspectors

The Campaign for a
Better Workplace, 1893–1921

The University of Georgia Press

Athens and London

For

Drake, Eliza, and Jennifer

Published in 1991 by the University of Georgia Press
Athens, Georgia 30602
© 1988 by Mary Drake McFeely
All rights reserved
Printed and bound by Thomson-Shore, Inc.
The paper in this book meets the guidelines for
permanence and durability of the Committee
on Production Guidelines for Book Longevity
of the Council on Library Resources

Printed in the United States of America

95 94 93 92 91 P 5 4 3 2 1

Library of Congress Cataloging in Publication Data

McFeely, Mary Drake.
　　Lady inspectors : the campaign for a better workplace, 1893–1921 / Mary Drake McFeely.
　　　p.　cm.
　　Reprint. Originally published: New York, NY, USA : B. Blackwell, 1988.
　　Includes bibliographical references (p.　) and index.
　　ISBN 0-8203-1391-2 (pbk. : alk. paper)
　　1. Factory inspection—Great Britain—History.
2. Women—Employment—Great Britain—History.
3. Industrial hygiene—Great Britain—History.　I. Title.
[HD3705.M37　1988]
331.4'813631164'0941—dc20　　　　　　　　91-4006
　　　　　　　　　　　　　　　　　　　　CIP

British Library Cataloging in Publication Data available

Contents

Acknowledgements	vii
Chapter 1 "The Ways of Man"	1
Chapter 2 "If Certain Evils Are to Be Redressed"	5
Chapter 3 Peripatetic Lady Inspectors	16
Chapter 4 Learning the Field	22
Chapter 5 "The Arthurian Period"	34
Chapter 6 Designing a Profession	44
Chapter 7 "Don Quixotes in Petticoats"	50
Chapter 8 "Such Is Woman"	58
Chapter 9 "Humanity and Red Tape"	63
Chapter 10 The Gombeen Man	76
Chapter 11 "An Army of Petticoated Inspectors"	87
Chapter 12 A Resident Lady Inspector for Ireland	93
Chapter 13 The Senior Inspectors	108
Chapter 14 "Come to the Lady Inspector"	118
Chapter 15 The War	125
Chapter 16 The Bureaucracy of War	136
Chapter 17 The Women's Side of the Situation	147
Chapter 18 Fusion	153
Chapter 19 New Challenges	164
Conclusion	172
Notes	175
Select Bibliography	189
Index	199

Acknowledgements

I am grateful for the assistance of the staffs of the British Library, the Public Record Office, and the Modern Records Centre at the University of Warwick. Transcripts of Crown copyright records in the Public Record Office appear by permission of the Controller of H.M. Stationery Office. Angela Raspin of the British Library of Political and Economic Science and David Doughan of the Fawcett Library gave me valuable guidance in the use of those collections. Jean Robertson and Elaine Miller provided information on Glasgow and the Muirhead family. Alice Crosthwaite, in a generous interview, recollected her own career as a factory inspector and her impressions of Hilda Martindale. Martin Wright allowed me to read and quote from Lucy Deane's diary and enriched my understanding of Lucy Deane. A year's leave of absence from Smith College in 1982–83 gave me time to accomplish much of the essential research. The interlibrary loan staff at Smith brought me published material from far and wide.

Many people have listened and read as I worked on this book. My colleagues at Smith College, especially the members of the Project on Women and Social Change, heard me discuss the work in progress in seminars and in conversation, and responded with perceptive and provocative comments and questions. The exchange of ideas and the moral support provided by the Project meant a great deal. Juliet Gardiner encouraged me to write an article on the inspectors for *History Today*. Peter Clarke, Jill Conway, Travis Crosby, James West Davidson, and Eliza McFeely read all or portions of the manuscript and gave me the benefit of their excellent advice. My editor, Peter Dougherty, has provided steady encouragement. Finally, William S. McFeely has helped, in ways that cannot be counted.

1

"The Ways of Man"

"Meet me at Aldgate East Station midnight for overtime inspection", read the telegram Irene Whitworth found waiting for her one evening in 1907. She had just arrived home from a long day inspecting factories where women worked, but she was far from dismayed. As a junior inspector for England's Factory Department, she thought the assignment was thrilling; she was "always ready for an expedition of that kind."

A few hours later, Whitworth and a senior lady inspector met at the underground station in east London. Borrowing a lamp, the two women walked at midnight to a tailor's house, one of many such workshops along the dark, narrow East End street. They knocked and demanded entrance. When the tailor reluctantly admitted them, Whitworth took the lamp and searched the basement. Her companion went upstairs to the dark workroom. Both areas were empty. When the inspectors met in the sitting room, however, Whitworth recalled that they noticed "a mass of unfinished coats and trousers evidently thrown down in a hurry." The pile of work increased their suspicions, and they insisted on looking further. Their thoroughness was rewarded when "in the bedroom we found, in bed, fully dressed, a little girl of fourteen I had seen before," Whitworth remembered. The law prohibited keeping young girls at work at such a late hour, and the two women inspectors had found the evidence they needed to prosecute the tailor.

"It was 2:30 A.M. before we reached home that night," Whitworth wrote later with satisfaction, "but what play could

give more insight into some of the ways of man than a good day's inspection?"[1]

Fifteen years earlier, the tailor would not have been disturbed by a knock at the door as he kept his young workers sewing far into the night. Neither would the dressmakers and milliners in the refined neighborhood of Regent Street who received and fitted their customers in a charmingly appointed shop while upstairs, crowded together in a poorly ventilated workroom lit by gas, young women cut and sewed from eight in the morning until ten at night. Many of these women traveled long distances from Wandsworth or Camberwell to their work; they endured the journeys and the low wages—often none for learners—in the hope that one day they would have their own shop, their success ensured by their fashionable London training.

In the industrial cities to the north, other hazards threatened the health of workers. The phosphorus used to make matches might suddenly catch fire or, more subtly, invade a worker's body with the disease known as "phossy jaw" because it ate away the jawbone. Lead poisoning disabled and killed potters and glazers in the china manufacturing industry, workers who used lead-based dyes in carpet factories, and others.

In one clothing factory the main drive shaft ran under the benches where the sewing machines stood. When the strap connecting her machine to the source of power slipped, a young worker bent down to make an adjustment to her machine and her long hair was caught in the rolling shaft. Within seconds she was scalped.[2] The industrial machines, inadequately fenced, threatened their operators with maiming and death.

In the ancient city of Bristol, boots and shoes, corsets, cigars, stationery and cocoa were produced in old, dilapidated buildings, some of them formerly private houses, where ventilation and temperature control were poor. In textile mills, the only consideration given to the atmosphere was for the benefit of the product; high humidity and temperature improved the cloth, although the workers suffered. In factories all over Britain, toilet facilities were added on without regard for privacy or adequate space, and no one was responsible for cleanliness.

When the fruit was ripe, workers in jam factories cleaned

and cut and cooked frantically, night and day, standing on floors sticky with syrup. When the catch came in at Peterhead or Yarmouth, the "herring girls" worked day and night on the beach cleaning, filleting, salting, and packing the fish before it could spoil, then catching a few hours' sleep in a crowded shack before the next boat came in. Seasonal overwork seemed inevitable if the crop or the catch was not to be wasted.

For decades, attempts to pass protective laws for all workers regardless of sex had failed. Laissez-faire doctrine allowed factory owners to make their own rules. Free men had the right to choose their working conditions and hours and make their own bargains, and to organize in trade unions. The employment of children had been regulated since the early part of the nineteenth century, and inspectors had enforced factory laws since 1833. Some safety measures for mines and heavy industry had been effected, and in 1842 a law forbidding the employment of women underground in mines was passed. In 1847, after a long campaign led by Lord Ashley (later Lord Shaftesbury), a Ten Hours Act was passed, limiting the workday of women and children in textile mills; in 1867 this was extended to all factories employing more than fifty people. In some industries, the factory schedule was reorganized so that men as well as women worked shorter hours, but often the women worked in shifts while the men continued to work longer days. Some industries simply ceased to employ women at all.

The largely middle-class organizations concerned with women's welfare and women's rights did not hold a common view. Some campaigned for protective legislation, but many opposed government intervention. These latter women's rights advocates wanted no less than the ideal—the emancipated woman able to make her own bargain. More pragmatically, they feared that if the laws were too restrictive, employers would simply refuse to hire women. "Protection" that applied only to women might lead to unemployment. The Women's Provident and Protective League, which later became the Women's Trade Union League, was among the strongest groups active on behalf of women workers. Its membership was largely middle class, but its first leader was a working-class woman, Emma Paterson, one of a handful of women members

of the Trades Union Congress. Paterson, like most trade unionists, believed that the workers should join together and use their united strength to gain decent hours and wages. She opposed legislation to restrict the hours and conditions of women's work on the grounds that such laws threatened to limit job opportunities for women. But after 1847 when the first legislation "protecting" women was passed, Paterson decided the Women's Trade Union League would have to ensure that the law benefited the workers. If women workers needed protection, women should do the job of inspecting. Male inspectors, she pointed out, usually allowed the employer or manager to take them around a factory, and seldom talked with workers. Most women workers never even saw a factory inspector, let alone talked to one. She persuaded the Trades Union Congress to accept her view and endorse the appointment of women factory inspectors.

Years passed before the goal was achieved. Another politically talented woman, Emilia Dilke, succeeded Emma Paterson as leader of the Women's Trade Union League in 1886 and took up the campaign, but government officials were hard to persuade. It was not until 1893 that H. H. Asquith, who, as Home secretary, was charged with all matters of domestic policy, made the decision to appoint women inspectors.[3]

2

"If Certain Evils Are to Be Redressed"

May Abraham, who was to become the first woman factory inspector in England, was Irish-born, dark-haired, tall, and handsome; she had a compelling personality to match her looks. She was twenty-four; she had come to London in 1888, at the age of eighteen, knowing nothing of factory conditions, trade unions, or reform movements, to make her way in the world.

Her father, Dr. George W. Abraham, a Dublin lawyer, had died in 1887, leaving his family impoverished but not without connections—or determination. With no assets other than a letter of introduction to Lady Dilke, May left the respectable suburb of Rathgar, with its well-kept enclosed gardens and detached houses,[1] for London. As soon as she had settled herself in a room in a Bloomsbury boarding house, she traveled across the city to present the letter on which her future depended. The address on the envelope was 76 Sloane Street; the large, dignified house she found there could hardly have suggested that this was to be her entrance to a life of political activity and social reform.

Behind the formal exterior, May found a less intimidating atmosphere. The house was luxurious but comfortable, a family home with old carpets and tapestries in deep blues, soft, rich reds, and dull greens. If she had arrived earlier in the day, the newcomer might have seen, through the window of the double dining room, Sir Charles in the garden engaging in the genteel pastime of fencing with a friend. As she climbed to the upper floor, she passed the portraits of

Dilke and Wentworth ancestors that lined the stairwell. In the rooms on either side of the upstairs corridor hung the paintings, drawings, and engravings collected by Lady Dilke.[2]

But the quiet, old-family gentility of the house where Charles Dilke had been born was deceptive. By the time May Abraham first came to 76 Sloane Street, it was well known as a meeting place for "enlightened and distinguished representatives in the world of politics, literature, and art."[3] Emilia Dilke, the woman she had come to meet, had been, even in the sedate life of her first marriage to an Oxford don many years her senior, actively concerned about the problems of working women. Now, at forty-three, as a leader in the Women's Trade Union League, she campaigned vigorously to organize women workers and was deeply involved in the movement to investigate the health risks of dangerous substances in industry. An art historian trained at the South Kensington School of Art, Lady Dilke continued to write scholarly articles about eighteenth-century French painting, but her political activities dominated her busy life.

The woman May Abraham met had dark hair and a pretty, round face. Behind her amiable appearance, she was witty and persuasive. Lady Dilke, who prided herself on her ability to judge people, was favourably impressed with the young Dubliner, although she knew that May Abraham came from a "harum-scarum impecunious Irish home" and that her education and experience of the world were limited.[4] Still, Abraham had grown up in a household where law as a form of social control must have been a topic of conversation. Her father had been Dublin's registrar of lunacy, responsible for commitment of the insane to institutions. He had written a study of the legal aspects of insanity, a social problem that often confounded the courts.[5] Although she knew nothing of London or the trade union movement, clearly this young woman was bright, a good listener, and a quick learner. Lady Dilke invited May Abraham to become her secretary. Her niece, Gertrude Tuckwell, had just left that position to take over the administration of the Women's Trade Union League. It was an extraordinary opportunity, and Abraham took it.

At 76 Sloane Street, she was in the midst of a living textbook on social reform. Over the next five years, May

Abraham learned much about the Dilkes' remarkable marriage and about the political causes for which the couple battled.

Widowed in 1884 after a long, unhappy first marriage, Emilia Dilke chose as her second husband a man who shared her political interests and with whom she had exchanged letters several times a week for a decade. Charles Dilke was neither handsome nor brilliant, but he had a beautiful speaking voice and, as one acquaintance put it, an "attractive capacity for concentrating the whole of his attention on the person to whom he was listening."[6] With hard work and an air of self-confidence, he had won a seat in Parliament in 1868, worked himself up to the front rank of Liberal party politicians, and was considered likely to become prime minister. He was a leader of the radical group in Gladstone's government and was widely recognized as a man of tremendous political talent and promise.

Shortly before he married Emilia, however, Charles's life and career were disrupted by one of the nineteenth century's most sensational scandals. He was named co-respondent in a divorce suit. The testimony in the ensuing trial included tales of his sexual relations with a Mrs. Crawford; some witnesses even said that a household maid was involved in their encounters. Emilia proved her confidence in Charles, however, by publishing a formal announcement of their engagement as soon as she learned of the impending trial. She was travelling in India; they were married as soon as she returned. But the newlyweds faced a life quite different from what they had expected. In 1886, Charles lost his seat in Parliament, and his career seemed ruined. Both Dilkes battled vigorously to restore his reputation. Both continued to work for reform in a variety of areas, but during this period, Emilia's political interests may have predominated. Chief among these was the Women's Trade Union League. It was at this time that May Abraham began assisting Dilke with her correspondence and accompanying her on her speaking engagements. The younger woman soon experienced, as Dilke and others in the League had, the difficulty of organizing women workers. Lady Dilke, like her predecessor, Emma Paterson, had come to believe that the working conditions of women would have to be controlled by legislation if women were ever

to achieve the strength to maintain strong trade unions. Like Paterson, she endorsed the appointment of women factory inspectors, certain that they would be not only more thorough but also more accessible to other women workers.

Convincing the government that women could do this work, however, took many years. In 1879 the chief factory inspector, Alexander Redgrave, had made his position clear. "I doubt very much whether the office of Factory Inspector is one suitable for women," he had written. "It is seldom necessary to put a single question to a female [worker]." Women, in his opinion, belonged in the nurturing occupations. "Possibly some details, here and there, might be superintended by a female Inspector," he allowed, "but looking at what is required at the hands of an Inspector, I fail to see advantages likely to arise from her ministrations in a factory . . . so opposite to the sphere of her good work in the hospital, the school, or the home."[7]

A decade later, in 1890, other organizations and individuals joined the campaign to prove him wrong. Emilie Holyoake wrote on behalf of the London Women's Trades Council to the Conservative Home secretary, Henry Matthews. The daughter of George Jacob Holyoake, a founder of the cooperative movement through which workers, seeking greater control of their own work, shared ownership of factories and shops, Emilie Holyoake was familiar with the reality of working conditions. As secretary of the Women's Trade Union League, she had heard complaints about the ineffectiveness of male inspectors, particularly in investigating small workshops located in employers' homes. When the inspector visited such a workshop, she pointed out, "the workpeople are hidden away in bedrooms . . . and it is resented as an outrage to propriety if 'a gentleman' seeks to enquire further." She believed that factory inspectors should be working women with practical experience in the trades conducted in small workshops. These women would be "less easily defeated" by employers than male inspectors, and get more cooperation from workers.[8]

Matthews's staff at the Home Office did not accept Holyoake's position. "I do not see how legally a woman Inspector would have better right than a man inspector to follow fugitive women into other rooms," grumbled Sir Godfrey Lushington, the under secretary. Indeed, he had

touched on a major stumbling block in enforcement, for the law, respecting the privacy of the home, specifically restricted the inspectors' right of entry to the workrooms only. Lushington joined the chief factory inspector in advising the Home secretary to refuse Emilie Holyoake's request that he receive a deputation urging that women be appointed: "My own opinion is decidedly against the employment of Women Inspectors." Chief Inspector Redgrave commented gloomily that although the London Women's Trades Council believed "that Females would be more willing to complain to Females than to men," in his experience "few either men or women will complain to an Inspector in a Workshop," and for good reasons: "In general a man or woman who is known to have made a complaint suffers from the employer in consequence."[9]

While the argument about factory inspectors went on, the League continued its efforts to organize women. Abraham quickly became involved in this, her employer's primary interest, and after traveling with Lady Dilke on speaking tours, began to take an active role in the effort herself. In 1888–89, May Abraham organized demonstrations by laundresses demanding the inclusion of laundries under the Factory Acts. In 1889, Emilia Dilke suggested she write an occasional "London letter . . . of gossip as to aspects of labour questions" for the League's newspaper.[10] In addition, she became treasurer of the League.

Abraham, a convincing speaker, was soon traveling around the country addressing gatherings of workers. Now passionately committed to improving the lot of women workers, she went out to Cradley Heath where the nail and chain makers were on strike. This was one of the many "sweated" industries; the employer (often called the "sweater") gave out materials and paid by the piece for the finished product. The prices were set so low that "mother, father and children toil[ed] all hours that were light 'to get a red herring for dinner on Sunday.'" She watched the striking workers march. A band played "The Lord Will Provide," and the women feebly sang the words as the line of thin, worn figures straggled along through the snow. Abraham's anger rose at the passive acceptance the hymn's words implied. "I can see her yet." a companion wrote many years later, "and the hot colour that came in her face." Abraham bit her lips to resist the impulse to shout. "Whilst

they sing that," she said to her companion, "the sweaters will have them body and soul." These women, she insisted, must assert their rights rather than passively accept their lot.[11]

Efforts to organize women workers often met with frustration. In 1896, after years of campaigning by the League, only 142,000 of the 2 million women in industry were union members. More than half of these were skilled workers in the Lancashire textile mills, where the demand for trained hands gave them some security. Even among men, organization had reached less than a quarter of the industrial work force, but the obstacles to union membership for women—endless work, low pay, and family obligations—seemed insurmountable. They had little energy or enthusiasm for maintaining commitments outside the home and the workplace. WTUL leaders came to the conclusion that unless women's working conditions improved, they would never have the strength to organize. Emily Faithfull, well known as the manager of the Victoria Press,[12] reminded readers of *The Times* in 1891 that twenty years earlier she had written to the Home secretary telling him protective legislation for women was failing for lack of effective enforcement. Women factory inspectors were the key, she had insisted, "if certain evils are to be redressed."[13]

Abraham had arrived at a crucial moment in the long campaign to use the power of the law to achieve minimum standards of safety and welfare for industrial workers. Sidney Webb, reviewing the history of factory legislation in 1903, described the development of the laws as "a typical example of English practical empiricism. We began with no abstract theory of social justice or the rights of man," he wrote. "We seem always to have been incapable even of taking a general view of the subject we were legislating upon. Each successive statute aimed at remedying a single ascertained evil."[14] Exasperating as this approach might be, Webb believed it was the only one possible in England at that time.

Perhaps the closest approach to the systematic view Webb wished for was the widespread investigation conducted by the Royal Commission on Labour between 1891 and 1894. This commission, appointed during Salisbury's Conservative government, had as its chairman a Liberal, the Duke of Devonshire; Sir Geoffrey Drage was secretary. Six hundred

witnesses testified before the commission, including representatives of factory owners' associations and trade unions as well as factory inspectors. Recognizing that these witnesses did not adequately represent the unorganized women workers, the commission appointed four women investigators to gather information throughout Britain.

May Abraham was one of the four lady assistant commissioners who met with Devonshire to receive their instructions in March 1892; the others were Clara Collet, who later worked at the Board of Trade, and two other active trade unionists, Margaret Irwin and Eliza Orme.

As a lady assistant commissioner, May Abraham had ample opportunity to observe the "evils" to which Emily Faithfull had referred. On behalf of the commission, she visited 170 textile mills in Lancashire and Cheshire alone; she also surveyed textile and clothing trades in Manchester and Yorkshire, silk mills in Macclesfield, and ribbon, braid, and trimming factories in Coventry, Derby, Leek, and Congleton. In her written report, she mentioned dirty and insufficient toilet facilities and frequent instances of poor ventilation resulting in unhealthy levels of dust and heat and steam. The local sanitary inspectors performed with varying degrees of effectiveness, but, she observed, confusion over local and national jurisdiction, combined with an inadequate number of inspectors at both levels, limited their effectiveness. Sometimes a local volunteer organization lent a hand. In Manchester, for example, the Ladies' Health Society, as a philanthropic effort, trained working women to observe factory conditions, report defective arrangements or contagious illness, and advise workers about sanitation.[15]

Abraham also learned that many employers subtracted unfair fines and deductions from women's wages. Workers were charged for such things as hot water and the cost of cleaning lavatories, as well as more immediate work-related expenses such as the oiling of looms in textile mills. Employers fined workers who arrived late. Weavers were fined when oil spots were found on the cloth they had woven, although they claimed the cheap oil used on the looms caused the damage. In confectionery factories, young workers were fined for talking and laughing at work.[16]

Amie Hicks at this time was general secretary of the East London Ropeworkers' Union, whose 250 members were all women. She testified before the commission that most women workers never saw an inspector and that those who did could not talk freely to a man about such problems as the absence or inadequacy of lavatories. Hicks, an outspoken witness, vividly described the drastic measures some employers took to avoid being caught when they kept their workers overtime: "At one factory in the Commercial Road, a rope-making place . . . the girls were working there till half-past ten, the factory inspector made a visit that night, and the women were taken over the wall, through the next shop, and put into trams, their fares paid, and told to go anywhere so as to get away."

Women workers told one another about these abuses, but they were reluctant to report them to officials. "It is only such as myself who can know of these things," Hicks told the commissioners, "and we women representing the various trades do appeal that women inspectors may be appointed, that such things may not go on."[17]

As pressure mounted, the gentlemen of the Factory Department raised more objections to the appointment of women inspectors. A Home Office memorandum, probably written by Redgrave, even expressed concern over women's clothing. Female inspectors in textile factories, the memo said, would risk injury from machinery; "unless Female Inspectors wore garments properly arranged, as those of the operatives are, they would run a great danger to which men Inspectors are not liable."[18]

Small workshops in city slums, on the other hand, were said to present another sort of hazard for lady inspectors. "One of the duties would be to inspect them at night—even after 10 P.M." the memorandum pointed out. "Could they—as inspectors are now doing—pass an hour or more after that time of night in the purlieus of Shoreditch and Whitechapel?"[19] But even this Dickensian prospect failed to silence the people who believed that women inspectors were needed.

Questioned in Parliament on the subject, Conservative Home secretary Henry Matthews reiterated the chivalrous views of his Factory Department staff, insisting that "no young woman could go about the streets and slums where

the Inspectors have to go in order to see that the provisions of the Factory and Workshops Act are carried out. It is not fit work except for a woman of mature age," he concluded. By 1892, however, he had to acknowledge the "very large public feeling on the subject." He asked the chief inspector to prepare a report on districts where a woman inspector might be employed, "so that I am getting the ground ready for the appointment of female inspectors if there is shown to be any necessity for them."[20]

A change of government relieved the honorable gentleman of responsibility for this decision. William Gladstone's Liberal party came into power in August 1892, and Herbert Henry Asquith became Home secretary. Charles Dilke, who considered Asquith "the only new man who is 'any good'—a bold strong man, of great intellectual power,"[21] returned to Parliament in that same year as the member for the Forest of Dean.

Radical Liberals like Dilke, together with highly visible pressure groups like the Women's Trade Union League and people of influence such as Lady Aberdeen, the indefatigable champion of women's causes, were publicizing the exploitation of factory workers and pressing for government intervention. Asquith, observing the lively interest in industrial reform, decided immediately that as Home secretary he would give special attention to industrial affairs. He was prepared to assign the most able civil servants to this side of the Home Office's responsibilities.[22]

The Royal Commission on Labour had not yet issued its final report and recommendations, but everyone who had followed its proceedings knew that support for the appointment of women factory inspectors had been frequently reiterated by witnesses representing various viewpoints. (By the time the vast report finally appeared in 1894, it could only recommend that *more* women inspectors be appointed.)[23] Lady Aberdeen promptly made a personal plea to Asquith for female inspectors. The Women's Liberal Federation, of which she was a leader, sent a letter supporting her position.[24] At a meeting in January 1893, Asquith received deputations from the Women's Liberal Federation, the Scottish Liberal Association, the Society for Promoting the Employment of Women, and the Women's Trade Union Association, to hear

their arguments in favor of women inspectors. In January and February, trades councils in Glasgow and Montrose passed resolutions urging the appointment of women inspectors.[25]

The Factory Department staff was still opposed, however, "Of all the innovations," Asquith recalled, "the institution of female inspectors for factories and workshops was perhaps regarded in the office with the most misgiving."[26] Nevertheless, Asquith decided to take the almost unprecedented step of appointing women to the inspectorate. Until that time, with the exception of a few specialists appointed to inspect and report on the education of girls, women had been employed in the civil service only in clerical positions.

Proponents, while agreeing that women workers would more readily communicate with women inspectors, disagreed on what kind of women would best serve in these positions. Trade unionists urged the appointment of working women, but the original Factory Act of 1833 had specified that inspectors be "persons of high standing." In the nineteenth century, it was generally held in European countries that factory inspection should be "entrusted to highly placed persons whose social and moral authority would give them first and foremost an educative influence."[27]

Emilia Dilke had given serious thought to the suitability of appointing working women as factory inspectors and had even "had one or two to stay with her." She concluded, however, that their backgrounds had not prepared them "to take initiative, or to organize, or to grapple on their own responsibility with work." They lacked experience in office work and the skill to write articulate reports; she condemned them as well for being "utterly lacking in tact."[28] She wanted to be sure that the women appointed would be unquestionably the equals or betters of their male colleagues.

As a leader of the Women's Trade Union League and now once again the wife of a powerful Liberal M.P., Lady Dilke was not easily ignored; Asquith decided to appoint women of the middle and upper classes. The title, "lady factory inspector," emphasized the point. He not only accepted Dilke's point of view but selected her secretary, May Abraham, to fill one of the two positions. Under Dilke's tutelage, Abraham had become well known and well informed. Her natural

ability to be both charming and determined, disarmingly attractive and poised, was now accompanied by a solid grounding of knowledge and experience. Ironically, her appointment to the civil service in 1893 was viewed by some as a real loss to the cause of women's trade unions.[29].

Abraham's circle at that time included a number of people central to the trade union movement. She shared a flat on Tite Street in Chelsea with Gertrude Tuckwell, and among those who climbed the 104 steps to visit them were Keir Hardie, Tom Mann, Beatrice Webb, and Margaret Llewellyn-Davies. Ben Tillett, the founder of the Docker's Union and leader of the dock strike of 1889, taught the two young women to bicycle in Battersea Park.[30] In her travels for the Royal Commission on Labour, Abraham had proved that a lady could navigate the textile mills without injury. She was admirably equipped to tackle this new and difficult job. She found the challenge of proving that a woman could adequately perform its duties exhilarating, and she must have seen it from the beginning as an opportunity to work within the government to achieve the reforms she had been fighting for from the Sloane Street headquarters.

The other lady inspector, unlike May Abraham, was the "woman of mature years" whom Matthews had thought essential. Mary Muirhead Paterson, a native of Glasgow, was in her thirties when she received the appointment. Through her mother, she was a member of one of Glasgow's best-known families, the Muirheads; her father was prosperous in the boot trade. Mary Paterson was one of the first women to study at Queen Margaret College, and as a young woman, she had traveled to America with her uncle, Henry Muirhead, a socialist and member of the Independent Labour Party. They had visited Canada and California and surveyed industrial conditions in Philadelphia and other cities. Returning to Glasgow, Mary pursued her interest in industrial questions affecting women. As a philanthropist, she engaged in charitable social work with working women and girls. Organizing working girls' clubs and health education classes, she gained experience in talking with them, which was valuable background for her future career. She also achieved an insight into the lives of working women.

3

Peripatetic Lady Inspectors

Abraham and Paterson started work in May 1893. Their assignment was peripatetic: Abraham, based in London, traveled wherever she was needed; Paterson continued to live in Glasgow but traveled throughout Scotland and the north of England. Unlike their male colleagues, who were assigned to geographical districts and reported to a district superintendent, the two women were responsible directly to "the Chief," R. E. Sprague Oram, who had succeeded Redgrave as chief inspector of factories. "Sprague Oram was a little man who wrote with an enormous quill pen," according to Abraham's biographer, Violet Markham, "which it was his habit to dip energetically in the ink-pot and then dispose of its superfluous fluid by vigorous gestures all over the floor."[1] His staff learned to stay out of the way of these showers of ink. But whatever his eccentricities, he stood firmly behind his women inspectors, entrusting them with responsibility and giving them latitude to design their new occupation. He backed them up, defending them when necessary against criticism from their male colleagues and from employers, defending attorneys, and others who tried to deny the value of a woman's opinion and actions.

Oram expected his two new inspectors to work as the male inspectors did, inspecting factories and workshops in search of violations of the Factory Acts, noting hazards in the workplace in order to make recommendations for new regulations, conducting special investigations of particular trades, and prosecuting offending employers. Women were not admitted to the practice of law until many years later,

but Oram, without fanfare, quietly took the position that the authority to prosecute a case in court belonged to all factory inspectors regardless of sex—a radical decision. Asquith apparently accepted this entry of women into his own favorite arena, the courtroom. The appearance of a woman inspector in court in the role of prosecutor was frequently greeted with astonishment and even mirth, but the lady inspectors relished the opportunity to pioneer at the bar. "Miss Abraham," said *The Times* many years later, "was conspicuously successful at the conduct of prosecutions. Tall and handsome, with charm of manner and voice, she combined a power of lucid exposition with a moderation and a sense of fairness that won approval from the Bench and compliments from her professional opponents."[2]

From the time of their appointment in the spring of 1893 until the end of that year, May Abraham traveled 3,646 miles and Mary Paterson 4,270. Abraham inspected millinery, dressmaking, and tailoring establishments in London, and visited Ipswich, Bristol, Gloucester, Manchester, Liverpool, Leeds, Hull, Rothwell, Dublin, Cork, and Belfast. In addition to standard inspections, she gathered information on the working conditions of women in laundries, a familiar field for her, but one that still was not covered by the law. She also investigated health hazards to workers in the manufacture of lucifer matches (wooden matches tipped with yellow phosphorus). On the basis of her observations in that first year, she recommended further investigation or legislative action to address the problems of illegal overtime, overcrowding in workshops, and infringements of the Truck Acts, which regulated the way piecework laborers were paid.

Both she and Mary Paterson criticized the "overtime exception," which the law allowed in dressmaking and millinery workshops. Because of the seasonal pressures of these trades, the law allowed dressmakers and milliners to work overtime beyond the usual limit of a certain number of days each year. Employers flagrantly abused this rule; records were easily altered and difficult to check. As one dressmaker's assistant told Abraham, "The overtime exception just spoils the Factory Act."[3]

Abraham, in her annual report, added her own acid comment: "Considering that men are striving for, and in some cases obtaining, an 8 hours day, it seems not unreasonable that the case of the dressmakers, &c, who are often of a superior class and unable to obtain other employment, should be considered." Responding to the usual laissez-faire argument that workers were entitled to work as many hours as they chose, she voiced her opinion that withdrawal of the overtime exception would bother no one except those employers who abused it. Paterson agreed. "I was pleased to hear from one or two employers that they worked no overtime because their workers would not do it," she reported, and added her own observation that work done in overtime hours was usually of poor quality. As for the need to meet customer demand, Paterson noted that "At present . . . few women [customers] know much about the Factory Act, or its application to dressmaking, but I am sure there is nothing, beyond habit, in the nature of the trade to make overtime a necessity." She was sure that "if women find out by one or two disappointments that a dress ordered, for instance, on Thursday, cannot be received finished on Saturday, they will soon find it possible to order it a little sooner."[4]

The Liberal Magazine, listing Asquith's accomplishments in his first year as Home secretary, pointed to several in which the women inspectors had a hand. They had contributed information leading to the identification of lead works, chemical, and alkali works as dangerous places in which to labor, and lucifer match–making as a dangerous occupation that should be covered by the Factory Acts. Abraham, continuing the work she had done for the Women's Trade Union League, had also conducted an official inquiry into conditions in laundries to support an effort to bring that industry under the Factory Acts and "to increase the safety, comfort and well-being of the operatives." Both Abraham and Paterson had provided supporting data for an amendment bill to protect pieceworkers by requiring employers to provide workers with "particulars" (written information as to what work was expected and what rate would be paid) for piecework.[5]

The two inspectors were assuming their official roles with considerable confidence, but this was only half of their job.

They were also expected to listen as the women workers spoke of their concerns. Although both of them were experienced in conversing with working women, they soon realized that it would not be easy to get the women to talk freely about their jobs. "I received a letter from a dressmaker's apprentice," Abraham reported, "stating she had not dared to tell me the truth at the time of my visit, as she dreaded the treatment she would receive were it known to her employer that she had given a truthful account of her hours."[6] This dread was justified; many workers lost their jobs and even were blacklisted because they gave information to inspectors.

The inspectors took up the challenge of getting workers to talk to them. To encourage communication, they provided opportunities for workers to talk or write to them without the employers' knowledge. They received complaints transmitted through advocacy groups such as the Women's Trade Union League, and they joined these "allies" in campaigning to protect workers from intimidation. They took pride in following up on every complaint, even though the information was often vague or scanty.

Some employers, in addition to intimidating workers, resorted to subterfuge to conceal the facts from factory inspectors. They would inform the inspectors that the doors of certain rooms were locked and that the only person who held the keys was away, or they would say that a room suspected of being a workroom was only a bedroom and therefore not open to inspection. This was exactly the sort of problem the lady inspectors had been brought in to solve, and they set about doing so with relish.

Other employers, however, were ready to accept the inspectors' advice. Abraham noticed in her first year that most employers were simply ignorant on the subject of ventilation, for instance, and that her intervention with suggestions and instructions for improvement produced good results. Similarly, many workers did not know of the regulations provided for their protection, but clearly worded abstracts of the law posted in the workshops could solve this problem.

During the lady inspectors' first year on the job, Lady Dilke advised Asquith "that women should enter [the civil service] as a special class of officers to serve in trades in

which women were employed."[7] Asquith, in response, made the women inspectors specialists and allowed them considerable autonomy. They operated outside of the hierarchy of the department and were not limited to certain geographical districts, as the male inspectors were. As a result, the women were empowered to travel anywhere and investigate anything that involved working women or children. Furthermore, they were not limited to enforcing the existing law; Chief Inspector Oram could assign them to gather information on industries and working conditions that might be the subject of future legislation. Oram began at once to place them on investigatory committees; in August 1893, May Abraham was appointed to the Committee of Enquiry as to Chemical Works "to assist the Committee in the particular department of making Inquiry as to the manufacture of Lucifer Matches."[8] Two years later, she was appointed to the Committee on Dangerous Trades, along with three men: another factory inspector, Captain H. P. Smith; Dr. Thomas Oliver of Newcastle-on-Tyne, an expert on industrial hazards; and H. J. Tennant, a member of Parliament.

Because Oram allowed his women inspectors such flexibility, they were able to shape their work in new ways. "Saved first from a hampering necessity of working entirely under conditions and according to standards already prescribed before they entered with their new instinctive understanding of complaints made to them by working women," Adelaide Anderson pointed out years later in her book about women factory inspectors, they were also "saved from losing themselves in an overpowering mass of technical requirements."[9] After the women had gained some experience, they grew impatient with having to defer to men on questions involving safety of machinery, and acquired the technical knowledge required, but in the beginning they concentrated on hours, sanitation, ventilation, and methods of payment.

Abraham and Paterson proved themselves during that first year. "In towns and villages where in times past . . . the manufacturers of wearing apparel have not received the attention that could be desired," Oram boasted, "their visits have been attended with marked success." He was also highly satisfied with the administrative arrangement he had devised for the women. "I think it desirable that they should

continue to occupy a position entirely independent of H. M. [Her Majesty's] Inspectors," he said, "and that they should be peripatetic, to go wherever their services are required, forwarding their reports direct to the Chief Inspector and receiving instructions from him."[10] The experiment had succeeded in the eyes of the public as well; some people were pressing for the appointment of more women inspectors, and Asquith was prepared to meet that request.

4

Learning the Field

In November 1893, May Abraham met Lucy Deane, one of two women local sanitary inspectors in the borough of Kensington, a woman whose work in many ways overlapped her own. Deane and Abraham had been inspectors about the same length of time, and shared many concerns. Deane had faced the necessity of earning a living after her father, an army officer, was killed in the Transvaal. She had trained in practical nursing at Chelsea Hospital. She lectured on public health for the National Health Society in London, and she was a member of the Women's Trade Union League. In Kensington, the first local area to appoint women inspectors, she visited laundries as well as dressmakers' and tailors' workshops, enforcing local health regulations. But after only a few months, Deane began to see the limitations of her local authority. In her work she observed conditions that seemed to her unacceptable, but about which she could do nothing.

Deane and Abraham met for tea and talked about two of their mutual concerns—the difficulties of persuading employers and workers to ventilate workrooms adequately, and the possibility of including laundries under the Factory Acts. Deane's enthusiasm and her sense of humor made her "a woman after May's own heart." Deane immediately liked Abraham, too—"very bright & sensible looking & handsome, dark Irish girl, fond of riding," she noted.[1] Abraham, seeing in Deane a promising candidate for the national inspectorate, probably told her that Asquith was preparing to appoint additional women inspectors, and she certainly convinced

her that in the Factory Department she would have an opportunity to do more for working women than her present position at the local level permitted. Deane made up her mind to campaign for a Factory Department appointment. She met the retired chief inspector, Alexander Redgrave, in December and persuaded this "kindly old man" to talk shop with her even though he told her frankly that he did not approve of women inspectors (Diary, 6 December 1893). Before the end of 1893, she presented her credentials at the Home Office.

Asquith's private secretary, H. J. Tennant, who interviewed Deane, cautiously insisted that no decision had yet been made concerning the appointment of additional women inspectors. Not overly impressed with this "very small, unassuming gentleman like fair-haired young little man," Deane persisted, and Tennant finally admitted that, indeed, two new positions were to be created. Towards the end of December she heard indirectly that Tennant's sister, Margot, had offered to say "what she could" on Deane's behalf to her fiancé, H. H. Asquith. Unimpressed with Margot Tennant's promise, Deane expected little help from this direction—"i.e. nothing!" she commented in her journal on December 29. She felt that an introduction to Lady Dilke, probably arranged by May Abraham, was far more likely to bear fruit.

Early in January 1894, Lucy Deane accepted Emilia Dilke's invitation to tea. "All very gracious & very reticent" was Lucy Deane's description of the occasion. Though Deane met Sir Charles as well during her first visit to 76 Sloane Street, it was Lady Dilke's conversation that she recorded in her journal. She learned that as a candidate for the inspectorate, she would face an examination which might include "Applied Mechanics," and she began to wonder how she might prepare herself. Her hostess explained why she believed firmly that the factory inspectors must be educated women. But the appointment of women inspectors was only one aspect of Emilia Dilke's concern for the welfare of workers, and the talk that afternoon turned to another question of great interest: the health hazards of white lead. Lead, which was used in factories for a wide variety of processes from pottery glazing to carpet dying, caused a terrible incapacitating and often fatal illness in workers who were exposed to it. The long campaign to

protect workers from the hazards of lead was to concern the Dilkes, and Lucy Deane, for many years (3 January 1894).

Deane was invited to visit again at Sloane Street the following week. But she was not relying on the Dilke connection alone to win her the position; she began at once to prepare for the examination. Abraham and Paterson had been appointed without examination, but when two more positions were created, Asquith decided that "a somewhat severer test of their qualifications" should be applied. The men proved their eligibility to apply for the inspectorate through competitive examination, but the first women had been selected on the basis of recommendation alone. Passing a qualifying examination before final appointment, however, might strengthen their position. The Home Office accordingly recommended that the Civil Service Commission devise an examination which would test the women in spelling, English composition, arithmetic, and handwriting, as well as general understanding of the Factory Acts, although "a very wide or thorough acquaintance with factory legislation" was not considered essential. As it turned out, the test on applied mechanics was omitted, since women, after all, had had no opportunity to be trained in engineering and could not be expected to know mechanics.[2] Deane, however, was unaware of this decision. While she anxiously awaited word from the Home Office, she spent time at the local Polytechnic, studying models of factory machinery (16 February 1894).

Early in 1894, she heard a rumor that one of the appointments was to go to "a Girton lady," a university-educated woman, and that she herself was being considered for the other. H. J. Tennant asked the opinion of Miss Lankester, an associate of Deane's at the National Health Society, who recommended Deane strongly, pointing out that her experience as a sanitary inspector and public health lecturer made her a superior candidate (30 January 1894). Several weeks later, on 5 March, Deane finally received a letter from Asquith offering her the position contingent upon her meeting the requirements of the civil service examination. She could hardly believe the news, but a letter of congratulation from Lady Dilke convinced her. On 12 March, she wrote in her journal, "so I suppose I have it. I am *very* nervous." She was invited back to 76 Sloane Street to celebrate.

Lucy Deane's new position carried an annual salary of 200 pounds. The women inspectors (all at the same salary level) earned considerably less than their male colleagues' 300 pounds; undoubtedly the government justified the difference, not only by the less specific requirements for education and training but also by the commonly held assumption that men, but not women, had families to support.

The "Girton lady" who had been chosen for the other inspectorship was Adelaide Anderson. Born in Australia, she had grown up in England and been to school in Dresden. At Girton College, Cambridge, she had studied moral science. A niece of the pioneer woman doctor, Elizabeth Garrett Anderson, she had lectured to Women's Co-operative Guild members and served as a member of the staff of the Royal Commission on Labour. Adelaide Anderson was thirty-one when she entered the inspectorate. Slight and even frail-looking, she had a gentle voice and "rather academic manner" that gave little indication of the determination and zeal for adventure she later manifested.[3]

As Emilia Dilke had predicted, labor organizations and trade unions objected to the appointments (13 March 1894). They had hoped that the new inspectors would be women drawn from industrial work. The *Labour Leader* found little proof of Asquith's "love for Labour" in his selection of Anderson, with her Cambridge background, and Deane, who was associated with the philanthropic National Health Society. "It seems that no working-class woman who has distinguished herself by work among her own sex is eligible," commented the newspaper sarcastically. "They don't belong to the proper set."[4] The complaint went unattended at the Home Office, and at ten o'clock on March 30, Anderson and Deane met for the first time as they sat down to begin the examination.

"I was seized with exam fright," Lucy Deane wrote on 30 March, but though she suspected her performance on the arithmetic paper was "shameful" she felt more confident about composition and the section on the Factory Acts. At six-fifteen, having had only one twenty-minute break during which she had "run out for a cup of coffee," she came home *dead* beat and very nervous." The next day she returned for an hour-long oral test on the Factory Acts; she

thought she had performed well. And indeed, she passed the examination. Anderson, however, had to retake one section, which she had failed, before she could be accepted.

Deane's mentors offered advice and warnings that, while useful, can hardly have eased her anxiety about starting a new job. Eliza Orme, one of the four women assistant commissioners of the Royal Commission on Labour, warned her that as a civil servant, she would have to "keep clear of public speaking or sympathy with anything political or trades union etc." because the government could not employ a "party" woman who conspicuously supported any cause; the factory inspector was supposed to deal evenhandedly with both employers and employees. Lucy heeded her advice; although she continued to contribute annually to the Women's Trade Union League, she, like May Abraham, had to learn to influence others to speak for her on political matters while her own public speeches appeared informational and objective. Orme, Deane had reported in her diary on 27 October 1892, also issued a warning with a curious codicil: "Don't believe without evidence . . . women and girls *lie* awfully."

Less than a week after the examination, Deane was summoned again to luncheon at 76 Sloane Street. This time the event was clearly not a social occasion but a caucus. May Abraham and Gertrude Tuckwell were among the guests, but Adelaide Anderson, evidently not a protégée of Lady Dilke, was absent. Deane was initiated further into Dilke's and Abraham's perspective on Factory Department politics. She learned, for example, that they regarded the incumbent chief inspector, R. E. Sprague Oram, as an ally and a friend. As Emilia Dilke later told Deane, he could be relied on to "tell you if there is anything done or said against you" or if any trouble threatened her within the department (20 April 1894). Trouble, it seemed, was likely to come from her male colleagues. Many of them resented the women inspectors. The reason, according to Abraham and others, was that "the men have been lax in their work thro', probably, want of enthusiasm and thro' having been appointed merely as a livelihood . . . they are angry at what virtually amounts to an Inspection of their inspecting work." Some of them greeted the women as allies—a "nice spirit," Deane

thought—but others were "disagreeable and when a woman is sent to help them they will send her to those places visited shortly before by them . . . thus virtually wasting her time and rendering her position . . . ridiculous" (6 April 1894).

On 27 April, Lucy Deane began work. Having planned to meet Abraham at the women inspectors' office in the afternoon, Deane went to early church and then to lunch at 76 Sloane Street. There she discovered that Abraham had expected her at the office at eleven. She rushed off, arriving late and somewhat embarrassed. Since no formal training program existed, May Abraham simply went over the procedures and forms for recordkeeping. Then the two women left their office at Finsbury Circus and went inspecting together (probably in dressmakers' workshops) in Bow Street, Sloane Street, and Buckingham Palace Road. Characteristically, Lucy Deane itemized in her diary what she had learned that day, but her observations of May Abraham's style outnumber her technical notes about procedure. She noticed that Abraham was "more abrupt" than she, going straight into workrooms without ringing, and asking penetrating questions. To a neophyte this must have seemed very brave, but it was a successful approach. At the end of her list, Deane noted a difference of emphasis between herself and Abraham: "Overtime *her* bugbear! Overcrowding *mine*!" (27 April 1894). At the end of the day Abraham took Deane home to the Tite Street flat for tea with Gertrude Tuckwell.

A week later, while on her own in Worcester, Deane had her encounter with one of her male colleagues. The meeting was amicable, but she was not taken in. "Mr. Arnold [the district inspector] *very* nice, but evidently wants to hoodwink me & keep me 'harmless,'" she observed, and added with a newcomer's zeal, "He is very careless about Forms and Abstracts very much against overtime." She was thinking of the Government-required forms and the abstracts that summarized the provisions of the Factory Acts and were to be posted where the workers could see them. This paperwork was irksome, and Arnold, like many of his colleagues, did not give it a high priority. The women inspectors, determined to educate the workers about their rights and encourage

them to demand them, viewed these notices more seriously.

Deane spent her first night on the road in Cheltenham, at the Stag (4 May 1894). This trip, like many later ones, lasted only a few days. After her return to London, she spent a day watching May Abraham conduct prosecutions in Marlboro and Westminster police courts, and she had an interview with the chief. She found Oram "charming," a "bewhiskered kindly little man," even as he told her confidentially "that Cramp & his Inspectors to whose District I am appointed dislikes women-Inspectors so I am to be careful." May Abraham gave her further reason to worry, telling her, as Lucy noted succinctly in her diary on 11 May, that "Capt. Bevan to whom I am going is *horrid.*"

Deane had heard that Captain W. F. Bevan, the district inspector for Nottingham, was "evidently *very* lax himself." She noted on 16 May that he claimed to be "very hurt about Miss Abraham's pros[ecutions]" of employers in his district. Lucy disliked him; she found him "jealous and cheating" (18 May 1894). On a later trip to Nottingham, Dean and Bevan went together to inspect a tenement factory, and she brought his wrath down on her head. Deane, observing bad sanitation and poor ventilation, carefully avoided pointing out these violations in the presence of the employer, suspecting that Bevan would consider that she was interfering. She did, however, suggest to one of the forewomen that the windows might be opened at mealtimes. Later that day, when Deane and Bevan met for dinner, he "at once burst into a furious tirade," accusing her of undermining his authority in the district, "going into places and finding fault where he had never done so." He threatened to report the incident to the district superintending inspector. Coolly, she pointed out that she was not Bevan's assistant and had not exceeded her instructions. She said little more, even when Bevan called Oram a fool. She knew she was not answerable to the district administration, but she wrote to Oram asking for confirmation that her actions had been correct (15 January 1895). He backed her up.

Having failed to prevent the appointment of women, many of the men continued to sabotage the work of female inspectors. Given the social circumstances, their opposition was not

surprising. Some of the men who entered this civil service job were university graduates or, like Bevan, former military men who were not especially talented or ambitious. Others came from industry, having been master cotton spinners, weavers, engineers, or managers in mills.[5] Stationed in cities far from London headquarters, these men had settled down with their families and fallen into friendly relationships with the local establishment, including the employers it was their duty to regulate. The lady inspectors, with their confident reformers' zeal for strict enforcement of the law and their determination to prove themselves, were likely to disturb this quiet coexistence of management and guardians of the law. For the working-class men, the uncomfortable differences in class caused added uneasiness. Small wonder that some of the district inspectors felt threatened by this encroachment on their territory.

Deane's journal entries from this period tell much about the life of a solitary woman traveler in these previously male-dominated industrial cities. In Nottingham, a steep and hilly city where lace and hosiery and bicycles were the major industries, she found the choice of accommodations limited, as it was in many factory towns. The George, "a bad hotel . . . noisy and dear," was "the only decent one in town." In Newark, the "Coffee-Temperance tavern hotel," with a Bible in every room, was more comfortable and respectable, but at the Bell in Leicester she found "very bad food" and complained that there was "only the public coffee room to sit & write in." The North Stafford Hotel, opposite the railway station at Stoke-on-Trent, was less dismal. It was a large, handsome brick building that boasted electric lights. The grim, smoky town, the center for china and pottery manufacture, was another matter. Lucy Deane found it *"hideous,* and no shops" (19 and 26 May 1894).

Sent to Stoke by the chief to investigate a complaint he had received from a local citizen, she got a cool reception from the inspector there. J. H. Walmsley, she wrote on 25 July, was "evidently taken aback and annoyed at my coming." Since the chief had instructed her "not to show anything to Mr. Walmsley, or mention *any* names to him," she probably did little to assuage his discomfort.

Her informant, Miss Sarah Bennet, was "a hard-featured, reserved, middle-aged woman, a *Lady* from Lyme Regis in Devonshire." This minister's daughter, after her father's death, had "felt drawn to come and work curing the Pottery girls" who suffered from lead poisoning. Bennet told the inspector in detail the dismal facts of lead poisoning among pottery workers and, without revealing Deane's official identity, took her to visit patients at the local infirmary. There Deane saw for herself the grim disease she had heard about at the Dilkes' tea table. Bennet cautioned Deane that although she had found the pottery women "rough and uncivilized but *straight*," they were difficult to help. Terrified of losing their jobs, they would "do anything to hoodwink" an inspector (24 and 25 July 1894).

Later, on a visit to Wolverhampton, Deane ran across a new kind of male inspector. After having faced the devious hostility of Bevan and Walmsley, she appreciated the frankness of C.C.W. Hoare, the district inspector in Wolverhampton. Hoare said plainly that "he disliked me very much (officially) but did not object so much (personally!)." She suspected that he had a bad temper, but she found him "conscientious and just, and his District most in order of any I've seen yet" (29 November 1894). Perhaps Hoare, a veteran of over twenty years in the department, was sufficiently confident about the work he was doing to have no fear of review by a woman inspector. A few months later, when Oram showed her "an outrageous letter" complaining about Mr. Hoare and his dealings with a Mr. Edmonds, she defended Hoare. She told the chief she was convinced that the charge was "a spiteful fabrication. Mr. Hoare may be ill-tempered and a real nuisance to deal with," but "I'm sure he is as honest as the day in official work" (29 April 1895).

She found a less satisfactory reception in Walsall, a leather-working town near Birmingham. The district inspector, G. Sedgwick, himself a former general secretary of the National Union of Boot and Shoe Operatives, had written apprehensively to his superintending inspector before Deane arrived, asking, as she recorded it on 4 December 1894, "what for & why I've come into his district." Deane immediately contrasted Sedgwick's district and Hoare's. Sedgwick boasted of his record of no prosecutions; to Deane, this meant

he was shirking his job. He in his turn "evidently *hates* me (but didn't say so as Hoare did!)."

In this generally hostile atmosphere, an evening spent with male colleagues was unlikely to be relaxing. Lucy Deane kept her wits about her however, when she dined with W. D. Cramp, superintending inspector for the Birmingham district, and H. W. Cooke-Taylor, inspector for Coventry, one evening at the Northampton Grand Hotel. She found Cramp, who had started out as a customs-house clerk and made his career in the Factory Department since 1868, "a fairly common rather *narrow* man" who "evidently had a great prejudice against me." While Cooke-Taylor was "gassing (humbug) about 'Women' & their 'noble work,'" Deane seized the opportunity to win over Cramp, allaying his obvious suspicion by letting him know "incidentally . . . (while speaking to Cooke-Taylor) that *I* was not a New Woman" (16 October 1894).

Lucy Deane's judgment of her working-class male colleagues was as severe as her rating of provincial hotels. Although she had been at ease with Miss Bennet, the minister's daughter, she found her first encounters with men inspectors awkward, not only because of their evident hostility but also because of the difference in social class. Raised in a genteel environment, she had little knowledge of the ways of working-class people or experience in dealing with them on an equal footing. Her comments reveal an unconscious disdain, which may have hampered her efforts to get along with the men. But establishing herself among the inspectors and adjusting to traveler's discomforts were peripheral matters and did not prevent her from plunging into the work she had been appointed to do, inspecting workshops. In Mansfield, for example, she faced down an employer, Ellen Munday, who refused to allow her to question the workers. Deane, in defiance, took the employees off to another room, whereupon Munday sent for her husband. Deane threatened to issue a summons to Munday for obstructing an inspector in her investigation, and "in midst of uproar" she obtained a statement from one of the workers providing evidence that Munday had kept her people at work until five in the afternoon on a Saturday (21 May 1894). Such confrontations with employers recurred frequently in an inspector's work, and Deane and her colleagues often had to stiffen the resolve of the

workers to provide evidence, even though they risked losing their jobs.

Not all workplaces were dismal, however. She "went all over" a wholesale boot factory maintained by a cooperative to supply boots to all cooperative stores and found it "a *splendid* place! . . . *splendid* fans and ventilating arrangements," she wrote on 24 May 1894, with a connoisseur's delight. But in a tinning shop, where the women ate their meals at the workbench, the fumes were so bad she could scarcely breathe (7 December 1894).

As an observant new inspector, Deane was constantly learning about the peculiarities of the various trades in which women worked. In Coventry, for instance, she realized how unpredictable the ribbon trade could be, with its "sudden rushes" and equally sudden slumps caused by changes in fashion. Occasionally the routine of inspection brought something extraordinary before her. A shroud-making shop in Coventry was filling a highly unusual special order, a brown woolen shroud, "shaped like a nightgown and trimmed with brown 'love-ribbon' in frills & forming I.H.S. on breast." Fascinated by this macabre creation, she found out that the order also required "a large crimson stuffed satin heart (i.e. Sacred Heart), hoods, & stockings & gloves to match!" (6 October 1894).

To the west, on the way to the carpet-making city of Kidderminster, Deane visited Stourbridge, a rough, wild town "flung on the side of lovely hills & valleys, enveloped in smoke from tall chimneys." Here she watched the women nail makers "hammering the glowing iron & shaping it & working the bellows. *Very* hard bodily labor I should think," she commented on 21 November, but she was "much struck by the *extreme* health of their looks." When their day's work was done, the women stood in groups in the street and stared at her, their heads wrapped in shawls. Unruffled, she surmised that they were curious, having rarely seen "an ordinarily clad woman." To her surprise, she found that the district assistant inspector in Kidderminster was "vinegar bitter" about this. He complained to her that the nail makers' "habit of staring & assembling in crowds and shouting" at him "'fetched his hair off' and made him mad." Possibly

neither of them understood the suspicion these traditionally independent workers felt toward government representatives.

In general, by the end of this second inspecting trip, Deane felt quite satisfied with her initial encounters with colleagues, workers, and employers. Her information assembled, she returned to London to discuss with Chief Inspector Oram the next step—prosecution.

5

"The Arthurian Period"

When Lucy Deane saw Oram late in May 1894 she proposed eight prosecutions. She was pleased that he approved all but two of them (Deane Diary, 31 May 1895). This was her first approach to the courts. The policy for prosecution of cases under the Factory Acts, according to an 1869 statement, was that unless the inspector was the principal witness, "he shall open the case, and state the facts, and call his witnesses, presuming a plea of not guilty is made." Only if there were complications or the case moved to a higher court did the Factory Department seek help from the Treasury solicitor. The system, in Oram's opinion, had "worked well for years," and he saw no reason why the women inspectors should not participate.[1] He instructed Deane to proceed with the cases, and a month after beginning her inspections, she appeared in a courtroom in Derby to prosecute a case against a draper.

Deane had attended Abraham's prosecutions in Westminster Police Court one day in May, but otherwise she had quite possibly never been in a courtroom before, even as a spectator. Now she was there as a prosecutor. Experience was to be her teacher, and an unpredictable one. An inspector never knew in advance whether she would confront an ordinary solicitor or an elegant lawyer of the highest prestige and skill. "Without warning," Adelaide Anderson wrote, "an Inspector would find herself when in a police court arguing her case not merely with an experienced solicitor acting for the defendant, but sometimes with a well-known Q.C. [Queen's Counsel] (or K.C.)" [King's Counsel].[2] After this first case in Derby, Deane confessed in her diary on 9 June 1984 that the

defense attorney "certainly overcame me . . . I could hardly speak, must practice." Not long after this, she prosecuted a case in Mansfield, where she found the bench "stupid" but chided herself as well. She needed to prove that this was not the employer's first offense. She had a letter in her pocket from Bevan stating that the workshop in question had been visited and found in violation before, but she "*very* stupidly forgot" to present this crucial piece of evidence and could not back up her statement (21 June 1894).

As she became more experienced in prosecution, she also learned that witnesses could not be counted upon to stay on her side. She would gather declarations from workers on the scene, using her talent for persuasion and dodging interference from management; these statements were needed as evidence in court. But by the time the trial date arrived, the workers often had grown nervous about taking a stand and risking the loss of their jobs, and management had by then had time to influence them. At the last moment they might disappear or turn against her and deny their own statement.

In one instance, Deane arrived in a factory town on the early morning train, prepared to prosecute a case. She soon received word from an ally that she had better see her witnesses if she "didn't want them to 'give [her] away,'" as the lawyer for the defense had intimidated them. Their employer, however, a Miss Moore, refused to allow them to meet with Deane at her hotel. Undaunted by Moore's protests, Deane said: "very well then I shall exercise my right to see them here [in the workroom] alone." She did just that, and her words of encouragement worked. She "heartened them up, and," she reported triumphantly "they stuck to me like *bricks*."

She won that case after a difficult day in court. The defense lawyer was "an *awful* little cad who said 'Will you keep quiet?' 'Sit down & hold y[ou]r tongue!' whenever I spoke or objected so that the assist[an]t Mag[istrate's] Clerk had to remark on it." He "bungled the case *awfully* and was *so bad* & so ignorant that my work was easy" (9 March 1895).

The enforcement of existing regulations by inspection and prosecution was the constant responsibility of the factory inspectors. But another important aspect of their work was the gathering of information that might demonstrate the

the gathering of information that might demonstrate the need for further legislation. Their observations and conversations with workers, local physicians and clergymen, and "allies" who were interested in workers' welfare often led them to recommend further extension of legal protection. In addition, the chief assigned them to special inquiries, often into trades not included under the Factory Acts at that time. Lucy Deane participated in such an inquiry into working conditions in laundries in February and March 1895.

Two years earlier, May Abraham had visited laundries in a number of cities in England and Ireland, gathering information for Home Secretary Asquith, who was preparing to ask for an amendment of the Factory Acts to allow regulation of laundries. This move, supported by the Dilkes, Gertrude Tuckwell, and others, would, said *The Liberal Magazine*, "greatly tend to increase the safety, comfort and well-being of the operatives."[3] At that time, laundry workers' hours were long, sometimes seventy or eighty hours a week, and irregular. Sanitary conditions were often very poor, and in some of the more modern laundries, new machinery added new risks of injury to those already posed by hot irons and scalding steam.

Lucy Deane had witnessed some grim scenes in the Kensington laundries that she and Rose Squire had inspected in 1893:

> Every little house in a network of mean streets, in some respects almost rural in character, was a hand-laundry. Steam laundries were few and far between, wash-houses generally in back kitchens or basements had undrained wooden or earthen floors, soiled linen was flung down anywhere and the children and the cats played among it. Ironing was carried on in the living rooms (or rooms which had lately been such); dirty paper hung loose from the begrimed walls, the steam from wet clothes drying overhead condensed and dripped on the shoulders of the ironers, sweating at their work of polishing shirts and collars in intense heat from the red-hot stoves for heating the iron, all windows closed under the mistaken idea that drying of the suspended sheets would

thereby be accelerated . . . the work dragged on hugger mugger through the week, culminating every weekend in a frantic rush and scurry until it was finished at a late hour on Saturday night, or on Sunday . . . The workers toiled on fortified by the morning and afternoon visits to the laundry of the pot-man from a neighbouring public-house with the beer cans slung from a pole carried in each hand.[4]

The image of the laundress in the public mind was quite different from that of the pathetic, underfed seamstress or milliner's apprentice. People assumed that laundresses were strong, tough older women who could endure long hours in that heat and steam. They also had a reputation for independence and heavy drinking. Regular deliveries from the local pub reinforced this image; custom required that laundry owners supply beer to their workers. In fact, workers at one small laundry sent a complaint to the women inspectors. Not only were the wages very low, they said, but the management had failed to provide beer.[5]

Most laundresses were mature women with families; they endured the discomforts and the exhausting schedule, and they risked scalding and burning in overcrowded workrooms with a fortitude born of the need for wages. The introduction of machinery in laundries, however, added new hazards. Mangles, wringers, and hydroextractors, often operated by inexperienced girls and young women, were capable of maiming or killing their operators, and (as Deane later demonstrated statistically) the carelessness of workers (cited by employers as the cause of most accidents) increased drastically with the number of hours on the job.

Two major obstacles stood in the way of regulation of laundries. First, English custom decreed that households send out laundry at the beginning of the week and expect it back by the following Sunday. This uniform schedule required that most laundresses work overtime several days each week. Second, the wide range of size and variety among laundries seemed to make it impossible to devise rules that applied to all—hand laundries and steam laundries, family businesses and large establishments.

In addition, opponents of government intervention claimed that regulation interfered unduly with the owners' right of free enterprise and the workers' freedom of choice. Small laundries, they insisted, could not compete with large ones unless they could get the laundry done within the time limit required by their customers. Laundresses, they maintained, preferred to make their own schedules, working fourteen hours or more on some days in order to be with their families on others. The inspectors, visiting hundreds of large and small establishments, found evidence to the contrary. They were not surprised to find poor working conditions and to observe the heightened risk of accidents when workers were exhausted. But the response of the workers surprised them, and clearly contradicted the claim that laundresses would resist regulation. Deane found that laundry workers greeted her with warm enthusiasm. Of one inspection visit she wrote, "The door of a hand laundry at which I knocked opened directly into the ironing-room, and the woman who replied to my summons, requested my name and business that she might go and inform her mistress; I told her, and the irons were instantly put down to admit of a hearty clapping of hands among the listeners followed by exclamations of pleasure, and an entreaty that I would 'listen to what they had to say' as well as to the statements of other 'folk who objected.'"[6]

While workers in other industries were justifiably apprehensive about talking to government inspectors, the laundresses indeed appear to have been sufficiently confident to see possible benefits, rather than loss of employment, in regulation of hours and safety.

Abraham, Anderson, and Deane, the three women inspectors at the London headquarters, consulted with Deane's former associate, Rose Squire, who was still a local public health inspector in Kensington. Her valuable observations on conditions in laundries contributed to their recommendations for the amendment to the Factory Act. Political support was important, but the bill's foundation was the mass of information gathered by the inspectors. Women, however, were still only spectators to the action that made the law. Rose Squire watched from the Ladies' Gallery while the men in Parliament debated "matters which had been part

of my daily life," the subject about which she knew so much at first hand. The legislators refused to specify the portion of the day during which the laundresses could work, and this, she knew, made the limitation on hours virtually impossible to enforce. If an inspector, visiting a laundry at ten o'clock at night, suspected the workers were putting in illegal overtime, the employer could easily deceive her by claiming they had begun their workday in midafternoon. Ignorant of the practical requirements of enforcement, the lawmakers had undermined the intent of the law.[7]

Although the lady inspectors had only restricted access to political machinery, the laundry amendment enabled them to overcome their limitations in another area. Women in the Factory Department had not been expected to know anything about industrial machines. In other industries they had dealt with questions of hours and ventilation and temperature, but in the laundries they found their first opportunity to try to solve technical problems of machine safety. As Adelaide Anderson pointed out, "Lack of engineering training was not confined to Women Inspectors; and, as laundries first came under the Factory Act after the Women Inspectors were appointed, a special opportunity arose for them of acquiring useful new knowledge which was then available for the whole Factory Department."[8] In short, no one in the Factory Department had previous experience with laundry machinery, and so the women inspectors who did the preliminary investigations had a head start on becoming the experts.

Promoting safe operation of machinery meant, for factory inspectors, checking to see that required protective guards were in place and that workers used and maintained machines with the least possible risk to themselves. Factory inspectors also recommended safety regulations, which the Home secretary was empowered to issue. The inspectors even designed safety devices for machines when they saw a need.

The amended Factory Act, which went into effect in January 1896, in addition to bringing laundries under regulation, also required all factories and workshops to keep detailed records of accidents. Lucy Deane and Adelaide Anderson, who shared an enthusiasm for gathering and interpreting masses of information, recognized the potential

usefulness of accumulated accident reports as "a finger-post to special causes of accidental injury to workers in the particular workplace," and, more importantly, as "a general review of dominating risks in an industry as a whole."[9]

When the women's branch of the Factory Department acquired responsibility in 1899 for a "special district" in West London covering four thousand women's workplaces, including many laundries, Lucy Deane saw an opportunity to campaign for safer laundry machinery. Systematically gathering information from the accident reports and her own investigations, she consulted with laundry managers and worked with engineers to develop and test automatic guards. She tested the effectiveness of these devices by maintaining safety records over a period of several years. Meanwhile she and her colleagues, through successful prosecutions, made management responsible for compensating workers who were injured by machines on which adequate guards had not been installed.

In this way the women inspectors established standards of safety that greatly reduced the number of accidents in laundries. Deane was able to report in 1904 that while some laundry employers still looked upon the inspector as a "fusser" and a "nuisance," she could bear this accusation with equanimity as she contemplated with pride the steadily decreasing number of accident reports. She was willing to be a nuisance if it meant that she was "less often faced with the painful duty of visiting working women deprived suddenly, in the most painful manner, of their ordinary means of earning their living."[10]

Although the number of accidents did decline, the inspectors continued to see the results of gruesome mishaps—arms torn off or crushed by machinery, burns caused by steam—and to hear managers insist that the carelessness of the workers had caused these catastrophes. Detailed records, however, correlated accident occurrence with the number of hours an individual had been working, showing clearly that fatigue increased the chance of "carelessness." Nevertheless, it was not until 1907 that a new amendment to the Factory Acts limited the working hours of women in laundries to sixty a week, and of children to thirty a week.

The inspectors were proud of the results of their efforts to improve conditions in laundries. One of them recalled with

satisfaction: "I was destined through the years to come to see every prophecy of the 'ruin' which State regulation would bring upon the laundry trade falsified and the industry improve by degrees in every respect, better premises, better methods of work, shorter hours, a well paid, first-class staff of employees gradually superseding the 'washerwomen' of old."[11]

Abraham, Anderson, and Deane appreciated Rose Squire's participation in the campaign to regulate laundries and recognized her potential. Hearing that the appointment of another lady factory inspector was under consideration, Lucy Deane suggested to May Abraham that they arrange an introduction at the Home Office for Miss Squire.

Rose Squire, at thirty-five, had only recently emerged from the sheltered life of a Harley Street doctor's daughter. Educated by governesses, she had made her debut and continued in a routine of entertaining and being entertained and engaging in some voluntary social service activity. Then, unexpectedly finding herself without adequate financial resources, she went to work. Perhaps she did so because she did not want to be dependent on her brother, a physician, or perhaps she was simply eager to set out on a career of her own. At any rate, she and Lucy Deane began at the same time as sanitary inspectors in Kensington, and she, too, was a public health lecturer. She was offered a place in the Factory Department and took the civil service examination in December 1895, a month before the Factory Act of 1895 took effect. Like Deane, she approached the test with trepidation. Unlike the men of their class, who had gone to public school and university, these women, educated privately at home, had never sat for an examination. No matter how well they knew the subject matter, or how much practical background they had, they dreaded this new experience.

"I was the only candidate." she remembered. "My terror of such an ordeal was not rendered less by the fact that a thick yellow fog, of a sulphurous density peculiar to the London of those days, enfolded the world." The fog delayed her. She arrived very late. With two men to watch her, she sat in a room full of empty desks, and took the examination. Experienced in public speaking and confident in the knowledge she had gained in her public health work, she, like Deane, felt happier in the oral section. She passed both.

Rose Squire joined the staff early in 1896, making a total of five women inspectors who traveled throughout Britain and Ireland on instructions from the chief, inspecting, investigating, hearing complaints, and interpreting a new Factory Act they had helped to construct. Though they spent most of their time in solitary travel, they formed a cohesive group. Their friends and family viewed their occupation as "unladylike," and "not quite nice," an eccentricity to be politely ignored. Rose Squire recalled later, "the disapproval and even dismay with which the news was received among relatives and friends that a young woman of the family had become 'an inspector.'"[12] Under these circumstances, the inspectors turned to one another. Lucy Deane's diary records frequent meetings with her colleagues for tea or dinner or the theater in London, and the women sometimes contrived to cross paths on their way to different destinations. Even Mary Paterson, though she lived in Glasgow and seldom came to London, arranged a visit with her London-based colleagues when they came to the North. Meeting at a railway connection en route to different destinations, they would share tales of experiences in the field and departmental gossip.

With Squire's appointment, the group that established the female inspectorate was complete; no further appointments were made until 1898. These five pioneers lent a special character to the women's section. Sir Malcolm Delevingne, their longtime associate in the Factory Department, later described these early years as "the Arthurian period, when the lady inspectors were stationed in Whitehall and sallied forth to all parts of the country investigating abuses and redressing wrongs." He recalled "incidents and reports as thrilling as any to be found in the pages of Malory,"[13] as the peripatetic lady inspectors set out on trains and bicycles, in Irish jaunting cars, and on foot to do battle against health hazards, industrial dangers, excessive hours, poor sanitation, bullying employers, and unfair wages. While Asquith and Oram held office, the female inspectors had a chance to establish their position. But they were aware that their protected situation, with a benevolent chief and a Home secretary who boasted of having appointed them, could not last long. Oram, who had come to the Factory Department

in 1861, was soon to retire, and the Home secretary could be replaced in the political shuffling that followed any election. The lady inspectors, too, were well aware that national politics might bring an end to their security at any time. From the beginning they looked for ways to ensure the permanency of their branch of the Factory Department, and they soon began to consider how they might consolidate their position.

6

Designing a Profession

On a June afternoon in 1895, four of the lady inspectors gathered at their office at Finsbury Circus. Although Chief Oram refused to allow official time for such meetings, the women met at regular intervals anyway, feeling a need to discuss their work. Some of the four hours they spent together that day were passed, as usual, comparing notes on prosecutions and common problems such as ventilation in workshops, but the central issue was, in Deane's words, "our very ticklish position" in the Factory Department (Diary, 15 June 1895). The impending change of administration threatened their still precarious situation, which Oram had protected so well. The four—Mary Paterson was not present—had learned something about politics through their activities in the Women's Trade Union League and other groups concerned with women's rights and welfare. They talked about supporters outside the Home Office on whom they might rely. They also agreed on a proposal for reorganization, which they believed would strengthen their position within the Factory Department. They decided to ask Oram to appoint one of them to take charge of the administration of the female inspectorate.

They felt that the appointment of a single person in authority would give official recognition to the women's branch, making it an entity comparable to the districts into which the men were grouped. This, they hoped, would shore up their position in the bureaucracy. Oram liked the plan immediately. He proposed, further, to strengthen the new administrator's position by giving her the title of superintending inspector,

indicating a rank equal to that of the district heads. May Abraham, the youngest, but the senior woman in London, was her associates' choice for the job. When she modestly demurred, Lucy Deane responded with a forceful "bosh!" Deane convinced Abraham that she must put aside her doubts about accepting the new position. The designation, she argued, would benefit all of them immediately by enhancing their prestige in the public eye: in the long run the existence of a basic administrative structure would make room for the establishment of allowing ranks, promotions and salary increases for experienced women inspectors. "*Now* is the time, the *only* time" they would have such an opportunity, Deane insisted, "it will strengthen us in the coming struggle in the Inspectorate" (20 February 1896).

Mary Paterson, the only inspector who did not attend the Finsbury Circus meeting, was uneasy about this new development. From her distant post in Scotland she had reported directly to the chief; now she would have to defer to a supervisor in London. She voiced her doubts in a letter to her colleagues.[1] Adelaide Anderson, with characteristic faith in face-to-face discussion, persuaded Lucy Deane that they must see Paterson at once. The two women took a train north to Preston where they met Paterson for "a *very* long talk." Mary Paterson suggested that a new chief might not like finding this reorganization already in effect, and the women inspectors would start out on a bad footing. Deane and Anderson quieted her fear, and on 3 March, Deane was able to write in her journal, "We practically agreed in all fundamental matter." In the light of later events, however, it seems that Paterson's reading of the situation may have been correct.

The Home Office, in a memorandum requesting approval from the Treasury, supported the change on the basis of efficiency. The memo agreed that "the separation of the Female Inspectors from the ordinary Factory Staff is essential to their working effectively," but it noted also that the direct supervision of five individuals "entails much labour to the Chief Inspector." The reorganization would "relieve the Chief Inspector of such work as examining the accounts of the Lady Inspectors and supervising the routine arrangements of the branch."[2] The Treasury withheld approval until a later Home

Office communication gave assurance that no increase in salary was contemplated in conjunction with May Abraham's "new and special duties." The plan was approved.³

With the 1895 election, Lord Salisbury became prime minister. Under his Conservative government, Sir Matthew White Ridley succeeded Asquith as Home secretary. Oram, as expected, retired, and a new chief inspector of factories was appointed. In a departure from previous practice, the Home secretary chose the new chief from outside the Factory Department; he was Dr. Arthur Whitelegge, a physician and public health expert in Yorkshire. Ridley announced the name of the new chief inspector of factories and Abraham's appointment as superintending inspector simultaneously. "The men inspectors *furious*! at both plans which come upon them as a sudden shock," wrote Deane on 19 March 1896. Powerless to take action against the appointment of an outsider rather than someone from their own ranks as chief, the men turned their wrath against Abraham.

On 17 April, Lucy Deane reported in her journal, "I was to have crossed with Miss A. to Ireland but received letter from her with news that Mr. gould [sic] & all the other men Inspectors are making a violent effort to nullify her appointment as Superintending Inspector, & were questioning Miss Paterson's power to lay informations [before the court, preparatory to prosecution] with only Miss Abraham's approval of them. She [Paterson] had written to warn, & Miss A. had found a great deal of underhand dealing going on." Deane and Abraham saw the need for a swift counterattack and, knowing their former chief was still their friend, "drove to Mr. Oram's house & had conference with him."

Oram did not hesitate: "he at once went straight to Mr. Digby at H. O. about it." At Oram's urging, Kenelm Digby, permanent undersecretary of state at the Home Office, and an ally of the women inspectors, intervened, urging Ridley not to back off, but to sustain both appointments. Ridley may not have been entirely happy about the plan for the women's section, which he had inherited from his predecessor. He must have been aware that the women, and May Abraham in particular, though officially nonpolitical, had strong connections to Liberal politicians such as Charles Dilke. But so

soon after taking office, it would not have been desirable for him to accede to the demands of a group within his staff. He held to his decision. The men's hostility went underground.

Abraham's appointment meant that the women inspectors could no longer be regarded as a few specialists working on assignment from the chief. Their division was now organized like the districts, and the male inspectors interpreted this as a signal of greater power for their female colleagues. An alternative favored by the men, the assignment of the women to existing districts, would have put them under the control of the district supervisors. Instead, the female inspectors retained a direct line of communication to the chief. Many of the men were suspicious anyway of the newly appointed Whitelegge, an outsider who was unknown to them. To them, the women appeared to be his "peripatetic spies and stirrers up." Indeed, the administration may have hoped that the women would report instances of neglect and inferior performance on the part of the men, thus allowing the chief to improve standards of work. But Deane had long since recognized that she and her colleagues had nothing to gain by allowing themselves to be used as spies. In such an atmosphere, nothing could be accomplished, "no *lasting* good results." In fact, such tactics would have been likely "to increase friction to the breaking point" (10 January 1896).

As lady superintending inspector, Abraham reported to the chief and directed the work of Paterson, Anderson, Deane, and Squire. Perhaps the most important new power delegated to her was the authority to approve their decisions to prosecute violators of the law. District superintending inspectors authorized prosecutions, but the lady inspectors' legal actions had previously been under the direct supervision of the chief. This responsibility put Abraham firmly on an equal basis with her male counterparts.

Still worried about the precariousness of their position, Abraham and her colleagues persevered in their efforts to publicize their work and build support. "Our only weapon is to enlist as many influential & political people on our side as possible [and] to speak & lecture whenever we can," Lucy Deane wrote on 20 March. They mingled socially at luncheons, teas, and dinners with people who were actively

involved in the politics of reform. Friends like Gertrude Tuckwell, Emilia Dilke, and Beatrice Webb could speak out in support of their position. The inspectors themselves, as Deane had been warned, were required to steer clear of public pronouncements of political positions, but whenever they could, they lectured about their work. They also looked for opportunities to attend meetings of groups representing both sides of the controversy over protective legislation for women.

In the early spring of 1896, Deane and Anderson were invited to a meeting of the Women's Work Society, which opposed government intervention. They spent two fruitless hours at the home of Mrs Moberly Bell, defending the factory laws to the society's members. Exasperated, Deane wrote on 30 March, "none of those present had any practical experience and no definite knowledge of factory legislation and they returned to their prejudices after each argument against them as if to a fort from which they could not be evicted." Mrs. Bell and her friends were complacent in their belief that improvements in working conditions had come about and would continue to occur because of "'our more enlightened age & greater sympathy.'"

In public, however, the inspectors could not even argue their position, but had to endure opposition in silence. At a conference of the Women's Emancipation Union, led by Elizabeth Wolstenholme Elmy and Jane M.E. Brownlow, they listened while the speakers endorsed only factory regulations that applied to men as well as women, and expressed anxiety that women would be regulated out of their jobs as well as their freedom. "Any law which places full grown women in the position of a helpless, thoughtless, irresponsible child, who must be legislated for," said Mrs. Brownlow, "has the effect of creating and fostering an opinion that women are helpless, irresponsible beings, incapable of taking care of their own interests." In her view, as a leader of suffrage organization, women needed the vote and an equal footing with men in the workplace, rather than protection.[4] The inspectors could not at this public meeting explain the rationale behind their work—that job security for women depended on the strength and skill that would make them desirable workers. "Being officials," Deane complained afterward, "we couldn't stand

up & say . . . that inspection by improving calibre of women makes them too valuable to be turned out" (14 October 1896).

Beatrice Webb suggested another way in which the women inspectors could express their position and gain public support—through the publication of a series of articles on their work. These would not only set forth the benefits they had gained for working women but would also make clear their expertise. As Rose Squire put it, theirs was "a skilled occupation with its own standards, necessitating equally with other professions its specialised training and its peculiar qualifications."[5] While the inspectors themselves were best qualified to write such a series of articles, Webb suggested that an author whose name was widely recognized might draw more readers (5 August 1895). They considered several possibilities. Lady Frederick Cavendish, a daughter-in-law of the duke of Devonshire who took part in a number of philanthropic activities, seemed a good choice. Beatrice Webb interested her in the idea and invited her to meet the lady inspectors and Gertrude Tuckwell at tea, to show her that they were "Lady-like and tact-full and not likely to create an uproar" (5 August 1895; 12 January, 20 February 1896).

7

"Don Quixotes in Petticoats"

While their allies spoke for them in lecture halls and in the press, the lady inspectors had another forum—the courtroom. If persistent inquiry and quiet exertion of pressure were the daily constants of the inspectors' work, their performance as prosecutors was more dramatic. As women in a lawyer's role, they drew attention, and their performance commanded increasing respect. Defense attorneys sneered, calling them "Don Quixotes in petticoats," but the lady inspectors were learning how to present their cases in ways that not only won favorable decisions but brought positive reports in the press. The fines imposed on violators were usually very small and did not in themselves have a deterrent effect. Publicity about successful prosecutions, however, gave notice that the law was being vigorously enforced and that other employers might take warning and avoid the nuisance that would result from being caught in violation.

Rose Squire was perhaps the most spirited prosecutor of them all. The women who preceded her had been firm in establishing their ground and holding it. They had walked in where "ladies" were not expected or welcomed; they had learned to ignore management and talk directly to workers, to persuade when persuasion was the best tactic, to interpret the tales they heard from clergymen with the same sharp common sense they used when they listened to people in the street. They had invaded the courtroom successfully, and May Abraham in particular had made a striking impression before Rose Squire appeared on the scene. Squire compensated for

her lack of formal training by avid study of the law and its background and interpretation. Years later a newspaper described her as a "Woman Who Loved Blue Books." These official reports of Parliament are not everyone's favourite reading, but "Blue books have always had a fascination for me," Squire said. "I would much rather know the whole of an Act or a Blue Book than simply rely on extracts from either . . . I had to study Blue Books and Acts for the simple purpose of getting to know what was necessary for me in my work."[1] This thorough preparation was accompanied by a dramatic flair that made her an excellent prosecutor.

Squire created a stir at one trial by presenting an elaborately wrapped box of chocolates as evidence in court. The case involved women who, after a full day's work selling chocolates in a well-known Regent Street shop, were required to stay on to fill orders, packing the sweets in exquisitely fussy boxes and hampers, with delicate papers separating the candies and fancy ribbons decorating the exterior. During the busy Christmas season, the workers stayed for many hours after the shop closed. Squire had raided the elegant shop after midnight to obtain her evidence from the "smart but wearied young ladies whose pleasure at being caught was very evident!" The defense argued that packing the elaborate boxes was no different from putting groceries into a sack, and that since nothing was being manufactured in the shop, it was not subject to regulation as a workshop.

Rose Squire purchased a box of chocolates, "beautiful with its gorgeous and skilfully tied bow," and brought it into court. "The appearance of this brilliant object in the drab police court and later," when the defendants appealed the case, "in the Court of King's Bench, caused no little amusement and much enlivened the proceedings." Lord Alverstone, the chief justice, ruled in Squire's favour. Afterward, Squire celebrated her victory by sharing the contents of the box with her colleagues.[2]

Squire delighted in outwitting the opposition. If a wary management set scouts to watch for her at the railway station, she gleefully arrived by another route:

> On one occasion, after an absence of some weeks from a small town in the Midlands where I knew the railway station was watched, I arrived after dark by road from a distance, hurried into an hotel and engaged a room from whence I had a view of the factory windows. Watch was kept on the lighted windows until after ten o'clock, when I crossed the street and entered an unguarded door as someone came out. I was found half an hour later by the astonished employer (who had been hastily fetched from his house) among the workgirls, taking their names and addresses in preparation for the inevitable prosecution.[3]

Squire was a talented prosecutor but, like her colleagues, she discovered through experience that the Home Office administration frowned upon unsuccessful prosecutions. Whitelegge, the new chief, was a cautious man who believed that change should be effected only by moving from precedent to precedent toward gradual adaptation.[4] Under his administration, the inspectors undertook prosecution only after a careful estimate of the risk of failure. In 1895, the lady inspectors undertook 128 prosecutions resulting in 125 convictions. Despite this high rate of success, they prosecuted only 74 employers in the following year; they obtained convictions in all but two cases.[5] Indeed, the records for the entire department show that convictions were obtained in over 95 percent of all prosecutions in the years between 1897 and 1900, suggesting that inspectors went to court only when they were sure of their cases and quite certain of victory. The fines imposed by magistrates were generally too small to act as a disincentive, but employers might comply with the law to avoid the nuisance and publicity of a court appearance.

In situations where prosecution was unlikely to succeed, Squire and her colleagues learned to influence employers by persuasion. Justices of the peace, for example, were likely to suspect a woman inspector of feminine fussiness if she brought to court a suit involving sanitation. Instead of prosecuting in such cases, Squire would explain to a factory owner the way that walls and floors had to be cleaned and lime-washed in order to meet legal requirements. She would then set a time by which the work must

be done and hope for cooperation. She did not need to add that the power of the law lay behind her suggestions.

Newspaper accounts of successful prosecutions such as *Squire v. Fuller* demonstrated to employers that the law was effective. Workers also read these stories; an increase in workers' complaints to the inspectors usually followed such publicity. The female inspectors did everything they could to encourage such reporting, and usually were rewarded with a gain in public support. On one occasion, however, the publicity caused trouble in the department. The case was a frustrating one from the beginning. In February 1896, in response to a community complaint, Deane and Anderson investigated three straw-hat manufacturers in Luton, Bedfordshire and found them illegally employing children under the age of twelve. Searching for a local magistrate in order to "lay informations" before the court preparatory to prosecution, they located the first magistrate at his bacon stall in the market. His behaviour was hardly unbiased. Barely willing to receive the summonses, he "thundered" at the two inspectors, accusing them of interfering with custom and "making outworkers unpopular." He embellished his diatribe by "being vindictive & giving scripture-texts at us," according to Deane.

The inspectors, somewhat taken aback, "assured him that we knew no one in the town & had therefore no personal grudge against the Defendants who had offended after caution previously given," Deane wrote in her journal on 22 February. Of the other two magistrates, one turned out to be an auctioneer who, like the bacon dealer, was "actively hostile," and the other, James Higgins—the only one Deane found at all sensible—was himself a straw-hat maker. The results of the prosecutions were disappointing. One of the employers, whose defense was that he was a poor man, ignorant of the law, was let off with only a nominal fine, too small even to cover court costs. Another, a woman named Caroline Lawrence, "had employed in her workshop a child whom a doctor's certificate had exempted from attendance at school because her health was too bad to allow her to go there." The child's guardian, Mrs. Lane, "had taken this as a permission to employ the child at hat-making" and had sent her out to work. The magistrates,

construing Lawrence's action as one of charity, dismissed the case.[6]

Deane, anticipating that this day in Luton would provide a good illustration of the frustration experienced by inspectors when local magistrates failed to treat the factory law seriously, had taken along a friendly reporter. Marian Tuckwell not only wrote her story for the London *Daily Chronicle* but also gave her notes to another journalist. That writer's story in the *Pall Mall Gazette* emphasized "the difficulties which have to be faced by the factory inspectors" and pointed out that the Home Office had denied them permission to appeal. Deane knew she and Anderson had "committed *no* error or indiscretion"; they had given no information that was not publicly available. Nevertheless, she was embarrassed by the *Pall Mall Gazette* story. It not only "bristled with inaccuracies" but, worse, drew attention to a controversy between the inspectors and the Home Office administration. As a result of the article, the two inspectors felt that they might be suspected of having encouraged unfavorable publicity (26 January 1896).

Bizarre tactics were sometimes used against the inspectors. In one instance, the tables were turned when a worker brought Adelaide Anderson to court. Annie Mitchell, a worker in a clothing factory in Leeds, accused Anderson of assault, stating that Anderson had shaken her when she hesitated before answering a question. A large audience of factory girls turned out to see the factory inspector on trial. Anderson's sympathetic colleagues wanted to attend in force, but May Abraham—"very wisely," Deane thought—discouraged them. The case was dismissed on the grounds of discrepancies in the evidence (and Adelaide, small and soft-spoken, must have appeared an unlikely molester), but the occurrence depressed Anderson and her colleagues. What "miserable condition the poor women must be in to do such a thing to please their employers." Deane commented. Her friend Isabella Ford, a writer on women workers who lived in Leeds, confirmed her suspicions that women workers in that city were very vulnerable: "Leeds is the very worst & most miserably sweated town in England."[7] After the trial, Deane asked Ford to find out how much Anderson's

solicitor's bill would be, because the "Female Dept wished to pay it" (30 November; 4, 9, 11 December 1896).

A few days later, Deane did go up to Leeds to watch as Adelaide prosecuted two tailors (10 December 1896). Presumably these were the cases for which she had been gathering evidence when she confronted the reluctant Annie Mitchell. Anderson proceeded in court "with great difficulty owing to the perjury of the witnesses." In the first case, Anderson had seen a worker, Mary Ellison, leaving Benjamin Cohen's tailor shop at the end of a day's work, carrying a coat. She had ascertained that Ellison and her companion, Rose Traider, were taking the garment home to work buttonholes on it. Anderson had obtained signed statements from both young women that Cohen had given them work to do at home. She then summoned Cohen for employing young persons under eighteen outside his workshop after they had worked a full day inside. Traider, probably afraid of losing her job, denied her own signed statement in court, so the court fined the tailor only in the case involving Ellison. In the second case, the employer, Jacob Davies, was summoned for employing workers on Sunday as well as Saturday. This time the contradictory evidence drew the magistrate's attention. After observing that the defendant had induced children to make false statements, he imposed a heavy fine of 40 shillings in each instance.[8]

The appointment of female inspectors had been based on the belief that women would talk to other women. However, two circumstances worked against this premise: the intimidation of workers by employers, and the difference in class between inspectors and workers. Many workers viewed the government inspectors as intruders who were interfering with their efforts to earn a living and disrupting their relationship with their employers. They exercised their own forms of discipline on those who stepped out of line; in one situation, fellow workers "persecuted a woman employee of nineteen years with 'the silent treatment' because she was supposed, in this case incorrectly, to have lodged a complaint against an employer."[9] The lady inspectors, at least partially aware of their problems in communicating with working-class women, and eager to gain their confidence, established evening hours at their Finsbury Circus office. Workers and their relatives who

might be unwilling to be seen near their workplace talking to inspectors could visit, ask questions, discuss problems, and enter complaints. The annual reports took note of the number of complaints and the source from which they came, recording with satisfaction not only the increasing number of complaints, but the increasing percentage that came directly from workers and their friends, as opposed to those brought indirectly by groups concerned with workers' welfare. The observations of middle-class organizations like the Women's Trade Union League or the Women's Industrial Council were useful, but the real purpose of the women inspectors was to communicate directly with women workers.

In 1896, the women inspectors received 381 complaints, double the number received in the previous year. The inspectors diligently followed them up. Most were reports of illegal overtime, unsanitary or dirty workrooms, and inadequate sanitary accommodations, though occasionally, "curious or remarkable complaints," such as "the keeping of pigeons in workshops," offered diversion.[10] Unlike the men inspectors, who considered complaints from workers a nuisance, requiring inordinate amounts of time to investigate and too often proving to be outside the area covered by the law, the women inspectors welcomed and encouraged these direct messages as a means of improving their service to women workers. Rose Squire found, as she began to be recognized in the towns and neighborhoods she visited, that information came to her from unexpected sources. A passerby on the street or the driver of a cab might whisper that "my daughter is working overtime night after night" in a certain factory. Sometimes written complaints were hard to decipher or "strangely worded . . . the work-place was not always clearly indicated, and some skill and patience was necessary at times to find the place and effect an entrance," but these messages led to the discovery of some of the worst cases of illegal employment.[11]

Experience with workers' complaints and with both prosecution and persuasion of employers indicated that violations did not necessarily indicate willful disregard of the law. To reduce confusion about the complicated legislative provisions, May Abraham, with the Home secretary's permission, wrote a book explaining the Factory Acts in simple language.

The Law Relating to Factories and Workshops, published in January 1896, skillfully translated the essential facts of the amendment-encrusted old law into a clear and straightforward text, and it received an enthusiastic response.[12] *The Daily Chronicle* of London commented that "a really first-rate edition of the Acts such as this will greatly facilitate the administration of the law. We say it with respect, but the painful truth is that even magistrates have before now found the Factory Acts too much for them. We can recall cases in which, in their helplessness, they have flung themselves into the arms of the defendant as of a fellow-sufferer from an obscure, a troublesome, and a wanton law."[13]

Three years later, Clementina Black, a founder of the Women's Industrial Council, put the essence of the Factory Acts in verse. Her ostensible aim was to put the rules in simple form for young women workers, but in "The Rhyme of the Factory Acts" she also managed to suggest the ridiculous complexity of the law. Her long poem included such lilting stanzas as:

Of overtime, remember, none
May by young people, now, be done.
Two hours, and never more than two
Women, three times a week, may do,
But this, you will be glad to hear
Not more than thirty days a year.
This is the rule for trades, except
Those where the things may spoil, if kept.
There sixty times a year you may
Be overworked two hours a day.[14]

The lady factory inspectors were working together well and effectively under the leadership of May Abraham. They were building a reputation based on solid skills, and they were making positive contributions to the interpretation of the law. No longer an experiment, they had created a profession for themselves; their efforts were widely recognized.

8

"Such Is Woman"

Just when things were going so well for the women inspectors, a setback occurred. Some time earlier May Abraham had joined the Committee on Dangerous Trades. Since then, she and the secretary of the committee, H. J. Tennant, had been together frequently. As they shared a concern for the suffering of industrial workers and investigated the hazards of white lead and phosphorus matches, romance blossomed. Jack Tennant, a widower and father of a little boy, was a member of a prominent and wealthy family. His father was a highly successful entrepreneur; of his four sisters, one was married to H. H. Asquith, and another was the wife of a dashing country gentleman, Lord Ribblesdale. Jack himself was the least glamorous of the Tennants and never became part of the elite but unconventional social-intellectual group, the Souls, organized by his sisters and their friends. He was unprepossessing and quiet, and May's friends—including Beatrice Webb, who never minced words—thought her far brighter than he, but everyone acknowledged that it was a love match. Gertrude Tuckwell remembered May coming to her room in their Tite Street flat, "barefooted and night-gowned," in May 1896, to tell her that she was going to marry Jack Tennant. "He adored her," Tuckwell admitted, "I was sorry and glad but not surprised."[1]

'Such is woman!" Lucy Deane complained in her journal on 4 May, "it's *no* good this trying to do any Public work unless they are ugly & old or unhappy." The "marriage bar" requiring women inspectors to resign upon marriage did not yet exist, however, and May intended to continue in her work. As long

as she did, the access to influence brought by the Tennant connection would help the department, but Deane gloomily foresaw that this could not last. "She will do good in one way to Depart[ment] by this marriage but after a year when social duties & her husband's friends & politics and Babies all crowd in she'll *have* to drop the Depart[ment] and for this year's influence she will sell all the years of steady work & influence which she *might* give!" Still, even in the first bitter disappointment, Deane could not be too harsh about her friend. She concluded, "However, she's in love, & poor, and a clever, and (rightly) ambitious woman"—but she could not refrain from adding, "if *only* he were a little less unworthy of her!"

Not long after May's announcement, another calamity occurred. Lucy Deane, after a strenuous prosecution—she had spent two hours arguing a point of law with the magistrate—became ill on her way from Dublin to Belfast. She did not give in at once, but continued her visits to factories, feeling very "seedy." When she returned to London, she sent for her doctor, who diagnosed typhoid. She was very ill all through June; her first outing, a drive in Battersea Park, was not until 4 July, and she missed May Abraham's wedding on 8 July. May and Adelaide came to visit, but it was not until midsummer that Lucy was sufficiently recovered to show her normal curiosity about departmental activities. Then Rose Squire and Mary Paterson came to tea and regaled her with their first impressions of Dr. Whitelegge, the new chief, who had taken office during her illness. They found him "energetic & able," but Deane noted in her diary on 19 July that with his background in medicine and public health, he was, unlike his predecessor, "curiously ignorant as to the technical part of inspection & other work under the Act."

As Deane's health improved, Anderson and Squire confided in her their anxiety about the future of the women's department. May Tennant, who by then was pregnant, "*cannot* do the superintending work efficiently under the present circumstances." Mary Paterson was mysteriously out of favor at the Home Office and so could not take over as superintending inspector. None of the rest of them had enough seniority or experience to qualify for the post, but they were desperate to maintain the women's branch as a separate entity.

Their only hope, they decided, was to keep Tennant in office. "Her personality and influence are still extraordinarily useful to us," Deane wrote on 6 September.

The incumbent Home secretary, Matthew White Ridley, was indifferent to the women's efforts. Women inspectors, Tennant explained to Deane, "are not *his* fad as they were Asquith's." Whitelegge, still learning his job, was preoccupied with winning the men inspectors to his side, and so the maintenance of the women's department was for him a thorny issue. May Tennant herself was determined to keep working, although she had little support outside her department. Deane noted that "most of her family object [to her working] while the authorities are doubtful as to the possibility of her doing it" (6 October 1896). In any event, she hoped at least to ensure the continuation of the post of superintending inspector and in pursuit of that goal, she looked to Kenelm Digby as an ally. She withstood the disapproval of her husband's family and of some fellow civil servants through the first half of her pregnancy, but after the death of her little stepson in March, her determination wavered. In April, she decided she would resign before the birth of her baby.

Apprehensive that they might lose their small foothold, the women inspectors waited months for a Home Office decision about their future. When it finally came, it did not destroy the department, but seriously undermined it. Adelaide Anderson was appointed to succeed Abraham, but not as lady superintending inspector. Her title was to be principal lady inspector. The exceedingly important power to authorize prosecutions, which put the head of the women's branch on a par with the district superintending inspectors, was withdrawn. Once again the chief's approval would be required for each prosecution brought by a lady inspector. The women were no longer authorized to order structural alterations in workplaces to remedy deficiencies in ventilation or sanitation; instead, they were required to turn the information over to the district inspector for action—action that the district inspectors had frequently shown themselves unwilling to undertake. Here Whitelegge clearly capitulated to the men.

May Abraham Tennant was furious. In a blistering article for *The Fortnightly*, she denounced the new title as more

appropriate to "a leading position in a comic opera" than to a government official. In the name of reducing departmental friction, she said, Ridley had undone a carefully thought out scheme of reorganization that had taken ten months to formulate and had had only four months' trial. The change of title carried a "taint of amateurism" that would undoubtedly reduce the status of the lady inspectors in the eyes of employers. Worse, the withdrawal of power to authorize prosecutions could only cause delays and increased failures, undermining the ability of the women inspectors to do their work.[2]

Further, she wrote, the women's great achievements in insisting upon improvements in ventilation and sanitary provisions would now be frustrated, dependent as before upon the cooperation of the men. The result, she warned, would be "loss of time, loss of energy, the wear and tear of uncertainty, and, unfortunately, diminished administrative force." The original purpose of appointing women inspectors had been violated, and she was outraged "that they should, with their known love of thoroughness, be forced to stand by and see the cases the women workers have put into their hands left to take their turn when an already busy man is able to 'come round.'" This new arrangement was supposed to reduce friction within the Factory Department, but such friction was infrequent, she said, and should be dealt with on an individual basis. It could not be regulated out of existence. The administrative structure of the department should be designed for a different purpose, to ensure "that the protection the Department should give to the workers shall be given, and given to the full extent of its powers. [The public] will not accept as a substitute the promise of peace among its officials," she predicted in closing.[3]

Tennant still had influence; her words did not go unheard. Within a year, Whitelegge himself asked the Home secretary to return to Anderson the power to authorize prosecutions. He brushed past the opposition of male inspectors, stating firmly that he had now seen enough of Anderson's work to satisfy him that she was trustworthy and that he did not need to be bothered with this additional paperwork. The title of principal lady inspector, however, remained Anderson's until 1921 when it—and she—retired. Characteristically, Adelaide Anderson herself made no fuss about it. She fought for

and won the right to decide when to prosecute, but she quietly made people respect her "comic" title.

In general, the Conservative government of the last years of the nineteenth century was more willing to recognize the employers' prerogative than to support reform in behalf of workers. Nevertheless, under Anderson's leadership, the lady inspectors became involved in several long and hard-fought campaigns for change. These struggles occupied them for years, demanding patience, thoroughness, and tenacity, and testing their skills both as persuaders and as practitioners of the law. Prominent among these campaigns were two undertakings: the long, patient attempt to bring order to the work and wages of home workers in Ireland, and the battle against lead poisoning in the Potteries.

9

"Humanity and Red Tape"

Dinner tables all over England, including the queen's, were laid with beautiful plates and cups manufactured in the Five Towns of Staffordshire. Arnold Bennett, in his fictional account of the region, described the contrast between the beauty of the chinaware and the ugliness of the towns that produced it: "The Five Towns . . . are unique and indispensable because you cannot drink tea out of a teacup without the aid of the Five Towns; because you cannot eat a meal in decency without the aid of the Five Towns. For this the architecture of the Five Towns is the architecture of ovens and chimneys; for this its atmosphere is as black as its mud; for this it burns and smokes all night . . . that you may drink tea out of a teacup and toy with a chop on a plate."[1] Lucy Deane, on her first visit to Stoke-on-Trent, one of the Five Towns, in the summer of 1894, had been struck by the gloomy atmosphere, but she was more concerned that the cost of producing the fine china and porcelain was, for many workers, sickness, suffering, and death. The magnificent blues and reds in the china patterns owed their brilliance to lead, "the oldest of the industrial poisons except carbon monoxide," a cause of disease and death that had been mentioned as early as the first century A.D., in the writings of Pliny the Elder.[2]

Throughout Staffordshire, lead dust filled the air when certain operations, such as china scouring, were performed; workers in the vicinity breathed it into their lungs and developed the respiratory disease known as potter's rot. "Not many scourers live long," one worker said, "we all feel

overloaded upon the chest and cough very much; I cannot lie down all night."³ Painters and dippers of china absorbed lead from the glazes they handled through their skin and contracted plumbism, a disease characterized by paralysis, blindness, and often death. These risks were not restricted to pottery workers: tinplate makers in Sheffield, dyers of the fashionable Turkey Red carpets, and house painters also contracted plumbism. Some were more susceptible to the disease than others; one worker might show symptoms after only two or three months in the factory, others might work for years before their bodies absorbed enough lead to make them sick. But there were indications that women and children were more susceptible than men. Women worked in many areas of the potteries and were particularly skilled at painting the intricate and elaborate designs on the colorful earthenware known as majolica. Lead dust entered their bodies through the mouth and nose. The workers breathed it in, imbibed it with their food—they often ate their meals at the worktable—and carried the poisonous dust home from work on their hands, clothes, and hair, contaminating their own homes. Deane, in the course of her first investigation, had seen pitiful victims of lead poisoning—young women pottery workers who were hospitalized with severe nausea and abdominal pains, whose eyesight had been destroyed, and who suffered from "wrist drop," loss of the power to raise their hands. Older women had told her of multiple miscarriages and babies born with lead poisoning who sickened and died.

The manufacturers, however, insisted that lead was essential to their product and that no substitute would achieve the same effect. Consumers, they claimed, demanded the rich colors that only lead glazes had. They blamed the workers for carelessness in handling lead-based materials and for failing to observe precautions such as washing themselves and their work clothing and drinking milk to counteract the lead in their systems. The worker's attitude toward this industrial hazard was ambivalent. They dreaded disabling illness, but they could not afford to do without their wages. Workmen's compensation did not exist before 1906, and all the workers could do when symptoms appeared was to stay away from the factory until the level of lead in their bodies fell and the symptoms abated. Then

they would return to the same job, exposing themselves again, and continue until they were too crippled to work at all.

Women workers were in a particularly difficult position. When reports of stillborn or sickly babies, poisoned in the wombs of women pottery workers, aroused public sentiment, the manufacturers, to avoid the label "baby-killers," often would replace women workers with men. (The men, too, might become ill and die, but the link between them and their infants was less obvious.) Thus evolved a strange and unacknowledged collusion between women workers and their employers to keep the risks of working with lead from becoming public knowledge.

Because the manufacturers were obdurate, the battle against lead poisoning was conducted on the assumption that lead could not be eliminated from the factory. Safety measures centered, instead, on avoiding contamination by suppressing and removing lead dust, outfitting workers with protective clothing, providing washing facilities so that workers did not carry dust home with them, and teaching the workers to be careful. The Home secretary, acting on information from the inspectors, had the task of issuing "special rules" specifying ventilation and sanitary measures for the protection of pottery workers. Many manufacturers viewed these special rules as undue interference by the government, and enforcement was at best a difficult job for the inspectors. Managers and supervisors had ways of letting workers know they had better not insist on precautions, and workers, for their part, found special clothing, constant washing up, and other precautions a nuisance.

Accompanied by Mary Paterson, Deane returned to Stoke-on-Trent in March 1897, nearly three years after her first visit. Matters had not improved. The district inspector, J. H. Walmsley, gave them a gloomy report on the implementation and effect of the rules that had resulted from Deane's first inquiry. Lucy summed it up: in his opinion, the new requirements "were a dead letter and owing to wording not enforceable and if enforced no good." Walmsley saw no reduction in the number of lead-poisoning cases. He was strongly inclined to agree with the manufacturers that the potters' grievances "were all rot"—an unfortunate pun,

which Lucy noted with a stern exclamation point in her diary on 24 March 1897. The secretary of the women's union, Mrs. Goodwin, confirmed that the rules had had no positive effect. Paterson and Deane visited one of the works in Stoke-on-Trent and a pottery in Hanley to see for themselves, and "were impressed by general bad conditions & laxness."

The two inspectors parted to pursue other duties, but returned to Staffordshire on 8 April for a week of intensive investigations. They gathered information on patients in the infirmary, their symptoms, their specific occupations and those of their relatives ("mother and all her people [are] in Potteries work" was a typical report), and how long they had worked. They interviewed doctors in the district and received their recommendations. Lucy returned to London before Easter, and the following week she saw Dr. Whitelegge. These work-related medical problems interested him. He agreed to a thorough inquiry. Making an exception to the rule that inspectors operated alone, he authorized Deane and Paterson to continue working together until they had finished the investigation. A few days later, Deane saw May Tennant, who was still her supervisor, but who was preparing to retire at the end of May, since her baby was due in July. Alone with Deane over dinner, Tennant, drawing on her experience on the Dangerous Trades Committee, advised Deane to gather statistics regarding men as well as women, in order to make comparisons. Not only was this a sound social-investigatory technique, but it would also serve to blunt the risk of making lead poisoning a "women's problem" that could be solved by eliminating women from the workplace (26 April 1897).

Back in Staffordshire, Deane and Paterson established themselves in a hotel room in Hanley. They invited some "L.P. girls" (Lucy's shortened term for lead-poisoning victims) to tea. Nineteen workers came on April 30 and they invited thirty-two more to come on the following Wednesday. Once a rapport had been established through these group conversations, more thorough individual interviews followed. In at least one instance, the two inspectors interviewed a married couple, both china dippers and both suffering from lead poisoning (30 April, 1 May 1897).

A month later, Lucy Deane returned to London. At that time, May Tennant was helping her husband with a speech that he planned to deliver to Parliament for the purpose of presenting an amendment to the Employer's Liability Bill. The bill was intended to provide compensation to workers for accidental injury; Tennant's amendment would provide compensation for injuries to health caused by exposure to dangerous materials. Opponents to the amendment argued that "it would be extremely difficult to prove that the injury to health resulted from the employment." At May's request, Lucy supplied supporting information based on her investigations and wired Mary Paterson in Stoke, asking her to provide more statistics. When Jack Tennant proposed his amendment in the House of Commons, he used Deane's case histories to refute the opponents' argument.[4]

The first person to speak in opposition to Tennant's amendment was the Home secretary, Matthew White Ridley. He argued that workers who could prove that an employer's negligence was responsible for injury to their health had a remedy under the Factory Acts, and pointed out that women "are much more injuriously affected" than men in the trades Tennant mentioned. "If the obligation be thrown upon the employer to compensate . . . it will be made necessary for him not to employ men or women who are likely to suffer in health; and that would not be a very good thing for the workpeople," said Ridley.[5] Deane noted in her journal that the whole bill was "thrown out, alas!" a few days later (15 and 21 May 1897). It passed in a different form later in the year.

Deane and Paterson continued gathering information through June. When they traveled to London for the Queen's Jubilee, they met with the chief, who asked Deane to draft a circular to be distributed in the potteries, requiring reports from each factory on the number of workers employed in lead processes. Deane spent a day writing the draft and compiling a list of factories in which lead-poisoning cases had been reported during the previous year (15, 18, 21 and 22 May 1897).

The two inspectors filed their final report late in 1897. By then they knew themselves to be experts on lead poisoning. In the summer of 1897, Deane had met Thomas Oliver of Newcastle, a physician and well-known authority on industrial hygiene,

who had written a book on dangerous trades. She was satisfied to find that "his views are borne out" by their findings (11 July 1897).

While Deane and Paterson compiled their information, other advocates exerted pressure from outside the Factory Department. Speaking to the Women's National Liberal Association on 17 May 1898 on the subject of "women's work in the state," Asquith pointed out the appropriateness of using women inspectors in the potteries.[6] Two days later, the *St. James's Gazette* reported that "there was a pitiful sight of blind girls and boys and men and women waiting to be helped out of the railway carriages" at Euston Station in London when the train from Stoke-on-Trent arrived. These victims of plumbism were taken to the Home Office to meet Sir Matthew Ridley by Charles Dilke, H. J. Tennant, and several other members of Parliament, representatives of the North Staffordshire Trades Council, and members of the local branch of the Women's Trade Union League.[7] In Sir Matthew's entourage were Kenelm Digby, Dr. Whitelegge, Malcolm Delevingne, and members of the Home Office staff, but no woman, although Ridley knew that the deputation's primary request was for a woman inspector in the Potteries.

Dilke introduced the deputation to the Home secretary, pointing out to him the victims of blindness and paralysis. Members of the deputation asked for revision of the special rules and the appointment of a woman inspector to the district. As the chairman of the Trades Council explained to Ridley, "There are certain phases of female labour which a man cannot touch." He added that "our object is not to harass the employers but to help these people to protect themselves." Ridley's response was bland and unsatisfying; he thanked them for their "fair and temperate" statement and referred vaguely to administrative difficulties.[8] "The meeting between the officials and the enthusiasts," commented the *St. James's Gazette*, "resulted in the inevitable compromise between humanity and red tape."[9]

The officials had been forewarned. In April 1898, they had recieved a petition, prepared by men and women workers in the pottery-manufacturing district, asking for a responsible resident woman inspector to enforce the special rules and

"deal with the suffering there." The petition bore the signatures of local leaders, including the duke and duchess of Sutherland, Sarah Bennet, and several factory owners, trade unionists, the president and secretary of the local trades council, vicars, and curates, as well as a butcher, a deaconess, a poor-law guardian, a dressmaker, a schoolmistress, a telephone operator, a number of domestic servants, and a sergeant of the Royal Marine Artillery. But most of the four hundred signers were pottery workers—gilders, majolica painters, potters, printers, and kiln foremen. The last name on the petition was that of Gertrude Tuckwell.

At the Home Office, Undersecretary C. E. Troup belittled this array of signatures. "I suppose," he wrote in the note accompanying the petition on its official rounds, "this may be taken as indicating the direction in which the friends of the Lady Inspectors' Department propose now to agitate for extension of their powers."[11]

The administrative difficulties Ridley foresaw were potential conflicts between the local district supervisor and a woman inspector who was responsible, not to him, but to the principal lady inspector. In Parliament, Dilke, Tennant, and Asquith questioned the validity of this objection. "If there is friction, then the persons who are responsible for that friction" should be removed, Asquith said, pointing out that predictions of "perpetual friction" between men and women inspectors had not so far been correct.[12] Jack Tennant, who had accompanied the deputation to the Home Office, wrote a letter to *The Times* bluntly stating his position. "Our contention," he said, "was and is that there is a case so strong as to amount to a necessity of making a woman the inspector for the district, neither in dual authority with the man inspector nor subject to him, but instead of him."[13] Others concurred. Petitions came to the Home Office from the Veadon, Guisley & District Factory Workers' Union, the Alva Textile Workers' Union, the Women's Liberal Federation, the National Union of Women Workers, and the United Trades Council of Bolton. Editorials in the *Daily News* and the *Daily Chronicle* criticized Ridley's dismissive response to the deputation. The *St. James's Gazette* endorsed the appointment of a woman, stating firmly, "Few more useful careers than this of the Women-Inspectors

can be pointed to." This article reminded readers of the women's work record: "the ladies already employed are well known to have been an emphatic success. Their sympathy, their knowledge, and their freedom from so many of the petty vices of the minor ex-politician are at the service of the Home Secretary." The *Gazette* also suggested that Ridley had "a great opportunity for carrying into action the best traditions of the [Conservative] party to whom the welfare of the workman and the protection of human life have always been a matter of special solicitude."[14]

Reginald McKenna, the Liberal member for Monmouth, raised the question in Parliament again in July, pointing to "the very high degree of favour with which [the women inspectors] are looked upon by the working classes." He, too, cited their record: "we know that female inspectors have been successful after great difficulty where the male inspector was altogether unsuccessful. These facts point to the conclusion that the average work done by the female inspector is higher than that done by male inspectors." He then asked shrewdly, "Is it not possible that friction may have arisen from comparison of the work done by the male inspector and the superior zeal exercised by the female inspector?"[15]

As if to demonstrate the expertise of the women inspectors, Lucy Deane was called to testify at an inquest. The victim in the case was Henry Wagstaff, a pottery dipper from Staffordshire who had died in the London Hospital. The question was whether the cause of death was lead poisoning or habitual drunkenness. (Because some of the symptoms are similar, attempts to blame drunkenness for lead-poisoning deaths were common.) Home Office participation in the case was lukewarm. This inquest had been scheduled for July 1898, but it had been postponed because the male inspector of the district, J. H. Walmsley, could not be present at that time. Later, the Home Office claimed Deane was out of the country. Thomas Oliver, the nations expert on industrial disease, declined to testify, although he was working on a report on lead poisoning for the Home Office; he offered no excuse but said it would be extremely inconvenient for him. The Home Office supported his refusal.

The inquest finally took place in August. Walmsley failed to bring his records of his visits to Mountford's, the factory where Wagstaff had worked, although he admitted that Wagstaff's "muddled condition" before he died could have been the result of lead poisoning. Under continued pressure from the coroner, the Home Office allowed Deane to appear. She testified that she and Mary Paterson had visited Mountford's in the course of their investigation and found it wanting; they had instructed the management to make certain improvements and to supply soap, brushes, and towels, and she had submitted a report to the Home Office. She gave the court her opinion that the special rules that applied to the potteries were not strong enough.

A local doctor testified that Wagstaff was a sober man, and the jury found that he had died from lead poisoning.[16] An editorial in the *Daily Chronicle* accused the Home Office of obstructing justice, and the lawyer representing Wagstaff's brother protested the government's "hushing up" attitude.

While the Wagstaff inquest was in progress, the *Daily Chronicle* published an advance report of Dr. Oliver's investigation of lead poisoning in the Potteries. The report, prepared for the Home Office by Oliver and T. E. Thorpe, director of the government laboratory, included Dr. Oliver's statement that a leadless glaze was a practical alternative. The official document, *Report to Her Majesty's Principal Secretary of State for the Home Department on the Employment of Compounds of Lead in the Manufacture of Pottery, Their Influence upon the Health of the Work-People, with Suggestions as to the Means which might be Adopted to Counteract their Evil Effects*, had not yet been released.[17] The Home secretary, angry at seeing the report scooped by the Liberal press, called on his undersecretary, C. E. Troup, to explain how the newspaper had found out about the report. Troup denied that the information had been leaked by someone in the department; he insisted that the *Chronicle*'s information was based, not on the report itself, but on an "intelligent anticipation" by someone who knew a good deal about Dr. Oliver's views.[18]

The Oliver–Thorpe report attracted renewed public attention to the Potteries. Manufacturers rejected absolutely Oliver's recommendation to eliminate the use of lead, but there were indications that they might accept more thorough

enforcement of safety precautions. The women inspectors had been highly visible investigators on this issue. Their training and experience—to say nothing of what some viewed as natural womanly ability—were perfectly suited to enforcing scrupulous cleanliness, preventive sanitation, and proper ventilation. Demands increased for a woman inspector to be stationed permanently in the Potteries to enforce safety measures.

Since the only sure way to avoid lead poisoning was to eliminate lead from the workplace, and since the manufacturers refused to consider this, the women inspectors had only one recourse. They interpreted the rules literally and refused to compromise. They insisted on their right to examine registers of workers and records of illnesses, and they remained unimpressed by excuses. (Managers, for instance, claimed that when they provided soap, the workers stole it.) The inspectors did not hesitate to prosecute when they found irregularities, and they obtained convictions. In short, they were a nuisance. When managers complained about their constant badgering, the inspectors suggested that perhaps it would be easier to develop new glazes that did not include lead than to comply with the increasing number of complex rules about cleanliness and ventilation.

Deane's investigation and the public pressure organized by the Dilkes and the Tennants led to the adoption of a new set of special rules. But the flow of complaints about the pottery industry continued. In January 1900, Whitelegge asked Adelaide Anderson to submit suggestions for further regulation. She and Deane went to Staffordshire on a tour of inspection.

They found some improvement in ventilation, but Anderson was "disagreeably surprised and impressed by the carelessness" even in the best-run factories. Although manufacturers' records sometimes showed a decline in reported cases of lead poisoning, illness and injury were depressingly evident. With no workmen's compensation, workers had little incentive to report illness. "Stopped of own accord" frequently appeared on the records of workers who had quit their jobs in the potteries. A woman with a mild case of poisoning, for example, might go into domestic service for several months and then return to the factory when she felt better. Lead

has a cumulative effect on the body, however, and each successive attack of poisoning was likely to be more severe than the preceding one.[19]

Mary Paterson, in one week of "casual visiting," had discovered two unreported cases of lead poisoning, making Anderson wonder "what might not be disclosed by a year's steady visiting of workers?"[20] Anderson told the chief that workers could not be relied on to carry out essential measures of personal cleanliness on their own. "A Pottery ought to be as clean as a ship at its best," she stated, "but I cannot imagine the result of making sailors and officers jointly responsible for the cleanliness of the decks; thoroughness in a matter of this kind can only be obtained by disciplined control."[21] Only constant monitoring by a woman inspector or a woman doctor, continuously on hand, could maintain the scrupulous standard of cleanliness required by the regulations.

The manufacturers, already feeling harassed by the vigilance of the women inspectors, were annoyed by Anderson's visit. When the Home Office circulated proposed new special rules in the fall of 1900, factory owners responded with over four hundred objections and a series of amendments of their own. Some were clearly designed to keep the women inspectors out of the way. Anderson recognized the owners' response as an attack on her department and on herself. She pointed out to the chief that one of the spokesmen for management, "Mr. Ridgway strongly objected personally to my exercising this power [to examine registers of employees]," and another "Mr. Burton has in the public press made an attack on the work of the women Inspectors in terms which would be meaningless unless they were aimed at my personal inspection in the Potteries." But she doubted that Burton's statements represented his own opinion. "As I know him I am perfectly certain that on both occasions he was merely speaking for the manufacturers and not because he was convinced of the truth of his utterances." This particular manufacturer, she was certain, "will surely understand . . . that this proposal of theirs is impossible."[22]

To resolve the differences between the Home Office and the pottery manufacturers, an arbitration was conducted, beginning in November 1901. The umpire was Lord James of Hereford, a well-known lawyer and Liberal Unionist member

of Salisbury's coalition cabinet, known for his skill in arbitration. Mona Wilson of the Women's Trade Union League represented the workers. Lucy Deane was in South Africa[23] but both Anderson and Paterson testified at length, asserting their conviction that the only sure way to avoid poisoning was to eliminate the use of lead. Paterson explained that often the women most seriously affected were those "of whose cleanliness carefulness and sobriety there could be no question." Such measures as placing buckets of water to catch the dust could not be effective, she explained, because the worker "does not remain and keep her hand stationary over her vessel of water and much of the dust when it falls, falls on the floor."[24] Anderson added that alteration of the old buildings to provide adequate ventilation, washing facilities, lavatories, and eating places freed from contamination was virtually impossible. "It would seem less burdensome to remove the poison than to rebuild the Potteries," she asserted.[25]

The arbitration broke off several times. The umpire decreed a trial period during which all the new rules would be in effect except three on which no agreement could be reached. (These three rules dealt with the nature of the glaze and with medical examination and suspension of workers.) At the end of eighteen months, the arbitration resumed. A compromise agreement was finally reached in 1903. In closing the proceedings, Lord James gave his own strong recommendation that a woman inspector should be stationed in the potteries district.

The Conservative Home secretary, Aretas Akers-Douglas, who had served in government since 1885 and in the Home Office since 1902, at last relented. He announced that Hilda Martindale, who had joined the Factory Department as an inspector in 1901, would be stationed in the potteries "to secure the observance, so far as regards the employment of women and girls, of the provisions of the Factory and Truck Acts[26] generally, and in particular of the Special Rules now in force in the industry." Although still responsible to the principal lady inspector, Martindale was expected to "act in concert" with the district inspector.[27]

This was not the permanent resident female inspectorship that many had hoped for (and not until 1942 was a woman district inspector appointed to the Potteries). Early in 1904,

the *Daily News* decried the "cruelty of this decision" and the inadequate numbers of inspectors generally. Although there were now seven women inspectors where once there had been only two, the *News* printed out that "It is simply impossible for seven women to keep pace with the work of watching over the interests of hundred of thousands of women workers." How, the newspaper asked, could "the little band of brave women" cope with so grave a problem, given the limited resources "grudgingly placed at their command?" Pursuing a familiar argument, it suggested, "If Government would only spend £5 on the Factory Department for every £1,000 it devotes to the fighting services how much happier and wealthier the country would be."[28]

District Inspector J. H. Walmsley was not delighted at the prospect of having a woman inspector at his elbow in Staffordshire, and Martindale recognized that it would be difficult to work with him. The other problems she faced in her new position were no less acute. She was expected to arrange her own living accommodations and office space. She had no clerical staff; officially the clerical work was to be done in London, but most of it could not wait. Keeping her flat in Westminster, she established living and working quarters in a room at the North Stafford hotel. She had a trunk fitted out to serve as a traveling office, and wrote out her reports and correspondence by hand, making copies in a press and damping the "flimsies" on the marble-topped washstand in her hotel room.

For the next year and a half Hilda Martindale would be stationed here in the Potteries, fighting to bring management, workers, and the male inspectors into compliance with safety provisions in china manufacture. Her next assignment would take her to Ireland, one of the least industrialized regions in Britain. While Martindale worked in the Potteries, her colleagues, Lucy Deane and Rose Squire, were already in Ireland, in a remote area very different from Staffordshire, trying to make English law effective on a people who were unwilling to accept British authority.

10

The Gombeen Man

The chief sent Lucy Deane to Donegal, Ireland's far northwest county, in the chilly October of 1897 to begin a special inquiry. According to information he had received from a Mr. Walker, women outworkers there, embroidering handkerchiefs at home, were paid, not in the "coin of the realm" required by the Truck Act of 1896, but in goods or in credit at the local shop. Deane's instructions were to gather evidence for a case which would "serve as a warning and example against illegal practice of the kind."[1] In fact, hers was to be the only prosecution anywhere that year for infringement of the new Truck Act, although the chief factory inspector's annual report records forty-eight complaints of violation.

Deane had traveled in Ireland before. In the summer of 1895, she had inspected in Belfast and Dublin and conducted an inquiry into shirt factories in Londonderry. Since then, she had maintained communication with the Textile Operatives Society in Belfast, a small but determined women's trade union led by Mary Galway. At their invitation, Deane had lectured before them and had advised them on their legal rights. Two years later, in July and August 1897, she investigated a "workers' petition" opposing the Truck Acts and found it "mostly bogus"; the non-union workers, misled by their employers, were persuaded that the acts would take work away from them. She visited creameries in Kerry and reported reluctantly that all of them operated illegally on Sunday; she realized that in order to get their fresh dairy products to market they had to violate the law. She went to Donegal in 1897

to observe embroiderers and knitters and to Belleek to inspect the potteries, sometimes in the company of Mary Paterson. She talked with G. B. Snape, the local inspector, about the Donegal embroiderers and afterward proposed to him that they put together a list of Scottish, Irish, and English firms in the handkerchief industry that employed local agents to give out home work (Deane Diary, 8 August, 4 September 1897).

Inspection of factories in Belfast and elsewhere, and the kind of help Lucy Deane was able to give the struggling women operatives and their union, followed a well-established pattern. But in the matter of home work, the Irish situation was particularly complex. In rural Ireland, after the Great Famine of the 1840s, peasant landholdings were too small to provide a livelihood. Donegal country people purchased food and tea from the local shop, but few opportunities existed to acquire cash. Young men with few prospects—908 of the 1,226 who left the village of Glenties, in southwest Donegal, in 1899 owned no land—took advantage of newly established railway lines to the coast to travel to Scotland and find work on farms. They returned at the end of the season with their earnings. Women, children, and older men, left at home, depended on handcrafts for earnings and on credit at the shop to tide them over.

The Congested Districts Board, established in 1891 to find ways to alleviate the poverty of Donegal and other counties, not only taught improved agricultural techniques and purchased land for redistribution, but also encouraged local industries and crafts. It sought to bolster the economy through peat harvesting, sheep raising, and the development of the herring industry. Local crafts were losing out in competition with factory-produced goods; to sustain high quality, the board established schools to teach Irish children traditional crafts such as lacemaking. In addition, English philanthropists and Anglo-Irish aristocrats became involved in finding a market for Irish handcrafts. The Royal Irish Industries Association, founded by Lady Aberdeen in 1886, sponsored sales of Irish goods in London and encouraged manufacturers to give out handwork to be done at home. This movement, well-intentioned and partially successful, nevertheless carried the risk of exploiting the very people it was meant to help.

Handkerchiefs were made in Belfast factories and then sent out to be embroidered by hand. The manufacturers distributed the work in Donegal through local agents, many of whom were also shopkeepers; indeed many agents claimed that they could not live on their commissions and required another source of income such as shopkeeping. The country women, who lived miles from any other possible employment, depended on and feared these local agents, even though they recognized the absurdity of what sometimes constituted their payment—a package of inferior quality tea, or a small amount of credit that could be used to purchase goods at the agent's shop. "Eggs [were] paid over like cash," Adelaide Anderson observed. A woman who lived in a thatch-roofed cottage on a rocky hillside and who usually went barefoot told of receiving as wages for her work "a pair of thin elastic-sided boots." "Sure, and what should the likes of myself be after with such-like ilegance?" she asked Lucy Deane. Women who refused to work for such useless rewards, however, risked having no work—and no return for their labor—at all.

Politicians and trade unionists since 1894 had requested that Ireland, like Scotland, should have a resident lady inspector. In 1896, the Textile Operatives Society petitioned the Home secretary for a female inspector in Ireland. The Home Office resisted the idea; May Tennant, in January 1897, wrote a memorandum opposing the appointment of a resident inspector, pointing out that placing someone in Belfast would anger Dublin, and vice versa. Maintaining the peripatetic status seemed more diplomatic. Nevertheless, the issue did not subside. In the face of continuing questions in Parliament, letters, and petitions, the Home Office had to make sure that its traveling inspectors were highly visible and active in Ireland.

The Irish workers, in spite of the obvious inequity of their situation, did not welcome government or any other kind of English interference. Deane understood "the timidity engendered by their dependent condition" but she had little patience for their "strong natural inclination . . . to regard with suspicion and dislike any official attempt to enforce the law, even when it is for their own protection."[4]

To begin her investigation of home work, Lucy Deane went first to Ardara, twenty-one miles north of the town

of Donegal, at the head of Loughros More Bay. She stayed at McNellis' Hotel, an unadorned whitewashed structure on Ardara's wide main street. The remote countryside where she would be traveling was rocky and bleak. Not knowing what she might find in the way of transportation, she shipped her bicycle on ahead of her to the railway station at Glenties, some miles inland. The use of bicycles by Factory Department inspectors had received official sanction in 1896, when the Home Office, on an experimental basis, cautiously established a reimbursement rate of one penny per mile and the expense of rail transportation of the bicycle (if it was not greater than the cab fares that would otherwise be spent) for inspectors who used their own bicycles on official business.[5]

In Ardara, Deane began by visiting one of the schools where children learned crochet and embroidering. The local inspector, T. B. Snape, had criticized the schools: they were overcrowded, they kept twelve-year-olds working long days, and they encouraged the girls to take work home and continue working until ten or eleven o'clock at night. Deane talked at length with the teacher, Miss Tierney, and reluctantly concluded that it would be a mistake to prevent the school from giving out home work intended to improve the students' skill. She communicated her views privately to Adelaide Anderson to avoid going on record as sanctioning a breach of the law.

Tierney, concerned about her students' future earnings, offered to help Deane investigate the local agent's methods of payment. She invited Deane to lunch to meet Annie Mooney, an embroiderer who did sprigging (embroidering handkerchiefs with decorative sprigs and flowers) (Diary, 23 October 1897). Annie Mooney got her work from Teresa Boyle, the local shopkeeper and agent for a large handkerchief firm. Mooney told Deane that she generally got at least half of her wages in goods, and the remainder in the form of a "ticket" for credit at the shop. Deane persuaded Mooney to show her the next ticket she received.

Deane was embarking on an adventure that would involve undercover work, persuasion, and considerable exercise outdoors. Throughout the autumn of 1897, she traveled the countryside, only occasionally held back by "pouring wet" weather "far too stormy & wet to go anywhere on Bike or

foot" (16 November 1897). She walked or rode her bicycle instead of hiring a car and driver, which might have aroused suspicion. She wanted the country people to talk freely to her. Although "the probability that one would elect to spend the wet and stormy months of October, November and December in exploring the bogs and hamlets, and enjoying the accommodations afforded by that part of Ireland for *pleasure*, is at least doubtful" she nevertheless let it be known locally that this was her motive "for long, lonely walks undertaken (often by special request after dark) in wet and stormy weather." In fact, she was "quietly visiting and gradually obtaining the confidence of the scattered population." She soon discovered that frustration would be her companion. Local mores did not condone providing information to representatives of the London government. "My efforts to obtain evidence were constantly defeated by the fear of the speaker that he or she would be held up to scorn and hatred by the local public opinion as 'an informer.'"[6] One outworker's husband greeted her with the surly statement that "he wasn't afraid of Mrs. Boyle but would not for £100 that the neighbors should point him out as an 'Informer'! . . . One would think," Deane wrote on 9 November, "that *I* was the illegal conspirator instead of Mrs. Boyle!"

She was discouraged further by the ambivalent attitude of her own superiors at headquarters. Deane was ready for an all-out assault, but Anderson, who had supported her initially, after seeing the chief wrote, in a tone "which *smells* of Home Office," that while prosecution of agents was desirable, Deane would not be allowed to go beyond the agents and put pressure on the handkerchief firms or even to require the agents to name the firms.

Lucy recognized that she would have to rely on her own ingenuity and stamina to gather her evidence against the "gombeen men," as the agents who kept people tied to a system of credit and payment were known in Donegal.[7] Determined to meet the challenge, Deane sought support from the local clergy, who were known to disapprove of Mrs. Boyle's methods of dealing with homeworkers. In an interview with one priest, Father Kelly, "I was *very* cautious, didn't tell him who I was," she reported in her diary on

23 October. "He promised to look out & tell me if he came across some 'Tickets.'"

A few days later Deane saw a ticket. The scrap of paper, undated and unsigned, bore a notation in pencil:

$$\begin{array}{r} \text{To goods} \quad 9-6 \\ \underline{6-11} \\ 2-7 \end{array}$$

The worker receiving it would easily have understood this cryptic message: the worker had brought in finished work worth 6 shillings 11 pence: in payment for that work, she had received goods from the shop (tea and sugar) for which the shopkeeper charged her 9 shillings and 6 pence: Mrs. Boyle would later give her work by which she could earn another 2 shillings 7 pence to pay off her debt (25 October 1897). Lucy Deane could read its import as well: the workers were being kept in perpetual debt, which meant they had to continue producing goods.

When Father Kelly's support proved insubstantial, she turned to the bishop, but he, after a conversation with Father Kelly, refused to help her on the grounds that he and the priest could not risk offending "an influential parishioner," meaning, of course, Mrs. Boyle. Deane began to despair of gathering enough evidence to make a case. Local people and priests agreed that the agent was breaking the law, but withheld information from the inspector. Exhausted and baffled by the noncooperation of the people she had come to help, Deane, like other reformers in similar situations, felt herself a stranger in a strange land. Her objectivity deserted her, and she slipped back into the old language of prejudice. "Am depressed and appalled," she wrote one November night, "at the extraordinary feebleness & terrorism of this country, the want of truth & independence, the terror of all high & low of appearing or being unpopular, the utter disregard for law & justice [and] terrible tales of the corruption of the magistrates." Discouraged, she said good-bye to Miss Tierney and fled to Belleek in the pouring rain.

Disappointed by the priests' unwillingness to help her, Deane turned to the Methodist minister, Mr. Lyons, for advice. He suggested that she might import an outside witness to visit the shop and then give evidence. "I will have to fall back on a colleague to do this if I can find no single person in the country who will stand up bravely to give evidence," she realized. She wired Adelaide Anderson to ask permission to bring in Mary Paterson, who had been her able partner in the Potteries investigation. To her dismay, Anderson responded immediately, offering to come herself. Deane, realizing that official caution would come with her, declined the offer and sent directly for Paterson. At the same time she wired May Tennant, asking her to name a good lawyer in Dublin who might help her build her case (18–20 November 1897).

While she awaited Paterson's arrival, Deane investigated home work in Carrick, a town to the northwest of Ardara. In the hotel there, she struck up a conversation with a police inspector. Skillfully she extracted crucial information from him. From his remarks she learned the arguments that the district agents would use against her in her prosecution, "for which I am very grateful" (23 November).

In an elaborate cloak-and-dagger operation, she and Mary Paterson met, then traveled in different sections of the train to Glenties. Leaving the train, they made their way out of town separately. After dark, Deane picked up Paterson, who was dressed as a country girl, and took her to the outskirts of Ardara. Then Lucy returned to Glenties. Mary, carrying a bundle, walked into Ardara. She mingled with the working women, watching as they brought their embroidery to Mrs. Boyle's shop and received tickets in return. After three days, Deane returned to Ardara. Delighted with Paterson's success, she promptly wrote out a report declaring her readiness to prosecute and mailed it to Anderson (26 and 29 November).

Paterson's venture ensured that the case would not fail for lack of evidence and made it possible for Deane to go forward with the prosecution. As it turned out, however, Deane had underestimated the Irish workers. The local witnesses found the courage to testify, and "the case proceeded successfully without the necessity of falling back on this [Paterson's] testimony." Deane won: Teresa Boyle was fined forty pounds.[8]

It was clear to the lady inspectors that more serious matters were at stake than occasional cases of small town shopkeepers' mistreatment of women workers. British law was being flouted in Donegal, and a unionist government was prepared to commit its resources to demonstrating that it would not tolerate such disrespect, even in a remote corner of Ireland. When Deane, and then Rose Squire, went back to Donegal in 1899, they believed themselves to be engaged in "a prolonged struggle for the vindication of law and order ... in which the whole neighborhood and population took a keen and very personal interest."[9] All eyes were upon them, even when they concealed their official role, for as English ladies they represented, for the Irish, British rule.

Rose Squire's experiences in Ireland were no less adventuresome than those of Deane and Paterson. Squire's story begins in Dungloe, a coastal village in County Donegal some miles north of Ardara and Glenties, known chiefly for its excellent fishing. The English trout fishermen who were staying at the tiny hotel did not perceive a champion of the law when a solitary English lady arrived there toward the end of the fishing season in September 1899, but their curiosity was aroused. Unlike the other hotel guests, this lady did not fish, nor did she paint, though she did carry a camera and a sketchbook when she went out into the countryside. In conversation she only said vaguely that she was interested in Ireland and its people; the other guests conjectured that she might be an "authoress" searching for local color.

As the weather grew wetter, the fishermen began to depart, but Rose Squire maintained her masquerade. Though an occasional inland revenue man had been known to appear in Dungloe, Squire's sex and class camouflaged her perfectly. No one suspected that a *lady* might be a government inspector—least of all the hotel keeper, who was also clerk to the local magistrates.

Lucy Deane had tried to approach the local people through the priests and teachers of their community, but Squire went to them directly, roaming the region alone on foot or bicycle. The country around Dungloe, known as The Rosses, was a bleak and rolling landscape, rocky and wet, with few landmarks and fewer human dwellings. The long, narrow dirt

roads with broad fields of peat and rocks on either side, little traveled, were not much help; it was easy to get lost, and in those days, it was "dangerous to be benighted off the beaten track," but the country women welcomed her and chatted, knitting constantly. They invited her into their whitewashed, thatch-roofed cottages, driving the hens outside in honor of their guest, though the pig or the calf might remain, and offering her a cup of tea. "Such tea, kept in perpetuity on the side of the fire in a basin half full of leaves, to which fresh water is now and then added, is an acquired taste," she admitted later, but in pursuit of her investigation she drank it, and tasted the boiled potato or bit of herring that sometimes accompanied it, all the while listening sympathetically to what the women told her.

Walking on the bog, Rose Squire met girls herding the animals, and they, too, were knitting. She observed that the rocky land promised no success at farming. She pieced together a picture of the threadbare local economy. The men, she learned, went harvesting in Scotland every summer to earn cash; the women knitted socks with yarn given out by shopkeepers in Dungloe or Glenties. When the work was completed, the women, who lived as much as twenty miles away, walked back to the shop or out to the road to meet the agent's cart when it came around. Knitting in this remote region was a sporadic and poorly paid occupation; the rate of pay for a dozen pair of socks was one shilling and a few pence. But the women seldom saw any money. The shopkeeper, "the gombeen man," paid them in goods from the shop "of whatever kind and quality suited his purpose best." As the only employer for miles around, the gombeen man controlled his territory and his workers as he liked, despite the law. Squire, like Lucy Deane, was determined to bring these middlemen to justice.[12]

From time to time, the mysterious lady tourist wandered into the little local shops, apparently to buy thread or some other small item. She watched the women and girls carrying in the socks they had knit and saw them receive from the shopkeeper packets of tea or sugar. She was careful to investigate these transactions "in such a manner as not to suggest the exercise of a power, but rather to invite confidence as from one woman to another."[12] By the time some of the

local people had begun to suspect that her interest went beyond that of a curious traveler, Squire had collected her information and was ready to prosecute her case.

She had gathered they names and locations of the local gombeen men and had observed their illegal method of payment. She had talked to the priests and the Protestant clergymen, to the local constables and the ordinary citizens. Then she went away. After a brief absence (she was visiting headquarters in London), she returned, no longer as a tourist but in her true identity as "Her Majesty's Inspector of Factories."

When the news circulated that Rose Squire had come ready to prosecute the gombeen men, her situation changed. People who had willingly told the sympathetic lady tourist their sad plight proved reluctant to take the stand as government witnesses. People who had been her friends grew cool. Local people were reluctant to offend the shopkeepers, who were, after all, powerful citizens of the small community, often relatives of the magistrates or the priest. Hostility toward the inspector grew so intense that for a while, when legal proceedings were going on, Squire was placed under the protection of the Royal Irish Constabulary by order of Dublin Castle.[14] Nevertheless, she was "much cheered by the undoubted sympathy and gratitude of the peasants."[15]

Adelaide Anderson wrote admiringly in her annual report: "But for [Squire's] preliminary success in gaining the confidence of the peasant women, and the tenacity and resourcefulness she showed in following out the information gradually acquired, by proceedings in court under the most trying circumstances, [the campaign] must have ended in defeat."[16]

No one in Donegal wanted to give the appearance of helping Miss Squire, with the sole exception of her Dungloe driver, Coffey. If witnesses failed to appear in court on the scheduled date, a frequent occurrence, a court official had to serve a summons. To ensure that he succeeded, Squire traveled with him. Coffey risked the disapproval of the village to drive Squire and Sharkey, the summons server, out into the countryside. Without the local driver, it would have been impossible to search out the way to the remote cottages where the witnesses lived. They were an odd group. As Rose Squire described it:

The summons-server, Sharkey by name, and I made a strange pair; I, in mackintosh, sou'wester and fisherman's long boots, he (at all times something resembling a stage ruffian) was, as he expressed it, "apparelled as a beggar," so as not to be easily recognized! His appearance baffles description. No beggar would be seen in such strange and patchy garments, a sack around his shoulders, trousers tied with a straw at the knees, and a moleskin cap tied under his chin, his dark, good-humoured eyes beaming out of a pale, thin face fringed by straggling whiskers, and his chin dark and unshaven. When he and Coffey strove to entertain me so far as the rain and wind would permit, during the long car drives, the result was more comic than any comedy ever produced.[17]

Squire and her companions were often disappointed; the local people frequently saw them coming across the flat, nearly treeless land and managed to be not at home. Travel across the wet terrain was hazardous and a sense of humor essential. One day, after Sharkey had posted a summons on the door of an empty cabin, Rose Squire slipped and fell into a stream as they retraced their steps through the bog. "Lying on my back, the shallow water flowing round me, I saw Sharkey bending over me with such a look of consternation in his face that the absurdity of the whole situation overwhelmed me, and to his still further discomfiture I laughed so much that it was some moments before I could grasp his hand, outstretched to pull me up."[18]

11

"An Army of Petticoated Inspectors"

"The whole work of the year," stated Adelaide Anderson's annual report for 1899, "was affected directly and indirectly by the claims of Ireland." Four of the seven women inspectors—Squire, Deane, Paterson, and Anderson—spent much of their time in Ireland. The earlier struggles of Deane and Paterson, and Anderson's reconnoitering of the area before dispatching Squire to her task, had made them determined to press this matter to a successful conclusion. "For three members of my staff and myself," Anderson reported, "1899 will probably always be chiefly associated with a remote district of Ireland, with unregulated industry, and with almost baffled endeavours to enforce the earliest provisions of the law against truck." Anderson knew that "it would be impossible ever again to devote so large a proportion of the small staff" to such an endeavour. But Lucy Deane, who had helped Squire collect information in the early stages of the investigation, said, "My prosecutions under the Truck Act at Ardara in 1897 . . . only faintly indicated . . . the extraordinary industrial and social conditions which became fully revealed to us during this serious experience in Dungloe!"[1]

The inspectors were increasingly sure that they were battling not only for the welfare of poor workers but also for the whole concept of enforcement of British law in Ireland. The inspectors' opponents, on the other hand, found them overzealous. "People who are trying to formulate an industry to employ the people should not be harassed by overanxiousness on the part of the inspectors,"

one shopkeeper protested. "We have always found that male inspectors went on and did their duty vigorously, but they did not go about it and were not guided by impulse as females are. They were guided by reason."[2]

In 1900, an Irish defense attorney named Healy protested that the "fire and vigour" of the prosecution was detrimental to local industry. The local newspaper, the *Donegal Vindicator*, quoted the attorney's remarks at length. "It is not the first of these cases in Donegal," he said. When the Duke of Abercorn started a fishing industry, women workers gutted the herring at night when the boats came in, "but Mr. Mackey and his lady inspector friends put an end to it." Mr. Justice Andrews, before whom Healy was arguing, had heard this earlier case as well. "They sent down one of these petticoated inspectors," Healy reminded him, "and your lordship dismissed the case." Intimating that the lady inspectors were seeking to retaliate, he added, warming to his subject, "and it is out of that there is now an army of them squatted around Dungloe watching every little industry and striving to throttle them. The Duke of Abercorn having succeeded they now attack John Sweeney, who keeps half of these poor people alive during the winter. When the case was dismissed this very lady went in to beard this man; went into his house and brought in a policeman; in court she swore she did not go on business, but to make a case."[3]

By a stretch of dramatic imagination the defense attorney multiplied Rose Squire and two or three other lady inspectors into an army. But Squire's energetic pursuit of justice did sometimes convey the impression of multiple activities impossible for one person to have accomplished in such a short time. John Sweeney was one of four agents she prosecuted in November and December of 1899. She did not always succeed; some cases had to be withdrawn because the witnesses failed to appear, but she won some, and fines ranging from five to fifteen pounds were imposed.

The Sweeney case proved to be particularly difficult. John Sweeney, a Dungloe shopkeeper, was also a county councillor and an influential citizen. The case quickly became the center of local gossip. It involved an old woman, Mary MacGeoghan, mother of a large family of girls. With the yarn she received

from Sweeney, Mrs. MacGeoghan knit half-hose in a mixture of colors. These "gaudy looking socks" were popular with working men, who wore them with their Sunday clothes and low boots.[4] Squire contended that Sweeney paid for the socks in goods rather than cash. But the issue at stake went beyond workmen's Sunday socks. The villagers perceived that the real question was "whether John Sweeney shall rule Dungloe or the Law."[5] This, indeed, was precisely where the lady inspectors felt the line was drawn.

Squire and Deane, accompanied by Constable B. McCaughy of the Royal Irish Constabulary, called on John Sweeney to make inquiries. Sweeney's establishement included a grocery and a drapery shop fronting on the street. Another building, where the hosiery was given out, had its own entrance from the cobbled courtyard in back. When Squire approached Sweeney and asked to speak with him, he led her into his private office in the back. Once on his own property, however, he refused even to identify himself. Ordering her "in a violent manner" to leave, Sweeney turned Squire toward the door. He followed the two women and the constable onto the street, where he "molested and abused them . . . [and] contended that [his shop] was not a factory."[6]

When the local magistrate dismissed the Sweeney case on unspecified legal grounds, Squire issued a new summons, and a new hearing was conducted in February 1900. This time, four magistrates from other districts sat with the six local magistrates, and the Home Office sent the government's top lawyer, the Crown solicitor, to represent Squire. Despite this impressive array of authority, the scene was one of utter confusion verging on slapstick.

The attorney for the defense insulted one of the visiting magistrates. Sweeney, the defendant, "insisted on so frequently interrupting his own solicitor, that at last the exasperated lawyer sat upon his client," Rose Squire recalled, "not metaphorically but physically, using his elbows alternately to push back the protesting head that appeared first on one side and then on the other of the eloquent advocate."[7]

After all of this turmoil, the outcome was disappointing for Rose Squire. The High Court in Dublin ruled on appeal that

the knitters did not come within the definition of laborers protected by the Truck Act. Furthermore, the court pointed out, Squire could not offer positive proof that Mary MacGeoghan had done the knitting herself; Sweeney had insisted that she could not have done it, but had taken the work for her children to do.[8] Since the "artificer was not bound to execute the work himself or herself," the court declared, Mrs. MacGeoghan might be considered an employer. With this ruling, the whole carefully constructed edifice came crashing down. Fines, not only in Squire's Dungloe cases, but all the way back to Lucy Deane's prosecution of Teresa Boyle in 1897, were remitted.

Supporters of the Truck Acts were quick to question the Home secretary in Parliament about the implications of this decision. A week later, Sir Charles Dilke asked Ridley whether "the view uniformly taken by the Home Office is reversed" by this decision and "whether the judgement will have effect in England or Scotland." He also wondered "whether the Irish decision goes beyond the Truck Acts," affecting definitions in the Factory and Workshops Acts as well.

"I regard the question as so serious," Sir Matthew White Ridley replied, "that I propose to consult at once with the Law Officers of the Crown as to the effect and extent of the decision." But the parliamentary representative from Donegal, T. D. Sullivan, immediately rose to complain that the whole campaign of the factory inspectors was detrimental to the welfare of the people of Donegal. "Female factory inspectors have been sent to Donegal on several occasions, and have instituted legal proceedings against employers in poor districts, where," he suggested, "until local industry was started, emigration was the only resource of the population." Ridley replied simply that the "existence of grave abuses on the part of employers in some parts of Donegal have made proceedings necessary."[9]

Anderson put the issue far more bluntly in her annual report: "Where outworkers hold a strong enough position to make clear in their contract express or implied with the giver-out of work that they are not (as these peasant women are not) in the position of sub-contractors employing for profit other workers, this decision would not injure their prospects of securing payment [in cash]." But the position of most outworkers was anything but strong, and "unless

the long campaign on their behalf, making clear, as it did, the injury they suffered, and thus enlisting the sympathies of the better section of public opinion, arouses some organised effort in their midst, they cannot hope for release in the meantime from the tyranny of uncontrolled payment in kind."[10]

But Ridley's energetic response to Dilke was not followed by action. Confronted again by Dilke on July 31, 1900, he still could not say that the question of the applicability of the Truck Acts to knitting had been reviewed. For the time being, apparently, the Home Office had given up on Ireland.

Nearly a year later, in May 1901, H. J. Tennant asked whether the Irish decision affected similar cases in Cornwall. The new Home secretary, Charles Ritchie, reported that legal advice indicated that the Irish decision did not affect England and Wales.[11] But in 1905, in *Squire v. Midland Lace Company*, an English case, the court made a similar ruling, saying that the employers were not "aware of the person or persons who actually did the work." The court added, however, "We must therefore dismiss this appeal. We do so with some reluctance, having regard to the facts disclosed in this case as to the nature of the employment and the position of women clippers, who, though they do sometimes employ assistants, are evidently, as a class, wage-earning manual laborers and not 'contractors' in the ordinary and popular sense, or persons who 'speculate on the state of the labour market'; and we venture to express the hope that some amendment of the law may be made so as to extend the protection of the Truck Act to a class of workpeople practically undistinguishable from those already within its provisions."[12]

The disappointing end to this dramatic campaign did nothing to silence the demand that a resident woman inspector, preferably Irish, be assigned to Ireland. In 1901, the Irish Trade Union Congress, meeting at Sligo, passed a resolution to that effect; in 1902, the Congress of Irish Workers did the same at Cork. Each resolution was brought to the attention of the House of Commons by Joseph Patrick Nannetti, the member for the College Division of Dublin.[13]

In fact, it was not until 1905 that the Home secretary announced that he had appointed a lady inspector for Ireland, to reside there permanently. Quietly redeploying his forces,

possibly in response to continuing pressure from the powerful owners of the Staffordshire factories, he assigned this inspector to spend two-thirds of her time in Ireland and one-third inspecting in the Potteries.

The announcement came as a surprise to the appointee, Hilda Martindale, who had been spending most of her time since February 1904 in the Potteries. She read in the newspaper that she had been selected as resident lady inspector for Ireland.[14]

May Abraham

From *Women in British Trade Unions 1874–1976*
by Norbert C. Soldon, Gill & Macmillan, Dublin, 1978

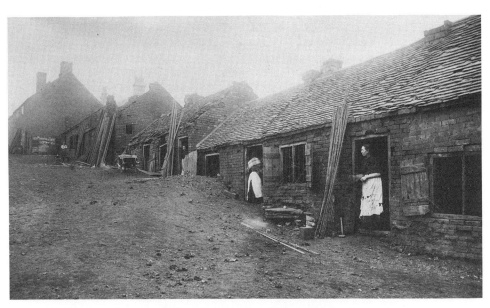

Chainmakers at their workshop doors

Reproduced by kind permission of Birmingham Library Services

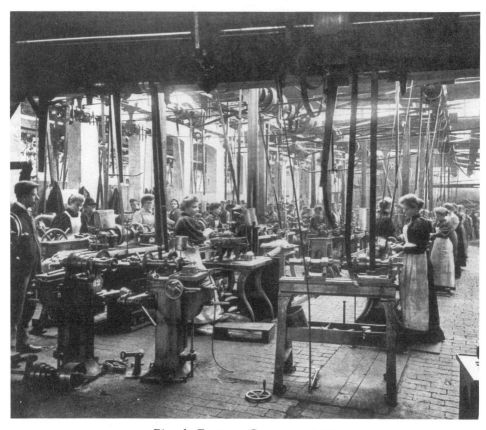

Bicycle Factory, Coventry, 1897

Reproduced by kind permission of the Mansell Collection

Mary Paterson
From *The Baillie*, 16 May 1917

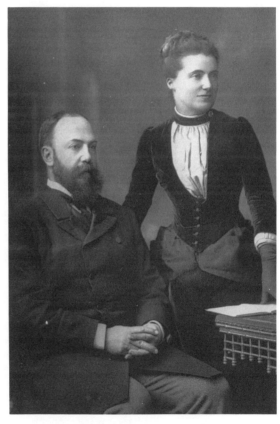

Emilia and Charles Dilke
Reproduced by kind permission of
Hulton-Deutsch Collection

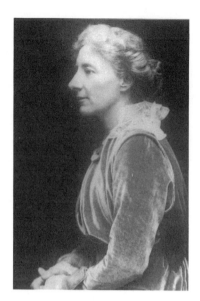

Lucy Dean

Reproduced by courtesy of
Martin Wright

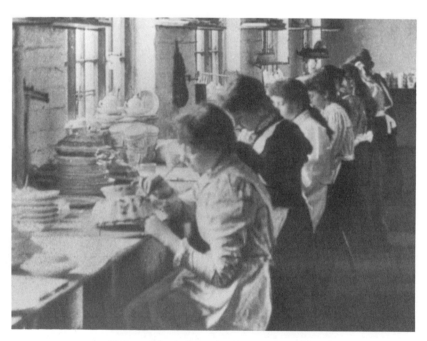

China painters in the Potteries, 1905

Reproduced by kind permission of the
Gladstone Pottery Museum, Stoke-on-Trent

Donegal home workers

Reproduced by kind permission of the
National Library of Ireland

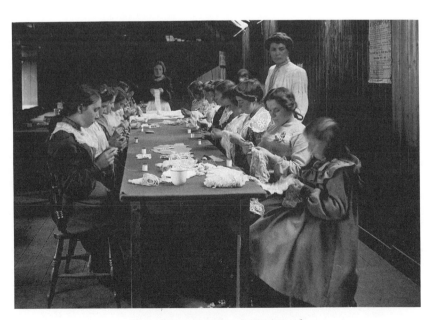

Lace-making school, Donegal

Reproduced by kind permission of the
National Library of Ireland

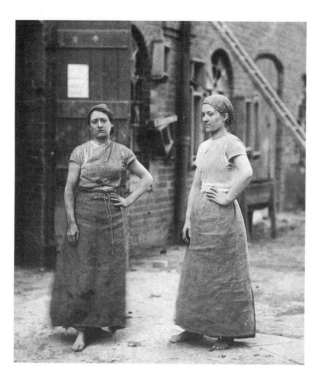

Brickworkers

Reproduced by kind permission of
Birmingham Library Services

John Sweeney's office

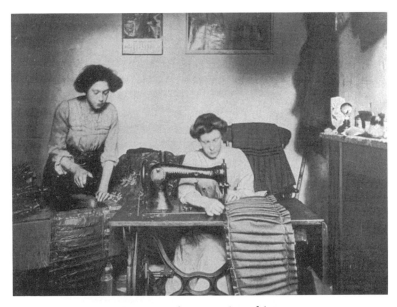

Home workers sewing skirts

Reproduced by kind permission of the
National Museum of Labour History, Manchester

Trouser finishing

Reproduced by kind permission of the
National Museum of Labour History, Manchester

"On her their lives depend"
Reproduced by kind permission
of the Imperial War Museum, London

12

A Resident Lady Inspector for Ireland

Hilda Martindale was admirably suited to take up the work Deane and Squire had begun in Ireland. She had joined the inspectorate as a temporary inspector in 1901, when Lucy Deane went to South Africa for the War Office, and early in 1902 she was given a permanent position.

Martindale's upbringing had been somewhat unusual. Her mother, Louisa Spicer Martindale, was an industrious amateur in social service and a suffragist. Widowed before Hilda was born, she determined to raise her two daughters to have careers: Louisa, the elder, as a doctor, and Hilda in social service. Mrs. Martindale carefully supervised the girls' education, moving from Lewes to Brighton so they could attend a girls' high school in which they mingled with "contempcraries of different social grades." As young girls they were taken to hear the speeches of leaders of reform movements, including Josephine Butler, Annie Besant, and W. T. Stead. Margaret Bondfield, later a leader of the women's trade union movement, was a protégée of Mrs. Martindale.

When the time came, Louisa Martindale planned her daughters' further education and training with extreme care so that they would be prepared for the careers she had chosen. Both daughters attended Royal Holloway College, outside London. Louisa studied at the Royal Free Hospital and took her medical and surgical degrees at London University. Hilda went on to Bedford College to study hygiene and sanitary

science, and then traveled through England visiting workhouses, schools, and Dr. Barnardo's Homes for orphans to gain practical knowledge in the care and education of pauper children; at the age of twenty-two, she had a summer job as a traveling inspector for the Children's Country Holiday Fund.

When the sisters' formal education was finished, they embarked with their mother on a world tour that lasted from June 1900 until May 1901. This was not the usual grand tour with emphasis on museums and society. Wherever they went—throughout Europe, India, Australia, the United States—they visited hospitals, schools, institutes, and talked to administrators and missionaries. In Vienna they visited institutions for the poor and children's homes. In Sydney they visited the Woman's College and a leper hospital; in Melbourne they talked with a woman factory inspector. In Adelaide, besides meeting representatives of the suffrage movement and discussing the Married Woman's Protection bill, they met the sister of a member of the Holborn Board of Guardians. In New Zealand, Hilda lectured on the subject of boarding out children in foster homes, an alternative to institutional life. Chicago was a high point of their trip: they met Jane Addams and visited the Juvenile Court and the YWCA. Mrs. Martindale seems to have allowed them the usual tour of public buildings in Washington, but in Baltimore, for Louisa's benefit, they visited the Johns Hopkins Hospital, opened in 1889, and for Hilda's interest, a home for girls. They arrived in New York by the Twenty-third Street ferry from Jersey City. Like other tourists, they saw the Brooklyn Bridge and the Stock Exchange, but they also visited the New York Foundling Asylum. The asylum occupied an entire block from 68th to 69th street between Lexington and Third Avenues: the great brick building accommodated six hundred babies and the staff supervised the foster care of an additional twelve hundred. Hilda's mother once told her she imagined her as the head of a large institution, and they may have looked at the Foundling Asylum as a model.[1] Their final stop was Boston, where the novelty of riding the subway intrigued them. They visited Lyman Reformatory and met a leader of the American suffrage movement, Julia Ward Howe.[2]

When the Martindales returned to London, Henrietta Barnett, the well-known social reformer and wife of the

warden of the famous settlement house in London, Toynbee Hall, asked Hilda to give a lecture based on her observations of institutions for children around the world. Hilda's old principal at Bedford College, Miss Hurlbutt, came to the lecture and brought Adelaide Anderson with her. A short time later, Hilda set aside her plans to work with children and accepted a temporary position as a factory inspector. (That Mrs. Martindale, a connoisseur of social service agencies, approved of this change suggests the reputation that the women's department had achieved.) Hilda began work on October 21, 1901. Her career as a factory inspector lasted for thirty-two years and took her to the second position in the Factory Department, deputy chief inspector of factories.

When she began inspecting, she knew almost nothing about industry or machines or factory workers, but she was a keen and practiced observer and investigator, and well used to traveling. She soon was visiting dressmakers' establishments, brickyards, iron mills, and home workshops where lace and gloves were made. Like her predecessors, she also learned to be a prosecutor in the courtroom.

In 1904, when Martindale was assigned to the Potteries to administer the new "special rules" for workrooms where lead was present, she was not welcomed by all. The Home Office regulations had been agreed to only after extended arbitration between the government and the pottery manufacturers. A few days after Martindale's arrival in Stoke-on-Trent, the M.P. for Stoke, Mr. Coghill, demanded in Parliament to know at whose instance she had been sent to the Potteries and how long she was to stay.[3] With the positive attitude characteristic of her, Martindale gave no indication that she noticed the antagonism. She ignored the history of workers' and employers' noncooperation and noncompliance with past regulations, and simply appeared to assume that the rules would be obeyed. In the course of the year, she visited nearly every china and earthenware factory in England, missing only those at Newcastle upon Tyne and one at Birmingham (H.M., p.87).

She found the workers friendly and welcoming, both at the factory and in their own homes. Insisting that she was there, not as an adversary or a spy, but rather, in a phrase she culled from an enthusiastic newspaper, as "the missionary of

the State whose business it is to see that, in the pressure and rush of industry, the human element is not driven to the wall," she looked upon herself as a consultant to the employers as well. "I was not met by an obstructive attitude," she maintained. "I found that there was a desire on the part of the occupiers that the Rules should be carefully observed, but that insufficient means were taken to ensure that this desire was carried into effect."

She agreed with Adelaide Anderson that absence of discipline was to blame for the noncompliance that was evident everywhere (p.86). No one, she found, was responsible for seeing that the scrupulous cleanliness necessary to the workers' health was maintained. In fact, she noticed with some amusement that employers often tried to leave that job to her. "For example," she said, "I was asked to speak to the man who swept the shops if I found them in an uncleanly condition." But she was far from amused by the sad condition of workers she visited at home. Warding off poverty, people already afflicted with plumbism returned over and over to their jobs and more exposure, until they could no longer work at all. One middle-aged woman was ill for the fourth time, with abdominal and head pains, wrist drop, and failing eyesight. Another, with wrist drop and affected vision, was suffering her third attack. "Amongst the very poor," Martindale realized, "there was a marked tendency to live merely in the present and an inability, perhaps in some ways fortunate for themselves, to consider the future" (p.88).

A long and patient educational process might have helped these workers, and Martindale was ready and well equipped to undertake such a program. But political pressures at the Home Office interfered. Instead of being encouraged to concentrate on the very necessary work to be done in the Potteries, Martindale was sent to Ireland in 1905, barely a year after she had begun her work in Staffordshire. In her new position, she was instructed to reside in Ireland. Since she would thereafter be spending only one-third of her time in Staffordshire, she could not be expected to provide the constant watchful eye that was needed to enforce the rules.

On St. Patrick's Day, 1905, Martindale arrived in Dublin, a city where the poor lived in appalling conditions. In 1900

some 32,000 of the 54,000 families in Dublin lived in 7,000 houses, "the average number of rooms being one and a half per family." The child mortality rate among laboring families was 27.7 per thousand.[4] As Deane and Squire had already learned, attitudes of employers and workers in Ireland differed sharply from those in England. In Ireland, Martindale was perceived, not as a missionary of the state, but as the agent of a foreign government. "To many of the employers she was somebody to be received pleasantly, and with a certain amount of blarney" she wrote, "but, if it appeared advisable, misled. To many of the workers she was a person to be treated with some apprehension, since a reputation as an informer was something to be avoided at all costs" (p.91).

Martindale's confusing assignment, to be resident in Ireland but spend one-third of her time in the Potteries, meant, at first, a continuation of her peripatetic life. Her specially designed leather file cases traveled with her to rooms at the elegant Shelbourne Hotel in Dublin or the Midland Station Hotel in Belfast as they did to the North Stafford Hotel. She was the first lady inspector to be posted so far from her own home and from the London headquarters (Mary Paterson resided in her native city of Glasgow). The fact that Martindale learned of her appointment from the newspaper clearly indicated that she was assigned to the post, rather than offered it.

The women, it appears, resisted the idea of living in their districts. Anderson objected officially, stating with some passion that living in a strange city was a greater hardship for a woman inspector than for a man, since the women's positions were more solitary and carried little status. This odd argument from the principal lady inspector suggests how far Anderson had moved from the proud independence of May Abraham and Lucy Deane. (Almost a decade earlier, in fact, when the Belfast Textile Operatives' Union begged for a resident lady inspector, Deane wrote in her journal on 29 January 1897 that she had offered to live six months of the year in Ireland.) Anderson's objection to living in the district also shows how strongly she felt the need to keep her staff under her own close control. She might have preferred the appointment of an Irish woman who, like Paterson, would be on home ground, but there was no such

person on the staff; in any case, Home Office officials argued, all factory inspectors were liable to assignment anywhere.

Hilda's mother affectionately but firmly pointed to duty. "I was told to work in Ireland," Martindale wrote (p.49). "I must accept the position, and make no complaint about it." But despite her mother's encouragement, she did not settle in quickly to her new post. By August 1905, she had arranged to give up her responsibilities in the Potteries to someone else so that she could spend one-third of her time in London "on account of the impossibility for her of giving up her joint home with her mother in this country."5 Even then, she spent only 134 nights in Ireland in 1906, being away, mostly in London, a total of 231 nights. From mid-May until November she was not in Ireland at all. This was hardly likely to satisfy those who had asked for a resident inspector; she was criticized within the Factory Department and a vigorous exchange of memoranda among Anderson, Martindale, and Whitelegge ensued. An anonymous supporter of the women's position wrote to the Home secretary, Herbert Gladstone, suggesting that "the strain of such work is very great. Ireland is anything but an ideal place for a woman to travel in alone doing such work, particularly little South Ireland towns." The writer suggested that it would be better to assign two women inspectors together and concluded ominously, "If you do not want the breakdown of one who has done good work in the Potteries, take care of her."6

In June 1907, Martindale delivered an ultimatum. She requested an allowance for clerical assistance and an increase in salary and threatened to resign unless her situation improved. Chief Inspector Whitelegge endorsed her requests. In a July memo, Malcolm Delevingne proposed a solution to the problems inherent in the Irish inspectorship. The position of lady factory inspector in Ireland, he wrote, should become a full-time appointment of senior rank with a higher salary, clerical assistance, and office facilities. By creating such a position, he pointed out, the government would save the expense of frequent travel between Ireland and London and of subsistence payments. He was careful to state that the change would be made not "on the ground of the difficulties which Miss Martindale has experienced

in making herself a home in Belfast, difficulties which have arisen largely from her own family arrangements and which are no ground for any alteration of rank—but on the ground of the undoubted responsibility and difficulty of the work and of the good service that Miss Martindale has already rendered there." Another hand, perhaps that of Herbert Samuel, scrawled agreement across the bottom of Delevingne's memorandum, grudgingly acknowledging the extreme tenaciousness of the women. "The Lady Inspectors are like the daughters of the horse leech, but in this particular case I think a case for consideration has been made out."[7]

Martindale bought a small house in Donegall Street, Belfast, and established herself in comfortable domesticity with her English housekeeper, Jemima Norton, and a small dog named Moa, an offspring of her mother's dog.

When she turned to her work, she discovered that the reputation of Lucy Deane and Rose Squire lingered. "Sure indeed they wrought desolation among the agents," Martindale was told. But constant vigilance had not been kept and, as was often the case with protective legislation, there had been backsliding. The ticket and barter system of payment known as the truck system was forbidden, but shopkeepers had ways of making sure that they lost nothing. When they paid in cash for work received, they simply let the women understand that if they wanted more work, they would have to spend their earnings in the shop. During the summer, when the men were working on the farms in Scotland, their families simply had no cash. The local shopkeepers, with apparent kindness, would allow them to purchase flour and other necessities on credit, to be paid for in November when the men returned. These gombeen men were quite willing to allow endless credit; as long as a customer was in debt she was a sure customer. The truck system and the credit system were intertwined, and Martindale believed that as long as the credit system existed, the truck system would be there.

The difficulty of holding agents and outworkers to the law in Ireland continued. Witnesses changed their stories altogether when they reached the courtroom. Magistrates dismissed cases but later, in private, told Martindale that of course everybody knew that the agent in question had

always paid his workers in goods. Even those who were working for economic improvement were divided. People who were trying to start up local industries—in fishing or handwork, for example—sometimes found the law a nuisance and said so. Despite all this, however, Martindale steadily established a reputation for herself in Ireland.

The exasperating task of enforcing the Truck Acts was not her only objective. As resident lady inspector, she was responsible for a wide range of industries in which women were employed. These included—in Ireland as in England—laundries and textile factories producing linen and woolens.

Many of the laundries in Ireland were operated by religious or charitable institutions to provide work for inmates, who might be orphans, the mentally retarded, or promiscuous women and unmarried mothers, euphemistically described as "penitent females" (H.M., p.95). Such institutional laundries had been excluded under the Truck Act at the special urging of Irish members of Parliament, but the inspectors were concerned for the safety and health of the inmates, and the operators of commercial laundries resented what they viewed as the privileged status of these competitors. The inspectors could only ask such establishments to submit to voluntary inspection, and then make suggestions. Martindale in Ireland, like the inspectors elsewhere, kept an eye on these charitable establishments and was not always pleased with what she saw.

While conducting a thorough survey of Irish institutional laundries, Martindale encountered a tactic of systematic delay. She was greeted with great politeness, but she was often kept waiting for long periods before being allowed to enter the laundry, leading her to doubt she was seeing it in normal operation. On the one hand, she was impressed with the spacious quarters and excellent conditions of work in some convents. Often the machinery, even the steam boiler, was attended entirely by women (one nun told her that her favorite recreational reading was an engineering publication, *The Vulcan.*) On the other hand, she found in some charitable institutions more concern with the income from the laundry than with the welfare of the inmates. She was depressed when she found little girls, some only nine years old, working long hours and suffering from poor diet, but she had no authority

to insist on change. Eventually, however, the information she collected reinforced the argument for an amendment, passed in 1907, including these institutions under the law.

As her continuing presence in Ireland and her frequent appearances in laundries made workers more aware of her, she began to receive letters, usually anonymous, asking for her help. One laundry worker complained that "the pay is alright but the air is awful no proper ventilation & the foul gas that comes from the irons is terrible." Another wrote

> Madam
> I think you are neglecting your Bussiness do you allowe wemen in there confinement to stand and hold an iron in there hand untill 3 minutes before there time and then go out and come back in the snow in 10 Days as that has been done in Mr. S's I wonder what kind of a forewoman that is I think a case like that should be looked into (H.M., p.99).

Like these laundry workers, some of the factory hands began to make their grievances known to her. One day eighty women, in their black shawls and skirts, marched angrily out of the factory where they worked and appeared unexpectedly at her Belfast office. They filled the tiny office and the stairway leading to it. "Hot, angry, and voluble, they were a formidable party," Hilda wrote later. She heard their story and was ready to help, though she had to tell them frankly that some of their complaints were not covered by law and were therefore out of her jurisdiction (pp. 96–97).

In the Irish textile factories she concentrated on hours of work and on temperature and purity of air. Surprise inspections were the best means of catching employers at "time cribbing" (starting the machinery earlier or running it later than the legal hours) or keeping the workers on Saturday afternoons. As soon as her presence was noted, employers would try to conceal the evidence of their misdeeds. Like Squire, she resorted to leaving the train at the next town and approaching by car to avoid being observed. Even so, getting evidence was hard. In one instance involving work outside of legal hours, as she arrived at the factory

gates,

> I noted that a little boy was sent running full speed to the top [floor] factory. I followed him, and when I arrived I found women rushing helter-skelter to the engine room. In this room there was a trap-door through which they disappeared down a stairway into a cellar below from which there were outlets. I followed them, and, in the semi-darkness, asked them for their names. They refused to answer, and, with the exception of one old woman, fled in all directions. The men above would give no assistance, and I was met by passive resistance on all sides (pp. 100–1).

She persisted and finally prosecuted the employer, but the magistrates imposed only a small fine on the hours charge, refusing to find the management guilty of obstruction. She was not consoled by the resident magistrate's pronouncement that "the young lady, Miss Martindale . . . seemed to have behaved with great pluck and activity, and His Majesty was to be congratulated upon the possession of a lady inspector who did her duty so conscientiously and well" (pp. 101–02).

This blarney was something she had to take with grace. The novelty of a woman prosecutor's appearance in the courtroom was irresistible to reporters and magistrates alike. Reporters wrote about her "charm of manner' and likened her to Portia. A magistrate, after agreeing that a serious infringement of the law had occurred, might then impose a fine of only one shilling, or he might say, as one judge did before a courtroom full of local farmers and others, "Gentlemen, the presence of a lady in court has given in my opinion a tone to our proceedings." She could only bow, grimacing inwardly at the miserable results (p. 109).

Martindale had considerably more in mind than lending grace to the proceedings when she went into a courtroom. She knew the strong educative value of her prosecutions, and she could count on an audience. In the days before the cinema, Martindale recalled later, court sessions provided rare entertainment for local citizens. During her tenure in Ireland, she prosecuted two large firms for failure to comply with the rules concerning air quality and temperature. The

public, she reasoned, would learn from the evidence something about the health risks involved.

Phthisis (in this case, tuberculosis) was prevalent among workers in Irish linen mills. Employers insisted that the climate in northern Ireland was so mild that heating the plants was not necessary, yet Martindale found factories where women sat working for hours while the temperature never rose above 46 degrees Fahrenheit. Many workers walked long distances to work and, in that damp and rainy climate, frequently arrived wet. To warm the workroom, they closed the windows and allowed the gas jets to warm the air, polluting it at the same time.

Martindale decided to prosecute two large firms. She took special pains to ensure that her case was firmly grounded. She had her assistant, Irene Whitworth, a bachelor of science, take a sample of the air; Whitworth found excessive amounts of carbon dioxide. She asked Dr. Thomas Legge, the medical inspector of factories, for help. Dr. Legge examined fifty-six women and found that over half of them suffered from anemia, the result of working in a "vitiated atmosphere" (p. 105). Martindale herself interviewed seventy-two doctors, nurses, clergy, workers, and local officials to gather information. She then went into court with the death certificates of four young women who had died of phthisis; all had been healthy when they went to the factory and had no family history of the disease.

The courtroom was crowded with some three hundred people on the day of the hearing. Workers on their lunch hour came to stand outside (p. 109). The expert witnesses were convincing, and Martindale won her case. The press, reporting the proceedings at length, let the public known how bad matters were and that something could be done about them.

Hilda Martindale was not always so successful, however. In one Truck Act prosecution in a country court, her witnesses went back on their statements and she lost her case. Still hoping that the newspapers might at least quote her own long statement on the serious consequences of infringement of the Truck Act, she was disappointed to find no reference at all in the local press. Puzzled, she arranged to talk privately with a local clergyman who was known for his opposition to

the gombeen system. The tall priest met her uneasily at the door of the rectory. "He murmured under his breath: 'Miss Martindale, Home Office?'" He could not invite her inside, for he was on retreat, but he had arranged for them to meet at the convent at the other end of town. At his instruction, Hilda did not accompany him, but followed him at a distance as he walked through the little town, "busily saying his prayers"—or, more likely, reading his Office. The cheerful mother superior met them at the door of the convent and led them to a pleasant parlor where she offered them "some delicious strawberries." Martindale sat down with the priest for "a good talk, in the course of which I told him about my disappointment over the newspapers. He agreed that this was unfortunate but, after a few moments of thought, said if I could provide a golden sovereign . . . all would be well."

The priest was as good as his word. He used Martindale's sovereign to persuade a local editor, and very soon, "a long and detailed account appeared in one of the principal papers." The helpful clergyman "sent copies far and wide." Martindale relished this devious means of ensuring useful publicity, and was properly discreet about it. "The gold sovereign was not charged up to H.M. Treasury and I saw no need to report the matter to my superior officer!" (p. 137).

Publicity about her work and the results of her investigations not only served as a warning to employers but, equally importantly, inspired workers to overcome their reticence and communicate with her. Martindale also looked for other avenues of communication. She continued the relationship, well begun by Lucy Deane, with the Textile Workers' Union in Belfast. She gave a series of weekly talks to women workers on how the Factory Acts affected their everyday lives (p. 141), and she addressed a meeting of the newly established Irish branch of May Abraham Tennant's Industrial Law Committee. She even conducted a Saturday afternoon class for social workers to familiarize them with the requirements of the law. At a conference arranged by the YWCA, she spoke to an audience composed largely of wives and daughters of Belfast manufacturers on "How the Law Helps the Working Girl" (p. 142).

Martindale made it clear to her audiences that not all employers ignored the welfare of workers. In 1911, addressing the Congress of the Royal Sanitary Institute, she spoke about voluntary welfare provisions in Irish factories. She explained that she spent much of her time dealing with employers who failed to comply with the law, but she also pointed out that some firms went beyond the legal requirements in providing for the health and safety of workers. These employers, who had listened to the advice of the women factory inspectors, appointed to their factory staffs chemists to check air quality and inspectors to check machinery guards. They conducted fire drills, appointed doctors, established dental clinics and first aid offices, and provided workers with dining rooms and inexpensive, nourishing meals. She explained that, in some factories, "an educated and highly trained woman" had been appointed as social worker. (It is worth noting here that the women inspectors approved of this, but many people regarded these social workers as management spies.)

Martindale's early interest in the welfare of children renewed itself as she tackled the problems of the youngest Irish workers; indeed, her most vehement anger was directed against those who employed children. Many child workers had had an unhealthy start in life before going to the factory; they were underweight and suffered from eye problems and lung disease. The death rate among these children was high. The law allowed children to work half-time and required that they go to school as well. In Belfast, they worked every other day from 6:30 A.M. to 6:00 P.M. with forty-five minutes for breakfast and dinner. It was not surprising that their teachers found them tired and apathetic on the alternate days they spent in school. Yet public opinion was not opposed to factory work for children. Many parents felt the state, by regulating child labor, was interfering with their right to their children's earnings; some of them produced false baptismal certificates to show that their children were old enough to work. Children were required to have a doctor's certificate of fitness to work, but the parents of children who failed the examination sometimes simply sent them to another factory in the hope that a different doctor might let them by. In one town where Martindale was conducting

a prosecution, "Parents ran after my car begging me not to interfere with the employment of the children" (p.116). It was not until 1920 that a law was passed forbidding employment of children under the age of fourteen.

When Hilda Martindale looked back on her seven years in Ireland, she perceived "an onward move to greater industrial well-being" (p.140). In the best progressive spirit, she based her optimism on a sense that people had become conscious of industrial problems and their social cost. Yet the record suggests that even when cases were prosecuted successfully, the fines were too small to offer real dissuasive power, and the impossibility of maintaining frequent, recurring inspection and enforcement reduced the effectiveness of the law substantially. Determined employers simply wrote off the fines as an inevitable business expense, which in the long run proved to be cheaper than meeting legal requirements. The end results of Martindale's dramatic and vigorous courtroom activity largely repeated the ambivalent achievements of Deane's and Squire's often frustrating efforts.

On the other hand, her resident status did serve to reinforce the role of the lady inspector. Miss Martindale became for employers a name to be reckoned with, and for workers a recognized supporter and adviser. Women workers, at least in Belfast, found her office and came to seek help. Her public appearances and reports of her work in the newspapers enhanced the professional image of the women inspectors.

Both Martindale and Squire had achieved considerable competence in the courtroom. They took the lead in this field, often stepping in to conduct a prosecution prepared by one of the junior inspectors. But while the earlier work of Lucy Deane and Rose Squire had been characterized by deep personal involvement, Martindale's was a more objective, more pragmatic approach. She was less idiosyncratic and more systematic—more institutionally minded—than they, and her perspective on women workers was more remote, more professional.

The residency in Ireland, initially regarded with such apprehension by Adelaide Anderson, became a prototype for a new organization of the women's branch. As the

work increased and the staff became more numerous, working out of the London headquarters became less practical. The Treasury grumbled at the travel expenses; the men inspectors grumbled at the unpredictable appearances of lady inspectors. By 1907, it was clear that reorganization on the Irish model was inevitable.

13

The Senior Inspectors

Hilda Martindale's experience as a lady inspector "stationed" in the Potteries and then resident in Ireland paved the way for decentralization of the women's division. She demonstrated the value of having the women inspectors permanently on the scene in provincial cities. When an inspector was in their midst and available in her office, the workers overcame their reluctance to make complaints and learned to use the inspector as an ally. The old fear of being perceived as an informer yielded to a willingness to discuss problems to be solved. The inspector's constant and vigilant presence helped to discourage dangerous and illegal practices, and even, occasionally, to persuade some employers that they could improve working conditions and efficiency at the same time.

Martindale and her colleagues had proved that, independently, they could act effectively in the public arena. Despite her own initial reluctance to live in Ireland, Martindale had now also shown skeptics that a middle-class woman could live and work successfully far from her friends and relatives. But the reorganization that came into being in 1908 represented more than simply an acknowledgment that male and female inspectors need not be treated differently, or that the women could manage without constant supervision and advice from headquarters. It marked, also, a change in the women inspectors' own approach, the end of the "Arthurian period" of setting out to right wrongs. They had revised their appraisal of what it took to keep factories and workshops up to minimum standards.

The women inspectors subscribed to the belief that social investigation was the background to effective social change, a belief that lay behind most of the great reform efforts of the late nineteenth century. The work of Charles Booth, Joseph Rowntree, and Beatrice and Sidney Webb; the tremendous information gathering of the royal commissions; and the patient door-to-door research into the economic ways and means of poor families performed by women like Maud Pember Reeves were all done in the belief that when facts and statistics proved needs, government and well-intentioned citizens would meet them. If people understood the problems, the reasoning went, they would do something about them. Enlightened public opinion would lead inevitably to reform. But in the first decade of the twentieth century, a change of attitude took place. As H. V. Emy explained, "the notion of social reform was giving way to the wider idea of social reconstruction . . . the role of the state was seen as a positive agent in ensuring not only the principle of equality of opportunity amongst individuals, but also the productive utilization of society's resources in the interests of the great majority of individuals."[1]

Since the mid-nineteenth century, the state, by regulating conditions and hours in the workplace, had intervened to protect certain classes of workers from being exploited by their employers. But to some in the labor movement, the annual report of the chief factory inspector only proved the ineffectiveness of the laws. "The humbug of 'legal supervision,'" in the words of one labor weekly, *The Voice of Labour*, excused managers from any humane provision not specifically required by law.[2] The newspaper challenged women political activists to look to the needs of their working-class sisters, commenting, "If only a tithe of the courage and activity devoted to the women's franchise agitation had been given to trying to rouse the poorly-paid women workers to a point where they would make a stand for better conditions, what a wonderful improvement there would have been before now."[3]

The chief motivating impulse of the first women inspectors was the desire to strengthen women workers to the point where they would be able to act in their own behalf, to organize and achieve a bargaining position vis-a-vis their employers. Over more than a decade, however, they could

see little progress in this campaign. Although the number of women trade union members was increasing, the position of most women workers continued to be weak. Men who were organized in trade unions still kept women out and supported "protective" laws in the hope that employers would be discouraged from hiring women. Maintaining the rules in force required constant vigilance on the part of the inspectors.

Meanwhile, labor had become a political force to be reckoned with. In 1906, the Labour Representation Committee, formed in 1900 to support the election of labor representatives to Parliament, changed its name, becoming the Labour party. In the election of 1906, which returned the Liberal party to power after a long Conservative administration, forty working-class members were elected to Parliament. The Liberals had not only the opportunity but also the need to find ways to show that it was the party of the workers. Seeking to offer an alternative to socialism, they moved toward a different definition of the relation between the state and the worker, a relation in which the state would see to it that the capitalist system worked fairly. Responding to labor's political strength, the Liberals instituted "an ambitious framework of social legislation."[4]

As the good economic times of the first years of the century gave way to recession in 1905–8, bringing the highest unemployment since 1886, Winston Churchill, at the Home Office and later at the Board of Trade, took the position that the government was responsible for providing the social organization necessary to counteract such industrial fluctuations. He moved toward establishing minimum wages for home work through local wage boards and controlling unemployment through labor exchanges (government employment offices). Through such measures and the provision of health insurance, the state endeavored to make workers free agents, less dependent on a particular employer and thus more in control of their own lives.[5]

The lady inspectors, who had proselytized for worker autonomy from the beginning, were a part of this new process. Investigating, inspecting, and prosecuting on an irregular ad hoc basis, they gathered information for inquiries in progress, tested the efficacy of existing laws or rules, or responded to specific complaints. The fruit of their labor was not simply the

correction of conditions in an individual workplace, but the amassing of data to support the amendment of existing rules and the passage of new legislation. But as long as they were peripatetic, the routine, repeated inspection of every factory or workshop had not been and could not be a normal part of their work. If the regulations were to be consistently applied, the necessity of a concentrated presence seemed evident.

This sort of concentration was the object in establishing a special district, under the supervision of Lucy Deane, in West London in 1900. Here, and in another special district in Glasgow, the women inspectors had full responsibility for inspection of dressmakers' and milliners' workshops and of steam and hand laundries. When Adelaide Anderson and May Abraham Tennant proposed the scheme to a departmental committee in 1898, they had made it clear that they did not favor assigning the women inspectors to existing districts. Instead, they suggested that their branch could properly, and independently, relieve the men of the burden of inspecting hundreds of small workshops employing only women. The laws established standards of work space, ventilation, and temperature as well as restricting hours of work. The hours in these establishments fluctuated wildly in response to changes in fashion or to specific events. The death of King Edward VII in 1910, for example, brought a sudden demand for mourning clothes. This surge of activity was followed by a slowdown in the industry, and the showdown, in turn, gave way to an upsurge in orders for grand garb for the coronation of George V the following year. The regulations dealt with such crises in fashion by providing numerous exceptions to cover varying conditions—which made enforcement nearly impossible. Inspection in response to specific complaints could not begin to deal with the problem of enforcement. The special district was established as the only possible solution.

Lucy Deane tackled her West London assignment with her customary enthusiasm. Her sister recalled driving with her around the city at night, looking for lighted windows. If they saw lights, Lucy would investigate, to see if the house was a workshop.[6] Deane also brought to the new job her talent for organizing. She devised a card system for keeping records of inspections, violations and accidents in each establishment

in her district. Beginning with about 3,000 records copied from the district inspector's register, she deleted hundreds representing defunct workshops and added many more as a result of her own survey of the area. At the end of the first year she had about 6,000 cards; each listed the address of a workplace and had space for records of ten inspections. The ease of access of Deane's card system meant not only that information could be kept current but also that any factory inspector could use it easily, "even in the absence of the inspector in charge or her clerk." Adelaide Anderson was so impressed with Deane's ingenious scheme that she included all of Deane's lengthy description in her annual report.[7] By 1905, when Deane left the West London district to return to the field, the files had already proven their value in supplying cumulative evidence of workplace hazards and their effects. Emily Sadler, who had joined the department in 1898, took over the district and the files, while Deane traveled widely, investigating and reporting on printing factories and tobacco industries over the two years that followed.

Deane's West London district in no way overlapped with the work of the male inspectors, and in fact Anderson had carefully defined it to avoid conflict with the men. Hilda Martindale's assignment to the Potteries in 1904, on the other hand, was a direct encroachment on the male inspectors' territory. The Home Office administration had ample justification: the lady inspectors' investigations of lead poisoning in the Potteries had contributed information to the making of the special rules; the public, as a result of the investigations, perceived the women as experts; and, finally, the preventive measures dictated by the rules, depending largely on cleanliness, required physical inspection of women workers that only women could perform with propriety.

In the potteries, as in the textile mills and other establishments, both employers and workers, when left alone, became careless in observance of the rules and even deliberately avoided complying. Persuading employers that it was in their own interest to treat workers humanely and preserve their health required more than simply showing them the evidence. Though government staff, from the Home secretary to the newest woman inspector, might grumble that the number

of inspectors would be ample if only people would obey the rules, they had to acknowledge that this happy state of affairs did not exist. The 172 men and 15 women inspectors of the Factory Department in 1908 had the Herculean task of maintaining watch over 3,116,726 men and 1,737,831 women workers and their employers in factories and workshops.[8]

Martindale's subsequent residential appointment in Ireland had pointed the way to a further and more formal regional organization of the women's branch. Not only was a resident inspector clearly more effective, but in view of Treasury officials, who looked with increasing disapproval at the expenses of travel, the work could be done more economically; each peripatetic inspector traveled between 7,000 and 11,000 miles each year, incurring transportation and hotel bills and other expenses of itinerant work. A committee was appointed in 1907 to recommend changes in the organization of the Factory Department; it included two Home Office representatives, Malcolm Delevingne and George H. Tripp, and the chief factory inspector, Arthur Whitelegge, but no women. Despite the fact that the committee reviewed the work of the women inspectors thoroughly, Adelaide Anderson was only invited to provide information.

The committee's report pointed out that the women's rate of inspection visits was lower than that of the men. While allowing for the "greater thoroughness and particularity" of inspections by this branch, the committee suggested that the long journeys from London headquarters were wasteful, occupying time that might have been spent inspecting. Though well aware that the men inspectors continued to object to the encroachment of visiting women inspectors on their authority and that the men wanted to bring the women under the control of the administrative structure of the existing districts, the committee did not suggest abandoning the women's branch; the women had demonstrated too well the advantages of allowing them autonomy. Instead, it proposed a new structure for the women's branch. While remaining independent, it would, like the men's department, have regional divisions with resident staff. To meet the requirements of this parallel plan, the women's branch would be increased immediately by three junior inspectors, and

in due course, when enough women inspectors had the requisite experience, three senior positions would be added. Eleven inspectors would be assigned to divisional work, two (as before) to the West London special district, and five would be unattached, to be dispatched on the instructions of the principal lady inspector. Looking at the records of the first fourteen years, the committee also recommended that the women be allowed more sick leave.

The report recommended salary increases that still left the women's salaries a notch below the men's: the principal lady inspector would receive £500, rising to £600 (the deputy chief inspector's salary range was £750–£850); senior lady inspectors' salary would be £300–£400 (equal to the male inspectors' £300–£400, but far from the superintending inspectors' £600–£700), and lady inspectors were in the same range as Class II men inspectors, £100–£300.[9] None of the women could expect to approach the salary of £700 that Edwardians considered comfortable.[10]

Adelaide Anderson, still strongly opposed to dispersing her staff to regional offices, was shaken by the committee's proposal. It threatened her carefully maintained control by interposing not only geographic distance but a second layer of administration as well—senior inspectors supervising juniors. Frequent personal conferences with her staff were essential to Anderson's management style, and she had been accustomed to gathering the lady inspectors frequently in her office in London. But Delevingne and others saw this as an expensive and time-consuming method of supervision. They believed that the principal lady inspector should visit her staff in the field, observing their work at first hand and incidentally making herself known in the provinces.

Anderson voiced her objections in a strongly worded letter to Herbert Gladstone. In her view, the recommended change to "rigid Divisional separation" meant "the narrowing of responsibility and scope of work of the experienced Senior Inspectors." She found the recommendations "entirely contrary to the whole spirit of all my past evidence and recommendations for this Branch," and she was convinced that "they would most injuriously affect our work," effectively

"destroying the Branch as a Branch." She was particularly concerned about her own authority: "My own powers to arrange and guide the work of the individual members of my staff on the lines best fitted for their nature and capacity and experience would be seriously limited." While she acknowledged politely that "the scheme has been carefully weighed in its main lines," she begged Gladstone to delay implementation "until I have had opportunity to lay before you the considerations that my experience persuades me are vital to our usefulness" and to propose modifications.[11]

But she failed to stem the tide of change. The reorganization began in 1908. Mary Paterson was transferred to London and promoted to deputy principal lady inspector and senior inspector in charge of the South Eastern and English–South Western Division. The deputy inspectorship might well have gone to Lucy Deane, but she was ill at the time. She had been on sick leave for three months in 1904, and eighteen months in 1907 and 1908. She finally left the department in September 1908. The chief blamed overwork. In her diary, Deane had recorded severe menstrual problems as far back late 1890s, when she had consulted doctors who recommended surgery and warned of the possibility of permanent invalidism. In spite of these dire predictions, two years after Deane quit her job she was participating in a series of lectures on women in industry sponsored by the Clubs Industrial Association: she spoke on "Sanitary Conditions of Factories and Workshops" and "Employment in the Factory, Workshop, and Home."[12] She continued to maintain an active interest in women's work after her marriage to Granville Streatfeild in 1911.

Hilda Martindale, Rose Squire, Emily Sadler, and Anna Tracey (another former staff member for the Royal Commission on Labour who joined the department in 1897) were made senior inspectors. Martindale remained in Ireland. Squire had spent nearly a year, from June 1906 until March 1907, away from the department as a special investigator on conditions of industry affecting pauperism and poverty for the Royal Commission on the Poor Law, at the instigation of Beatrice Webb. After the reorganization, she took charge in Manchester, supervising a staff of three: F. Lovibond, Irene Whitworth, and Lucy Pearson. Tracey was assigned to London. In 1909, Sadler took

charge of a new Birmingham district. Only one of the newer inspectors seemed to Anderson to be ready for promotion when the plan first went into effect; Mabel Vines had replaced Martindale in the Potteries in 1905 and subsequently worked in the West London district. Anderson considered her poorly suited to training new staff or indeed to working without supervision.[13] Whitelegge promoted Vines anyway, and sent her to Glasgow, where, he felt, there were "fewer general complaints and less infringement of the Truck Acts . . . than in other parts of the Kingdom."[14] Three new inspectors—Henrietta Escreet, Lucy Pearson, and Alice Parry—were appointed in the summer of 1908. Gladstone, to soothe Anderson's fears, allowed for consultation between the divisional staff and the principal lady inspector and granted her considerable leeway in assigning senior inspectors to temporary duties away from their districts.

No doubt the senior inspectors were more eager to take on authority than Anderson was to relinquish control. In July, Paterson, Squire, Sadler, and Martindale wrote to Gladstone to request that lady inspectors be assigned "definite responsibilities and a recognized local position" in the districts, so as to allow them to operate efficiently and avoid friction with the men. The senior inspectors also wanted their names and local addresses to appear on the summary of regulations that was required by law to be posted in every workplace, so the workers would know to whom they should report violations.[15]

The senior inspectors were put in charge "exclusively or primarily" of investigation of accidents to women and girls in laundries and clothing factories, supervision of industries conducted in institutions, investigation of cases of industrial poisoning among women and girls, and routine inspection of all factories and workshops that employed women and girls where special regulations applied. They were also to administer the provisions of the law governing sanitary accommodations, child labor, and the employment of women after childbirth.[16]

The new district supervisors were so eager to establish themselves that they moved faster than clerical help and office space could be arranged. Rose Squire, unwilling to wait for suitable accommodations, began running her district from a one-room office she shared with three other inspectors

and a clerk. There was no typewriter, and almost no furniture, and papers were piled up on the floor, but, pleased with her new authority, she went to work enthusiastically.

14

"Come to the Lady Inspector"

Although the senior inspectors enjoyed the challenge of their new responsibilities, Adelaide Anderson found the transition to the new regional organization extraordinarily difficult. Her anxiety increased. She worried about the "sudden" scattering of her experienced seniors, who were now "out of touch with each other and far from me." She feared that the staff was being stretched beyond its capacity. She demanded the establishment of another special district in London on the grounds that the overwhelming preponderance of complaints came from there; Delevingne should not have needed to remind her, as he did in a marginal note to her memorandum to the chief, that "complaints follow inspection"—she herself had proclaimed this in her annual reports year after year—and that if the provinces were as well staffed as London, the workers' complaints to the inspectors there would rise. "So many new difficulties and anxieties will be introduced," she complained, "that it is absolutely indispensable that my periodic Staff conferences shall be continued."[1]

While Anderson worried over the potential problems of reorganization, Martindale and Squire took to their new supervisory role with enthusiasm. Along with their other duties, the district supervisors now trained and supervised their junior colleagues. "Fortunately training new Inspectors appealed to me," Martindale later wrote (H.M., p. 149). "I enjoyed passing on any knowledge I happened to have acquired, and so I welcomed the arrival of newly appointed Inspectors who were embarking on this somewhat unusual form of work."

A new dimension was added to their position: they became role models as well as supervisors, and not only their actions but their interpretation of government policy influenced the work of their junior colleagues. They moved from solitary and quite independent work to teamwork and to being captains. They welcomed this opportunity to assume leadership with such zeal that sometimes their work threatened to exhaust them. In November, Anderson warned the chief: "An immediate modification is necessary to prevent either (a) break-down in health of the Principal Lady Inspector and Deputy Principal Lady Inspector and Senior Lady Inspector, Miss Squire *or* (b) complete congestion in dealing with the sudden multiplication of work, correspondence and reports." But while Paterson, Squire, and the other senior inspectors had gained control, Anderson had lost some. She felt the change severely. "The care and trouble caused by this imposition on me of excessive work, with decreased control of its rate and amount, and decreased opportunities of conferring with my staff," she admitted, "have been accompanied by insomnia, and as soon as it is possible to arrange matters, I must ask for a few weeks' rest."[2]

Besides, she pointed out, people continued to assume that her London office was the place to obtain information on the law concerning women and girl workers. She had moved into a new office at 66 Victoria Street, closer to Home Office headquarters but more distant from the neighborhoods of the women workers than Finsbury Circus, a move that suggests closer ties with headquarters and, for Adelaide, a more purely administrative role. Storage cabinets were ordered and the doors of the two rooms labeled—"Enquiries" on the entrance to the clerk's room, and "Private" on Anderson's. A standing desk supplied for her had to be altered, being "too high for a woman's use and not broad enough for . . . supporting several large registers in which rapid entries have to be made."[3] The volume of her administrative correspondence increased, but she had only one clerk to deal with it. She might have expected help with her administrative duties from Mary Paterson, the new deputy principal lady inspector, but Paterson was still conducting prosecutions in Scotland as well as carrying out her new responsibilities in

the southern districts. She could spare little time to assist Adelaide.[5]

Arthur Whitelegge was concerned about Anderson. "She was looking ill and overdone," he reported after an interview with her. "I told her that she must take rest when necessary, and that none of her staff were called on to do more than a reasonable day's work, except in emergencies." Whitelegge believed the women showed a tendency to overwork. He acknowledged that the seniors bore a heavy load; for the time being some of them were dealing with doubled districts and with a young staff all in need of training. Undoubtedly they would confront different problems and encounter unexpected emergencies more often when they were on the scene, and perhaps, he suspected, they might miss the respite offered by long journeys on the train. But, as he reminded Anderson, the seniors themselves had requested these new responsibilities, and, once they were established and living in the districts, they should find it easier, rather than harder, to accomplish their work.[5]

At Troup's suggestion, Whitelegge persuaded Anderson to take a leave and to delegate some of her work to Paterson and Squire, both of whom were "well qualified to act in many matters on their own responsibility." A period of rest appears to have improved her perspective, for by February 1910 Adelaide's tone conveyed more resignation, if not confidence. "I think it is fairly started now and all are trying to make it as successful as possible," she wrote to Gladstone. "I am sure that there will be some good results before long."[7]

Things did indeed take a turn for the better. Anderson's annual report for 1909 concluded that the four regional centers were a success. Concrete results, such as a reduction in the number of accidents in laundries and improved safety of workshops in institutions, could be seen. On another level, the resident inspectors were becoming familiar with the people of their communities. In their first year, they had "already done much to develop friendly relations with all kinds of associations and representative persons interested in improvement of the life of the industrial worker."

Both employers and workers visited the inspectors in their local offices. Rose Squire reported in 1910 that "Many heads

of large firms have availed themselves of this opportunity of obtaining full information verbally respecting such matters as the Truck Act and the Particulars Order."[8] At the same time, workers seemed to become more comfortable about visiting the offices and bringing their friends. "One woman with a shawl over her head," Squire recalled, "was brought to my office by another smartly dressed; they were complete strangers but had met at the Labour Exchange" where, in the course of waiting-room conversation, the woman in the shawl had told her story to her new acquaintance. She been summarily dismissed before breakfast by a tyrannical foreman in a situation that evidently involved sexual harassment. The listener not only knew what to do—"come to the Lady Inspector who helped me a year ago"—but even took the time to escort the woman to Squire's office. Squire did not disappoint them. She went to the owner and made him aware of his foreman's "bad behaviour towards young girls in his employ" as well as illegal employment during meal times.[9]

Although the need of working women for protection by the inspectors and the laws they developed and enforced did not diminish, the increasing number of women in trade unions seemed to indicate that they were taking a more active part in their own defense. The number of women members of trade unions nearly doubled in the decade between 1901 and 1910, increasing from 152,000 to 278,000, and included women from a wider range of industries. The traditionally high percentage of women union members who were employed in the cotton textile industry declined from 65 to 54 percent during the same period. At the same time, the number of women—both union and non-union—who were employed in manufacture and transport work rose from 1,710,313 to 2,398,310 in the twenty years between 1891 and 1911, an increase of 40 percent. By 1911, an impressive 54 percent of all unmarried women over the age of ten were employed.

The labor unrest of 1910 to 1912 affected women workers as well as men. Strikes occurred in major national industries—railways, mines, transport, and others—and workers engaged in many spontaneous actions unauthorized by trade unions. These incidents sometimes took place when unskilled workers, including women, their patience exhausted by a

continuing decline in real wages, caught the fever and staged angry demonstrations in a variety of industries large and small. During the hot summer of 1911, women workers in jam factories, biscuit bakeries, and confectionery works in the Bermondsey area of London spontaneously walked out in sympathy with a transport workers' strike. Their action rapidly gathered momentum; within twenty-four hours 14,000 workers had struck. "The sudden revolt of the underpaid, underfed, helpless, hopeless working womanhood of south London, taking its origin among a group hitherto held incapable of combination, spreading from factory to factory like wildfire, maintaining itself against the depressing influences of absolute penury and privation . . . will never be forgotten," the *Women's Trade Union Review* exulted. The Women's Trade Union League and its offspring, the National Federation of Women Workers, led by Mary Macarthur, came to the workers' aid, helping them to negotiate successfully and organizing 4,000 women in Bermondsey within one week. In eighteen out of twenty-one strikes handled by the League in Bermondsey, concessions were obtained, and the *Review* noted a new sense of self-reliance among these workers.[10]

The lady inspectors saw this progress as intimately related to their own work. Commenting on the annual report for 1911, one newspaper observed: "Miss Anderson is to be heartily congratulated on the work which has been done during the year by herself and her very competent and energetic staff. She has succeeded, too, in calling our attention to this very important development in industrial history: the rise of woman towards some knowledge of her trade value."[11] Communications from workers increased every year; by 1913, responding to women workers' complaints and investigating accidents took so much of the inspectors' time that few special investigations were possible. The inspectors were pleased to see progress in another area, too: some employers were showing a concern for workers' welfare.

When Mary Paterson resigned from the inspectorate in 1911 to administer the National Health Insurance program, Rose Squire succeeded her as deputy principal lady inspector. By then, the district organization of the women's branch was well established. Early in 1913, less than five years after the

reorganization had begun, Malcolm Delevingne and Arthur Whitelegge reported that the "localisation" of the lady inspectors was a success—so much so, in fact, that the increase in their work load argued for an increase of staff. They recommended the addition of two more lady inspectors for two new special districts in south London and Manchester, and the appointment of another senior inspector in London. Since none of the juniors had the years of experience requisite for promotion, they suggested hiring "someone from outside with wide experience of women's work."[12]

Constance Smith was indeed well acquainted with women's work when she became the new senior inspector in 1913. A veteran volunteer, she was active in the Women's Trade Union League, the Christian Social Union, and the Industrial Law Committee. She was a founding member—along with her friends, Charles Dilke, Sidney Webb, and Adelaide Anderson—of the British section of the International Association for Labour Legislation, the forerunner of the International Labour Organization. She had testified before the Employment of Children Act Committee in 1909 and had reported on the arbitration proceedings on lead in the Potteries for several papers. She and Mona Wilson had staged an exhibit of leadless-glazed pottery. She was over fifty when she joined the Factory Department. A quiet woman, well spoken and well dressed, Smith impressed people with her lawyerly skill in public speaking. She marshaled her points "as though a wig covered her brown hair," said her good friend Gertrude Tuckwell, in reference to the British courtroom tradition of bewigged legal authority.

Although her friends knew Smith was capable of going "into an almost comic fever over a lost paper or a pinching shoe," she was extraordinarily calm in larger crises. "The idea of translating agitation into legislation appealed to the lawyer in her," Tuckwell recalled. Smith's friends were delighted not only by the recognition of her talent, but also by the opportunities the appointment to the Factory Department afforded her. J. J. Mallon, well known as a settlement worker and writer on social problems, gave a dinner to celebrate her entrance into official life, and another friend anonymously established a scholarship in her honor at a working women's college.[13]

The women inspectors had become more professional, if less passionate, in these first years of the twentieth century, more orderly in their pursuit of fair working conditions for women and children, if less personally involved. The addition to the staff of Constance Smith – a strong, highly experienced woman who was well known as an agitator for reform and was friendly with such influential people as Dilke, Tuckwell, and Mallon—indicated a commitment on the part of the government to the idea of a women's branch. Adelaide Anderson, now in better health and feeling optimistic, seems not to have regarded Smith as a threat to her authority. In the first months of 1914, she commented confidently on the "hopeful work and increasing cooperation with us on the part of workers, employers and their organisations in obtaining improved general conditions in factory industries for women and girls."[14] H. H. Asquith, who had become prime minister in 1908 and who was still an ally, promised a further increase in staff: "I think we should look towards the extension of the Women Inspectorate as one of the best securities for a healthy condition of things."[15] In the years just ahead, that security would be needed in ways yet unimagined.

15

The War

"It was for the Factory Department as if a sponge had wiped off the slate all that was written there, and no one knew what to write in its place," Rose Squire recalled. Prosecutions and plans for action all "ceased to be of any consequence" at the moment war was declared in August 1914. Everything changed—not only all the activities in hand but the very outlook on life. Even the perception of values was fundamentally altered. Squire remembered the Great War coming on her suddenly, "in the full tide of busy official activities, engrossed in the day-to-day direction of the women inspectors' work."[1] Hilda Martindale, traveling on the Continent with two friends, was far from her work when war broke out. Realizing at once that she would be needed, she used her official position "for all it was worth" to get a seat on the first refugee train. Even so, by the time she returned to the office, the department had already begun to deal with change.

The first months of war brought bizarre shifts in the economy and in industry. Off the coast of Grimsby, five trawlers were sunk by mines. Fishing stopped and so did the jobs of women who kippered and barreled fish and made nets and twine. Luxury trades such as dressmaking and millinery suddenly faded, and 40 percent of the women who had been employed in thousands of workshops were out of work. The textile industry, its usual products unneeded, paused in confusion. As imports from the Continent ceased, British industries were disrupted. Calibrated tools and machine parts were not available; porcelain heads for English dolls

no longer came from Germany. Employers and managers were confused about their duty, uncertain whether to go at once to the war or stay and keep manufacture going. Rose Squire, making her rounds, saw women and girls standing in groups outside factories, unsure whether or not to go to work.[2] Although normal inspections seemed irrelevant, the inspectors continued to visit factories anyway, finding that their routine visits had a steadying effect on the workers.

It is difficult to realize, in light of the great increase in number and variety of jobs for women that characterized the later years of the war, the very real anxiety about unemployment and underemployment that gripped the country in August 1914. Early responses reflected a familiar philanthropic approach. The queen, anxious to demonstrate her concern, established Queen Mary's Work for Women Fund to set up workrooms where women thrown out of work by wartime changes could find employment. She assigned the administration of the program to the Central Committee for Women's Training and Employment under the leadership of Mary Macarthur, the well-known trade union organizer.[3] Macarthur, in turn, sought help from the women inspectors. Adelaide Anderson served as adviser to the committee at its London headquarters, and the senior lady inspectors—Anna Tracey in Manchester, Emily Sadler in Leeds, Hilda Martindale in Birmingham, and Emily Slocock in Ireland—advised local committees.[4]

The workrooms proved controversial. Sharp observers like Sylvia Pankhurst criticized the low wages (10 shillings a week).[5] The inspectors were alert to the possibility of extended hours and sweatshop conditions in these well-intended establishments. By the end of the year Anderson's staff had inspected ninety-nine such workrooms.[6]

During this period of transition, the inspectors' expertise was in great demand. "Who but the men and women of the inspectorate knew where materials were to be found, where machinery and plant suitable for mass production, where trained and disciplined staffs of workers?" Rose Squire asked rhetorically.[7] The inspectors' wide and detailed knowledge of factories, equipment, and labor force throughout the country put them in a position to provide a referral service. Manufacturing firms sought their help in finding work to keep their

women employees occupied. A theatrical costume maker in London who had two hundred women workers on the payroll and no work to give them asked Squire what to do. Making uniforms, she suggested, was not so different from making costumes. She told him how to apply for a government contract.[8] Hilda Martindale assisted in planning new factories to manufacture a wide variety of items previously imported from Germany. Some, like precision hand tools, were vital; others were luxuries—toys, fancy handbags, and dolls' heads.

The war awakened an exhilarating national spirit that swept aside differences everywhere. In industry, the first period of transition was marked by cooperation; Rose Squire observed that it "linked Inspector and employer and workpeople together in a common interest at a time when the foundations of life as we knew it seemed to be threatened."[10] To Adelaide Anderson, it seemed that the social reforms of past decades were at last bearing fruit, "clearing away misunderstandings and softening relationships between employers and employed." She was confident that most employers' "foremost thought was to 'stand by' the weakest of their workers and share alike in profit and loss."[9] At last, she thought, women would have their chance. People "realized as perhaps never before how a nation could increase its own strength if it would take full thought in advance for the skilled training and mobilization of its women as well as its men workers." With sweeping optimism, she said women "are surely summoned to take their full share in the building up of a better industrial life for the people—as fellow-producers with men, but with their 'other' point of view as guardians of the home." She envisioned as "practically certain" a future in which "women and girls must take a larger share than hitherto in productive industry."[10]

Her vision did not quite match reality. Some leaders of industry were reluctant to accept what they viewed as interference from the state, even in wartime. Workers, too, were disconcertingly happy to see the Factory Acts laid aside as the war effort took precedence and it became unpatriotic to talk of limiting hours of work or to worry too much about safety. Men in trade unions were nervous about the women workers who might replace them, and accept lower wages, when they went off to war. They insisted

on assurances that they would get their jobs back after the war.

Women's trade unions, for their part, demanded strict enforcement of equal pay for equal work, assurance of adequate living wage for all women workers, and security against postwar unemployment. The Women's Trade Union League and the National Federation of Women Workers, alert to the danger of exploitation, stepped forward eagerly to take advantage of the opportunity to organize women workers, only 10 percent of whom belonged to trade unions in 1914. They campaigned vigorously, and women munitions workers joined unions "in thousands," according to the economist, Barbara Drake.[11]

Offering their "intimate knowledge of industrial processes and long experience in the guardianship of the health of protected workers," the factory inspectors helped develop voluntary agreements to regulate working conditions in these new situations. Urging the employment of women to replace men who had gone to war, they convened meetings of employers and trade union representatives in a variety of industries—woodworking and furniture making, biscuit and pastry baking, and boot making. They drew on their long experience in persuasion and diplomacy, and sometimes succeeded in producing agreement.[12]

After the uncertain prelude of 1914 came a fanfare of mobilization. As the first rush of volunteers dropped their tools and entered the services, a patchwork emergency adjustment ensued. The composition of the Factory Department itself changed as men went to war or were loaned to other departments. Thirty-five male inspectors and six clerks had left their jobs by 1915, and a year later nearly ninety were gone. The women carried on the department's work and trained additional women as temporary inspectors to augment their ranks.[13]

Soon the war demanded more and more men; the government launched a massive campaign for volunteers and finally, reluctantly, introduced conscription. This tremendous insatiable need for manpower caused a huge shift in thinking. With the realization that the war would not be over quickly came the logical conclusion: women (and men who could not be used at the front) would have to

meet the need for production of munitions, war supplies, and necessities of existence at home.

Industrial production changed rapidly to meet the country's new needs. British soldiers needed clothing, food, and equipment. Textile mills began producing khaki. Industry supplied equipment for Britain and its allies. British manufacturers supplied, in the course of the war, "over four million rifles, a quarter of a million machine guns, 52,000 aeroplanes, 2,800 tanks, 25,000 artillery pieces and over 170 million rounds of artillery shells."[14] Meeting these production quotas required the substitution of female labor for male wherever possible.

The first phase of recruitment of women to wartime industry began in 1915. Many women workers transferred from textile mills and lace-making factories to war industries; married women returned to the work force; an additional 200,000 women left domestic service for war work.[15] In rural areas where no previous industry had existed, a higher proportion of women workers came from domestic work or from home; in one chemical works, half the women had not been employed before, and another quarter of them had been servants. The factory inspectors instructed these women about their rights under the law. But overall, the number of women who came fresh from their kitchens and their drawing rooms without previous work experience was relatively small.[16] For the most part, the female work force had prior work experience, but they had to learn new skills.

The demands of war precluded the traditional long apprenticeships. Instead, manufacturing processes formerly performed by one experienced man were broken down into small steps to be performed in sequence. Inexperienced women workers learned these tasks quickly in large-scale intensive training programs. British employers took advantage of the emergency to introduce these scientific management methods, already practiced in the United States, but long resisted by British trade unions.

Unskilled women workers rapidly became proficient under the new system, and Adelaide Anderson was delighted to see them publicly demonstrating women's "technical and personal capacity."[17] But, as union leaders had feared, some employers claimed that the experiment proved that long

training was not required for these jobs, thus undercutting the assumption basic to the demand for high wages. Trade unionists, seeing a long-term threat to their secure wages, viewed every move to employ women in place of men with suspicion. They demanded assurance that these wartime expedients were temporary. Meeting each change with resistance, the men dug in their heels, and the old argument raged between employers, who wanted to use cheap and "docile" female labor, and the trade unionists, who wanted to keep women out of all but the most menial jobs.

In short, attempts to put women to work in wartime industries initially met with considerable opposition. But women were determined to participate in this war. They conducted a significant campaign to take their rightful place in war work. On July 17, 1915, Emmeline Pankhurst, who had set aside her suffrage campaign in favor of the war effort, led thirty thousand women in a demonstration demanding their right to serve. They called on Lloyd George, the new minister of munitions, to guarantee women equal pay for equal work. Summoned from Whitehall by Mrs. Pankhurst, Lloyd George promised the crowd on the Victoria Embankment a fixed minimum wage and fair pay for women war workers.[18]

Lloyd George also established a Labour Supply Committee to consider how to meet the needs of the munitions industry. In spite of his public assurances to Mrs. Pankhurst, however, and despite the presence of Mary Macarthur on the committee, its proposals offered little for the woman worker. A new phrase, "dilution of skilled labour," came into the committee's discussions. This meant that the small number of skilled men who remained on the job would perform the highly technical tasks and supervise women and semiskilled or unskilled men, who would do the remaining tasks. The terms of dilution satisfied the men's unions by strictly limiting women's participation in "male" jobs. The committee endorsed the principle of equal pay for equal work, but failed to define the boundaries dividing skilled from unskilled work; the resulting ambiguities made it easy for employers to avoid paying women and skilled men at the same rates. In fact, throughout the

war, no woman ever succeeded in proving that she was doing the exact work of a skilled man.[19]

Women replacing semiskilled or unskilled men were to be paid "by results," and the minimum wage for women was set at a pound a week, but these provisions were not compulsory, and Barbara Drake claimed that employers "snapped their fingers in the face of Mr. Lloyd George" on this question.[20] The Munitions of War Act of July 1915 wrote dilution into law; it also restricted workers' freedom of action, forbidding strikes and lockouts in "controlled establishments" essential to the war effort and prohibiting workers from moving from one job to another without a "leaving certificate" from the employer. The Ministry of Munitions, through this act and its 1916 amendment, became responsible for regulating wages and working conditions for controlled establishments.

Rose Squire attended conferences at the Ministry of Munitions during the summer of 1915 to discuss the substitution of women for men in factories manufacturing ammunition; later she was appointed to the Health of Munitions Workers Committee that was established as a result of the conferences. The committee was "to consider and advise on questions of industrial fatigue, hours of labour, and other matters affecting the personal health and physical efficiency of workers in munition factories and workshops." Items on the agenda included hours of work, facilities for meals, dangers of hazardous substances, supervision of young workers, and child care for mothers employed in factories. In addition to Squire, Edgar L. Collis, a medical inspector, and Sir Gerald Bellhouse, the deputy chief inspector, represented the Factory Department. Their former associate, May Tennant, who was still very much involved in matters concerning women workers, joined them. Hilda Martindale gave evidence before the committee and took some of its members to visit factories and view working conditions at first hand. The committee's chairman, Sir George Newman, was a physician with long experience in the field of public health. Rose Squire admired his "knowledge, his zeal, his brisk manner and unfailing courtesy and charm" as he urged the committee to its work.

The strong language of the committee's reports reflected the women inspectors' influence. In the report were familiar

themes. The committee had learned that workers in munitions factories were not only putting in twelve- or fourteen-hour days and working far into the night, but working on Sundays as well, not occasionally but continually. The committee found workers as well as employers to blame for this situation, and pointed out that no matter how compelling the demands of war might be, in the long run such work schedules were counterproductive to both the quality of production and the health of the workers. "Conditions of work are accepted without question and without complaint, which, immediately detrimental to output, would, if continued, be ultimately disastrous to health."[21] The report recommended shorter hours, good food, and rest periods for workers and suggested that employers hire welfare supervisors to implement these recommendations.

The National Federation of Women Workers, the primary advocacy group for women, conducted a vigorous campaign in support of the Newman committee's recommendations. It staged demonstrations, sent deputations to government offices, and raised questions in Parliament. But the government, while encouraging employers to implement the committee's suggestions, did not enforce them. Some employers realized the good sense of maintaining workers' health through such measures, and some were convinced by the factory inspectors, but others continued to experiment with twelve-hour shifts and to show little concern about workers' health and safety. For some, the war effort provided a convenient excuse to forget the Factory Acts.

Night-shift work by women, prohibited under the Factory Acts, was again permitted during the war, under individual emergency exceptions granted by the Home Office to factories or workshops engaged in government work. Large numbers of applications for such emergency orders came in, sometimes after inspectors had reminded employers that exemption must be requested. Based on their knowledge of the factories in their districts, the women inspectors advised the Home Office whether or not to grant such exemptions. As the demand for exemptions increased, consideration of individual applications became burdensome and whole classes of industry were declared exempt.

Factories where women worked at night were required to provide women supervisors, and the women inspectors made frequent nighttime visits to investigate conditions. Hilda Martindale remembers spending entire nights in factories, roving the buildings. She checked to see whether means of heating food was provided, whether there were lights in the toilet, and whether proper supervision was supplied for girls working with men at night. Martindale advised employers and welfare supervisors about canteens, hostels, transportation facilities, and clubs for workers. She and her assistant, Henrietta Escreet, and two women physicians conducted an inquiry into health and conditions of employment of five hundred women munitions workers (H.M., pp.163–64).

Workers in wartime, Martindale found, were willing, in their patriotic zeal, to work "without a murmur of complaint long hours which entailed loss of all time for recreation and curtailed time for rest. They worked at night, although such employment carried with it conditions with which they were quire unfamiliar, and in spite of the fact that sleep during the day in their little houses in noisy streets was almost an impossibility." The inspectors were still convinced that long hours were unproductive as well as dangerous. In enforcing the rules, Martindale observed, not for the first time, that "long irregular hours for the workers seemed to go hand in hand with badly organized works, whereas good organization seemed to result in shortened hours, the elimination of Sunday work, and well-arranged shift systems." In factories with well-planned schedules, management subscribed to the theory that long hours were less productive, but where work schedules were confused, she found, management "appeared extraordinarily hazy" about production statistics (H.M., pp.159, 160).

The workers' patriotic effort was rewarded by increasing wages. Women who had earned 10 or 12 shillings a week before the war increased their earnings to 30 or 35 shillings by the war's end.[22] Many women found that for the first time they could afford to provide ample food for themselves and their families. Observers noticed that women tolerated hard work better when they had an adequate diet.

Nevertheless, the old emphasis on women as "mothers of the race" warmed up again, rekindled by awareness of the tremendous loss of life on the battlefields of France. People who were able to overlook the hard work and heavy burdens of poor women at home piously insisted that neither actual nor prospective mothers should be allowed to engage in industrial labor. No matter how well women seemed to adapt to factory work, or how satisfied employers and even male co-workers were with women's participation, many believed, as one Birmingham manufacturer put it, that "There is the patent fact of their physical condition, the unavoidable result of their sex, and its social mission in life. Undoubtedly the continued employment of women in factories will adversely affect the birth-rate, and also prejudice the health and training of children already born into the world."[23] The women inspectors—proud though they were to see women proving their ability to perform heavy work, such as driving cranes, and skilled work, such as toolmaking—nevertheless were ambivalent on this issue. They, too, regarded women as wholly responsible for the health and welfare of the nation's future citizens. Adelaide Anderson prudently acknowledged that women's contribution to industrial production "has to be duly considered in relation to the primary claims of life"—family and motherhood.[24]

While people worried about babies yet unborn, the inspectors saw an increase in illegal employment of children. The transfer of adult workers into the munition trades had created labor shortages in other industries. Parents were often quite as willing to send their children to work as employers were to hire them. Martindale often felt she stood alone in this issue. She rued "the never-failing willingness of children" to do what was asked of them: that, she wrote, was a "trait which needs careful watching." In Birmingham, local law required children to attend school full time, but Martindale found that jewelry manufacturers had devised a scheme by which children as young as ten could work five hours a day—before classes, during the midday recess, and after school. Teachers, not surprisingly, complained that children came to school not to learn but to rest. Martindale, unmoved by pleas of patriotic need, prosecuted four firms

for breaking the child labor laws. Wartime necessity, she argued, did not extend to hiring children to make "such luxuries as gold chains, tin trays, watch keys, babies' comforters, etc." The magistrates agreed that children's health and education should not be allowed to suffer for the sake of manufacturing trinkets (H.M., p.161).

16

The Bureaucracy of War

As the war went on, government agencies proliferated, and the inspectors found that they shared responsibility for women workers with an ever-increasing array of departments, bureaus, and boards dealing in one way or another with the industrial side of the war. The labor exchanges, in their effort to match workers with wartime demand around the country, became more active and more authoritarian. Early in 1917, Prime Minister David Lloyd George complicated things further by establishing the National Service Department, directed by Neville Chamberlain. This office was supposed to encourage a "voluntary" but organized system of assigning workers to industries, but from the beginning things went badly. The War Cabinet refused to grant it authority over the labor exchanges, assigning them instead to the new Ministry of Labour. The interdepartmental hostility that ensued, combined with Chamberlain's lack of understanding of the workings of the civil service, brought great trouble.

Neither Chamberlain nor his chief officers knew how to make things happen in government offices. Even May Tennant, who came out of private life to serve as director of the women's division of the National Service Department, could not make this agency effective, though she brought with her two well-qualified assistants, Violet Markham and Mona Wilson. Markham had first approached Tennant in 1902 for advice about establishing a social settlement in Chesterfield. Since then the two women had been close friends and political associates, sharing a concern for workers' welfare and

"digging enthusiastically the foundations of the Welfare State." Mona Wilson, another longtime acquaintance of Tennant's, was an experienced analyst of women's working conditions. May Tennant, with her connections and her administrative experience, might have helped smooth the way for the new agency, but apparently she could not reach useful communication with her friends at the Factory Department, nor could she use her famous charm to draw the labor exchanges into cooperating. Also, during the brief six months of the department's existence her son was killed in the war, and she was operating under a cloud of grief. This time the women inspectors' collegiality and networking abilities failed. Perhaps the National Service Department was simply not necessary; surely it was not effective. It failed to secure the cooperation of the labor exchanges. Access to the network of labor exchange offices across the country would have made a huge difference in the department's ability to match workers with jobs. As it was, however, Markham and Tennant resigned in frustration in August, and Chamberlain stayed only a few days longer.[1]

As the war continued, the War Office, the Admiralty, and even the air force came to play roles in the control of industry, and the situation became extraordinarily complicated. The Ministry of Munitions set up its own welfare department under the direction of Seebohm Rowntree, an industrialist who was an expert in the field of industrial welfare. Rowntree's expertise was an exception to the rule; most of the people appointed to deal with industrial concerns had no experience in or knowledge of industry. Perhaps worse, from the point of view of getting things done, as Rose Squire noted, they lacked "the traditions and the status appertaining to officers of an old Department."[2] This work might have been better accomplished within the Factory Department, but at least Rowntree, unlike the officers of the National Service Department, worked closely with the Factory Department. The women inspectors, who had learned the ways of the civil service and earned their status, "threw themselves into the work of co-operating" with him, supplying all possible information and assistance. By the end of 1916, Adelaide Anderson and her staff had supplied Rowntree with 1,396 surveys of conditions in factories employing nearly

200,000 women, classifying the establishments "according to the degree of urgency for his attention." Of these factories, 31 percent were rated first class, or acceptable. The rest—lacking adequate meal rooms, washing conveniences, rest rooms, first-aid service, and "suitable supervision"—were rated second class (49 percent) or third class (20 percent).

After Rowntree had established the welfare department of the Ministry of Munitions, Dr. Edgar Collis, the medical inspector from the Factory Department who had served on the Health of Munitions Workers Committee, succeeded him. Collis called May Tennant back as adviser. Irene Whitworth was lent by the Factory Department to the new agency for a time, but she did not stay: "her position among the many temporary women welfare officers on the staff was too indefinite for her experience and gifts of organisation to take effect," as Rose Squire delicately summed up the situation, and she soon returned to her own department.

Early in 1918, May Tennant negotiated to bring Squire into the Ministry of Munitions as director of the women's welfare staff. Squire resisted. Privately she thought that "setting up a separate organisation to deal with industrial conditions" was a "fundamental mistake." The women's welfare staff was known to be disorganized and ineffective. Squire doubted "whether anyone could put [it] right." Finally Winston Churchill, then minister of munitions, summoned her to a "long and very confidential interview." He used his great persuasive powers to induce her to undertake the task she believed was, at that time, "the most difficult . . . a woman Civil Servant could endeavour to accomplish"—that of making this "inharmonious crowd of women of all ages and callings" into an effective governmental unit.[3]

Squire's new surroundings in Northumberland Street, in a former annex of the Grand Hotel that had been hastily converted into offices, were uncomfortable, but she had not time to pay attention to them. May Tennant had rightly counted on her colleague's administrative skill. Squire, realizing immediately that petty jealousies and perpetual gossip were blocking any possibility of accomplishment, went into action. She ignored the office politics and simply required "each member of the crew . . . either to pull his or her full

weight or to go and make room for another." She pulled them together; "the disintegrating forces die[d] of inanition," and she transformed her staff of about a hundred into "a corporate body of loyal and useful servants of the State."[4]

Her welfare officers visited factories "largely managed by autocratic military officers" to establish and maintain welfare conditions according to standards set forth by the Ministry of Munitions and the Home Office. Compliance with the standards was not compulsory, and Squire's own experience in persuasion must have been invaluable.

Like the workers, welfare officers removed the hairpins from their long hair—"no bobbed hair then," Squire reminds us—and changed into rubber shoes when they entered explosives factories. They risked occasionally what the workers risked every day. Squire herself once spent several hours visiting a factory. In the course of their rounds, the doctor who accompanied her asked, "Do you realise that any minute we and all this may be blown sky-high?" She wished he had left the thought unspoken, but she remembered it a few days later when the same factory "in one moment of time disappeared with all its busy occupants in one tremendous explosion."[5] This may have been the Silvertown disaster of January 9, 1917, described by Vera Brittain's uncle: "'On Friday evening we were working quietly away in the office when there was a most appalling bang, and the whole building shook visibly and windows were shattered. We first thought a Zeppelin was overhead and had just missed us, but there was no repetition so we went out to investigate. There was not much news that evening—but we since learnt it was a great explosion about 10–12 miles away east of London . . . I should think it is the worst accident we have had at all on munitions work.'"[6]

Explosion was not the only danger munitions workers faced. With her long experience of industrial poisoning, Squire was not amused by the whimsical appellation, "canary girls," given to workers manufacturing TNT because handling the powder caused their skin to turn yellow. At first the word was that the industrial jaundice they suffered was merely temporary and nothing to worry about. But Squire attended inquests following the death of young women victims—"not the least painful of the sad and anxious duties during these

years"—and saw others suffering a wide variety of minor irritations like headaches and nosebleeds, and more serious toxic symptoms such as nausea, anorexia, swelling of hands and feet, and drowsiness.[7]

The young workers themselves took a romantic view of the risk. Caroline Rennles, who worked at Slade Green, Dartford, making "toffee apples" (the workers' nickname for TNT shells), recalled years later how she and her co-workers rode directly into the factory on the first-class carriages of the train. The factory doctor examined their yellow faces and "pulled our eyes down." They were given milk to counteract the poisonous effects of the powder. Some women suffered stomach pains, but "I wanted to die for my country then," Rennles remembered. "I thought it was lovely to die for England."[8] The inspectors did not agree. In November 1915 the Home Office added toxic jaundice to the list of diseases physicians were required to report and instituted compulsory periodic medical examinations and special sanitary regulations in factories where TNT was used.

The inspectors had always argued that industrial fatigue was detrimental to production. It became a subject of "scientific" attention during the war. Shorter hours, nutritious meals, and canteens in which to eat them were seen as means of combating fatigue, and so received official approval. The provision of canteens in the workplace was also supposed to discourage workers from frequenting pubs.

Keeping workers fit and on the job became an important concern in wartime. Women factory inspectors had for years urged industrial managers to employ welfare supervisors as a guarantee of the health and well-being of workers. Hilda Martindale had attended the first professional meeting of welfare supervisors, social secretaries, and women superintendents in Birmingham in 1909, organized by Edward Cadbury, the Quaker industrialist whose chocolate factory was a model of benevolent management. The object of that conference had been to develop professional standards, and Adelaide Anderson had been a speaker. The war created a demand that outran the supply of trained professionals, however, and the effort to professionalize welfare supervision faltered. Some of the wartime supervisors were inexperienced

middle-class women who, however well intentioned, were often condescending. Some of them imposed their own standards of propriety on the workers, interfered in their lives to an unwarranted degree, and criticized women's clothes, makeup, and choice of recreation.[9] Nevertheless, the Home Office first encouraged and then, in 1916, required the appointment of welfare supervisors in munitions factories.

One important reason for the introduction of welfare supervisors was the large number of women workers who moved to new jobs far from home. In 1914, the labor exchanges placed 32,988 women in factories away from their home villages or towns; in 1915, the number rose to 53,096; it tripled in 1916 to 160,003. Early in 1917, in a single month, 5,118 women from about 200 different exchange areas were brought into eight large munitions centers. The urgency of gathering workers for wartime industry—sometimes out in the country, sometimes in sections of cities where women did not usually go—led to concern about the workers' housing, food, and recreation.

The welfare supervisors were available to help workers with their problems and also kept an eye on their behavior, both in and out of the workplace. If a woman worker stayed away sick for two days, for example, the welfare supervisor paid her a visit. "If she is unwell, her sickness is recorded. If well, but undesirous of returning, her name is struck off the books. If her absence is due to slackness, she has to return at once to work."[10] The welfare supervisors also did not hesitate to reprimand young women workers for going to the movies too often or spending too much time in the street. Such a truant-officer approach cannot have endeared the supervisors to the employees. The women inspectors felt that welfare supervisors provided an extension of their own efforts, a way of furthering benefits and protection to workers; but, excellent though their intentions might have been, welfare supervisors drew criticism and even hostility from workers. Workers resented the intrusion of welfare supervision into their lives, and they did not fail to recognize the underlying assumption that working women needed supervision while working men did not. The workers saw the supervisor as a tool of management, a spy, and an enforcer of someone else's standards. Workers would have preferred to look after themselves. Barbara Drake

observed that "it is not so easy to make the best of the two worlds of capital and labour. In the actual conflict of opposing parties, it was evident that the 'welfare supervisor' could only truly serve that party which employed and paid her."[11]

While Anderson and her colleagues in the Factory Department envisioned a future in which welfare supervisors would link employers and workers in a great harmonious effort, many of the women's trade union groups disagreed. They wanted "worker control and more factory inspectors." Both the factory inspectors and the welfare supervisors came from the middle class, but they were not equally suspect in the eyes of the workers. The strong connections between the factory inspectors and the trade union movement strengthened the belief that they were genuinely interested in the workers' welfare. "One factory inspector was worth a hundred welfare supervisors," in the view of the women's trade unions.[12] "If employers often looked at inspectors as government intruders, trade unionists and their leaders displayed similar feelings towards welfare workers."[13]

In spite of the proliferation of agencies and the confusion of authority, the need to keep the machinery running with a finite work force led at last, Anderson recalled, to the broad introduction of measures the factory inspectors had long endorsed: supervision of women by women, proper accommodations for meals, rest, and personal cleanliness, and qualified nurses to provide first aid and health care in the factories. Anderson recognized the irony in the fact that "the manufacture of munitions of war on a terrible scale led at last to systematic introduction of hygienic safeguards that Factory Inspectors have advocated for many years." The necessity of maximizing production, she said, taught employers and managers the value of conserving the health of workers, and they learned to recognize "the dependence of efficient output on the welfare of the human agent."[14]

Public concern about the health of the people rose, as it had at the time of the Boer War, when Britain needed soldiers. The poverty and ill-health of industrial workers became conspicuous when only 36 percent of the 2.5 million men examined in 1917–18 proved to be fit for full service, and 41 percent were judged either "unable to undergo physical

exertion" or permanently unfit for military service.[15] Attention focused, as it had in 1902, on the mothers of the race. Even Adelaide Anderson declaimed: "in the greatest convulsions of society, such as that in which we stand, those people and nations will no doubt endure who possess the most intelligent, true-hearted mothers."[16] While some observers noticed that women's higher wages, meals provided in canteens, better factory ventilation, rest periods, and seats at work might lead to better health, others deplored taking mothers from home and allowing women to perform strenuous work. These critics overlooked the arduousness of many domestic tasks, of course, and of work performed by women chain makers and others. Almost no one seemed to think that the women themselves might have any sense about how to manage their own lives.

The inspectors' concern for workers' welfare extended outside the factory to housing and recreation. Vast numbers of workers came to centers of wartime industry such as Coventry, Birmingham, and Hereford. Young girls who traveled to work from the surrounding countryside were away from home for sixteen to eighteen hours a day. Others, imported from greater distances, had to find lodgings near the workplace. The "extramural officers" appointed by the Ministry of Munitions to deal with these and other problems (including provision of day care for children of women workers) often asked the women inspectors for help. Hilda Martindale served on three outside welfare committees during 1917, as well as on the Birmingham Works Morality Committee.

Morally acceptable recreation for tired workers was a special concern of this committee. The workers liked to gather at pubs in their free time, and Lloyd George and others worried about the effects of alcohol on war production. In response, the government strictly curtailed pub hours and reduced the alcohol content of beer and spirits, but that failed to discourage people from gathering at the local. Some citizens felt that "a problem still existed, due to the presence in the city [Birmingham] of a vast number of women and girl munition workers." They believed women needed protection both from alcohol and from casual association with men, but Martindale had more confidence in the good sense of the women.

To prove her point, she and another woman member of the Morality Committee visited over two hundred Birmingham pubs at night and on Saturdays and Sundays. The two did their best to blend in with the crowd; they mingled and chatted, and invented a friend called "Emily" for whom they could pretend to be looking. The pubs were packed with women and girls, but they never found a woman drunk. They concluded that, having no place to sit in their overcrowded lodgings, these people were simply gathering for relaxation.

War workers badly needed diversion. A Health of Munitions Workers Committee memorandum observed that "in very many munitions factories, the complaint is made by workers . . . that they are feeling 'done up,' or 'fair whacked,' to use local phrases; and the evidence shows that this state of 'staleness' is attributable almost wholly to persistent long hours and the deprivation of weekly rest. It has grave accompaniments which paradoxically appear not only in a state of lethargy and indifference, but also in a craving for change and excitement."[17]

Martindale found no indication that the workers' relaxation in the pubs interfered with munitions production. She herself had spent many hours in boring provincial hotel sitting rooms, and she realized that the tired workers "did not want to be improved." Instead of criticizing the workers, she campaigned for an alternative: warm, well-lighted "winter gardens," where good refreshments and light drinks would be served and where the workers could relax, talk, or, if they wished, do nothing.

The women inspectors' contribution to the war effort was recognized at the end of the war when the Order of the British Empire was established by King George V in 1918. Adelaide Anderson was made a Companion and Rose Squire and Hilda Martindale were named Officers of the Order. In pursuit of recognition of a more mundane sort, the women inspectors, in the same year, submitted a request to the secretary of state that "equivalent grading of pay for men and women should be considered in the light of equal work and equal pay."[18] Their wartime work had made them more consciously government officials, more accustomed to teamwork with other government offices and with industrial management. They took pride and pleasure in what women

workers had accomplished, but they no longer anticipated that the need to protect workers would someday decline.

Women, through the exigencies of war, had an opportunity to demonstrate their strength and their ability to perform in all areas of manufacturing. Employers reported favorably on their skill, speed and dependability: "one manager said that 'you did not catch them dodging'; another that 'they didn't want to go and have games of football around the corner.'"[19] Not only that, but some of the women inspectors' cherished dreams of the ideal factory had come true. Factory canteens serving nourishing food, nurses providing first aid and medical treatment, planned recreation, and the presence of a welfare supervisor to look out for workers' well-being—all these had become features of factories across the nation as women engaged in war production. Employers acknowledged that these measures, combined with shorter hours, improved production.

Adelaide Anderson and her colleagues believed that workers would increasingly participate as equals with union representatives and welfare supervisors in works committees to determine working conditions. "It is a new world that has to be faced now . . . harmony in industrial relationships promises to be the natural outcome of associated human effort for the sound, plentiful production that mankind so greatly needs and that may minister to a reviving desire for fitness and beauty in the world," Anderson wrote.[20] Similarly, Hilda Martindale saw a "general tendency" toward cooperation between workers and employers and the Factory Department; she had long believed that such cooperation was the best way to secure good working conditions, better than legislation alone (H.M., p.169). In 1917, the first report of the Whitley Committee, a subcommittee of the government's Reconstruction Committee, recommended works committees as one means of improving relations between employers and employed.

But the government committees and the individual writers who were most optimistic about the postwar period were disappointed. Darker views proved more accurate. Seebohm Rowntree had predicted postwar economic depression as early as 1915 and had recommended that plans be made for public works to supply employment for soldiers and

factory workers whose jobs would end with the war. Others had foreseen that women who had gone to work during the war would not be content to stay home. They even hoped some might emigrate to find work instead of competing with returning soldiers.[22] The end of the war did indeed bring upheaval and unrest among workers.

17

The Women's Side of the Situation

The postwar world did not bring the bright future that women workers and women inspectors had hoped for. Women workers faced disappointment and unemployment as the new avenues that had seemed to open up during the war shut down. Women inspectors struggled with hard questions about the place of women in the work force as the nation adjusted to a peacetime economy.

When the war ended, the women factory workers who had been so much admired and applauded for their participation in wartime industry became "an administrative headache," in the words of historian David Mitchell.[1] As early as June 1918, some 50,000 women were out of work. In the first two weeks after the armistice, 113,000 women were discharged.[2] Men's trade unions insisted that the government stick to the agreement that women substitutes in men's jobs must leave at the war's end. Returning soldiers vigorously refused to accept the government's attempt at an orderly arrangement of demobilization and reemployment; within eighteen months nearly 4 million men had left the armed forces. Many found their old jobs filled, and others, who had gone straight to the war as boys, had no training for peacetime work.

At first, the problems seemed only logistical. Women's jobs in engineering trades vanished before manufacturing peacetime commodities had fully resumed. Factories were being converted—from shell manufacture to box making, from building airplanes to making automobiles or wooden toys—but the conversion of old plants and the construction

of new factories took time. Adelaide Anderson observed that "too little thought seems to have been given, by those discharging women, to what might be done in the way of adaptation of work for them or improvisation of training to prevent their unemployment," but there were indications that some real social planning was considered. The shortage of skilled labor to make corsets, shirts, collars, blouses, socks, and shoes meant that women were in demand. Since "women . . . appear reluctant to leave home and live in lodgings," local officials made an effort "to bring suitable industries to their neighborhood."[3] The officials planned to provide jobs for both husbands and wives in the same community, building hosiery factories, for example, in mining districts. In Dundee and Londonderry, where most of the existing employment was for women, they hoped to establish shipbuilding works.

Anderson and her colleagues boasted about the increased confidence of women workers who had proved their ability to learn skilled trades and handle heavy work. When they were turned out of their wartime occupations some women went back to their old industries, taking with them a determination to achieve the amenities they had grown used to during the war—canteens, proper rest rooms, facilities for washing—and to have something to say about their own working lives.

Some employers complained of slackness among women workers. A factory welfare supervisor blamed mental and physical exhaustion after the long years of pressure to produce war materials. But where women had new lines of work to learn and were encouraged to show initiative, they had as much energy as they had shown in wartime. "During the war," Hilda Martindale observed shrewdly, "women's powers and capacities were called into full play and no one denies that there was a response beyond all exception. To-day there is little call to a strenuous and sustained effort, entailing full use of powers and faculties. Instead, interesting work is taken out of their hands, and they are being forced back into the routine of their hitherto normal occupations."[4]

But even in "normal" occupations, the postwar boom of 1919 was soon over. In her 1920 annual report, Adelaide Anderson drew a dismal picture. Not only had women been shut out of "men's" industries, but males had replaced

females in some industries that had once been considered the province of women. Even in laundries, methods were changed to create jobs for disabled soldiers, and many of the skilled jobs women had done were eliminated.[5] The depression in trade forced many small businesses—laundries, dressmakers, and tailors—to close or cut back.[6] Anderson saw no prospect of fulfillment of her wartime hopes "that after the war a body of industries and operations offering a hopeful field of fresh employment would lie open to women where their war experience could be turned to account." Instead, she found that "an automatically operating force has closed all these expected new avenues, and in various occupations hitherto regarded as peculiarly women's their presence seems, in certain directions, to be threatened."[7]

Business was bad, and the attitude of the public toward women workers was astonishingly vicious. The same women who had been glorified for their splendid patriotism during the war were condemned as traitors when they refused to disappear quickly and meekly from the work force, or at least to accept drastically lowered wages and perform unskilled "women's work." Perhaps most humiliating was the drive to convert these newly independent skilled workers into household servants. Women who had been servants before the war had tasted freedom; those who had never done anything other than industrial work were used to choosing their own spare-time activities, "dancing and other forms of recreation with congenial companions."[8] They had no wish to be confined in someone else's house, restricted by the mistress's rules. Middle- and upper-class women, on the other hand, felt they had suffered enough deprivation during the war and were eager once again to enjoy the comforts of a well-staffed household. They could not understand the reluctance of skilled factory workers to turn to domestic jobs. In letters to the newspapers, they expressed a conviction that it was the duty of government "to restore the supplies of domestic labour interrupted by the war."[9]

Rose Squire, whose responsibility during the war had been to encourage and assist in the expansion of the fields open to women, had the unhappy task of reorienting unwilling workers to the jobs that were available. She had left the inspectorate

reluctantly for her wartime emergency assignment. When the war ended, she was not released. She and her staff became a part of the new Department of Demobilisation and Resettlement, where one of her duties was "to deal with the women's side of the situation."[10] Squire, a government employee for over twenty years, accepted the assignment of getting women off the unemployment rolls. Tackling the task with her usual thoroughness, she added to her staff several expert supervisors, including Lilian Barker, who had achieved renown as welfare supervisor of 25,000 women workers at Woolwich Arsenal. Together the supervisors developed a program to train women for available occupations, paying them a maintenance allowance while they learned. The women inspectors had always been engaged in making women's work decent and dignified and encouraging the self-respect of women workers, but Squire now turned her energies to persuading women to overcome their prejudice against housework and take jobs they considered demeaning.

She formed an advisory committee that included two trade-union stalwarts, Mary Macarthur and Margaret Bondfield. The committee recommended that employers offer servants better conditions, including specified hours and holidays, recognized mealtimes, and outings, but it had not authority to enforce such conditions. At meetings in factories and labor exchanges, Squire and her staff tried "to stir the imagination of the women." In 1915, they had appealed to women's patriotism to persuade them to go to work in munitions manufacture; now, using the same rhetoric, they argued that "the national service of building and staffing homes" was a patriotic duty. Squire even seems to have convinced herself; she recalled later, "Women and girls who had never peeled a potato were turning out excellent dinners, housemaids and parlourmaids proudly showed their skill, and several enthusiastically claimed that they had 'no idea housework would be so interesting.'"[11]

Squire's program trained and placed over two thousand women. The persuasive power of her staff was reinforced by the government's restrictions on women's eligibility for unemployment compensations. If a woman refused a job offer, no matter how unsuitable the work or how low the

wages, her payments could be cut off.[12] In 1921, amendments to the unemployment act excluded from eligibility married women whose husbands were employed, and single women and men living with their parents if their parents had sufficient income to support them.[13]

Squire's unit, renamed the Women's Training Branch, consulted employers and trade unions to find out what jobs might be available to trained women, but found "almost insurmountable obstacles" in most directions. Tailoring and dressmaking offered opportunities, but needleworking could no longer be assumed to be a natural skill of women. The women who came to the training program knew how to fill shells with explosives, but they "did not literally know on which finger to put the thimble or how to thread a needle."[14] Factory workers who had lived in hostels during the war knew nothing of domestic work; other people had cooked and cleaned for them. Teachers in retraining centers found it hard to instill enthusiasm in their students while they taught them domestic skills.

While Squire was away administering the government's retraining efforts, her colleagues in the factory department found their work returning to its prewar emphases. Although excessive hours were now seldom encountered (most employers had adopted a forty-eight hour week, well below the legal maximum), cleanliness and basic comforts for workers were often below acceptable standards. Hilda Martindale reported more than one hundred complaints about the lack of mess rooms and cloakrooms; another inspector reported that the cotton factories were so lacking in comfort that even supplying a steam kettle for making tea was considered extraordinary. New factories were usually well equipped with toilets, although one mill employing 250 women "had a row of ten beautifully tiled conveniences, but not one had ever been provided with a door." In some districts, "the old-fashioned pail closet" was still prevalent. Washing facilities were a bone of contention; the employers insisted that workers had low standards of cleanliness and would not use them, while the inspectors suggested that washrooms without soap, hot water, or towels were hardly appealing. Several inspectors complained about the difficulty of enforcing sanitation requirements in buildings shared by several small

factories, where no one would claim responsibility and everyone referred the inspector to a "mythical landlord."[15]

There were exceptions to the general rule of employer indifference to working conditions. Some employers sought the advice of inspectors when they installed mess rooms or canteens. In Birmingham, outside volunteers provided factory canteens, sometimes with a woman caretaker and occasionally even boasting a piano. Small businesses had difficulty complying with welfare regulations, but some met the challenge with ingenuity. One Leeds laundry proprietor built a little mess room in his backyard with his own hands, and in crowded South London, Martindale discovered a laundry with a garden "laid out with a fountain and small ponds and many comfortable seats."[16]

While they attended to the needs of women factory workers, the inspectors also had to give serious thought to their own work situation. In the summer of 1919, a committee was formed to review the structure of the Factory Department; a major item on its agenda was the question of amalgamation of the women's and men's sections of the department.

18

Fusion

"It is a really important piece of work," Malcolm Delevingne, chairman of the committee to review the departmental structure, wrote to Violet Markham in 1919, "which may affect the fortunes of the Factory Department for a long time to come." He asked her to serve on the committee: "I know of no one whose help would be so valuable to us in the consideration of the subject as yours would be." Markham would join Delevingne; W. Leitch, a Treasury official; and "an enlightened factory manager," John Gray, the vice chairman of Lever Brothers Ltd. "I need not say," Delevingne added in his own hand, "how very agreeable it would be to myself personally to be working with you again."[1]

Delevingne knew that the question of fusion of the men's and women's sections of the Factory Department was a controversial one. Markham was an old friend and colleague of May Tennant and Constance Smith, the most recently appointed senior inspector. Smith, whose perspective differed from that of the women who had built the women's branch, had been stationed in London from 1913 until 1918,; then, after a short period in Leeds, she took over the Manchester office. Delevingne knew her well; he and Smith had accompanied Gerald Bellhouse to the International Labour Conference in Washington, D.C., in 1918. There, as chairman of the Women's Employment Commission, Smith had participated in discussions of night work for women and employment of women after childbirth. When the meetings ended, she and Delevingne had visited textile mills in the United States.

Delevingne wanted to achieve change without dividing the Factory Department into irreconcilable factions or drawing public attention to a controversy. Some of the men inspectors, on the one hand, hoped through reorganization finally to bring the women inspectors under their control and out of competition with them. Adelaide Anderson and most of the senior staff of the women's branch, on the other hand, were expected to oppose any attempts at fusion. Among the women inspectors, only Constance Smith agreed closely with most of Delevingne's views. Even in 1913, when she joined the department, reorganization was being contemplated, and Smith may have been brought in with the approaching change in mind. She had an impeccable record of action in behalf of women workers and legislation to protect them, she was connected with people whose support was important, and she strongly believed that the time had come to disband the separate women's division of the Factory Department. Like Delevingne, she favored a new, integrated organization.

Delevingne and Smith believed reorganization was necessary not only to rationalize the administration of the department but also to make the inspectorate attractive to younger women who were beginning their professional lives. The women who now led the branch had entered when women had few professional choices, and perhaps none that offered as much scope as the Factory Department inspectorships. The increased responsibilities and authority they had assumed during the war had seemed to promise a future in which they might achieve new prominence, but in postwar Britain, where women had new access to professions as well as the right to vote, a reexamination of the lady inspectors' position was inevitable. Middle-class women had achieved greater independence than ever before. The Sex Disqualification (Removal) Act of 1919 specified that no one should be disqualified by sex or marriage from holding any public office, from entering any profession, or from graduating from university, and young women found opportunities in teaching, medicine, banking, and particularly in the law, a field that appealed to the same women who might have considered entering the Factory Department.

The men inspectors' dream "of keeping women factory inspectors in a position of perpetual subordination to the senior men," was obviously archaic, but Smith, listening to the young women she supervised, realized that it was "absurd . . . even to suppose that you can restrict them in the future to a career under women officers." Young women entering professions in the 1920s expected to compete with male colleagues. They contended that they would not have equal opportunity for advancement unless they were granted equal responsibility.[2] Difficult as it might have been for the pioneer female inspectors to accept, it was time for a change.

In January 1920, before the committee had met, Constance Smith outlined the arguments in favor of reorganization in a confidential memorandum to Violet Markham. Historically, she reminded Markham, the women's branch had "grown up rather than been deliberately planned, and its development and expansion have taken place under pressure of circumstances and not as the result of any definite scheme." The result, over a quarter of a century, was a patchwork of overlapping responsibilities and conflicting instructions. Relations between the women and men inspectors depended on personalities and diplomacy, and she deplored "the amount of time wasted in exercising 'tact,' and self-recollectedness and in considering personal idiosyncrasy." She also pointed out that each division maintained separate files and there was no one central source of information to which all inspectors had ready access.[3]

The committee had three proposals to consider. The first came from Malcolm Robinson, who had succeeded Whitelegge as chief factory inspector in 1917. He recommended assigning the women to "real districts" with supervision by a superintending woman inspector. The male superintending inspectors, in turn, proposed placing women inspectors in the existing districts, but stated flatly that women were not fit for any supervisory role and, as Smith put it, "absolutely barred the way to their advancement to any superior position." This plan, of course, was unacceptable to the women. The principal lady inspector, Adelaide Anderson, offered the third proposal: to continue the women's branch with its responsibility for matters affecting women workers, but to make more specific requirements for exchange of information

between the women and men inspectors. This was, in effect, a recommendation not to change; many efforts had been made over the years to untangle responsibilities and ensure proper communication between the men and women inspectors.

Smith acknowledged that Anderson's viewpoint was natural to a woman who had spent a quarter of a century in the Home Office, "struggling for 'room to live,'" but she herself believed change must come. She told Markham that she had already heard people refer to the women's branch as a "back number, sadly out of date." In her opinion, unless the department gave up "this attempt to wrap women (all *over* 25 *at least* and called to considerable responsibility) in silver paper, and to provide them with a chaperon in the person of the Senior Lady Inspector," recruiting able women would soon become impossible.[4] The effect would be to "keep the women inspectors in a side current" and this, she believed, was "fundamentally wrong."[5]

In Smith's opinion, equality of opportunity was the fundamental need, and to achieve that, she felt it was essential to have women in top positions, not only as superintending inspectors but at headquarters as well. She wanted a woman deputy chief inspector (with the accompanying implicit possibility of a woman chief inspector) and a woman administrator in the Home Office to advise on policy questions related to the Factory Department.

Smith asked Markham not to show the memorandum "to *anyone* except Gertrude [Tuckwell]." Presumably she did not want to share either this detailed summary or her own views even with May Tennant, who, much interested in the future of the women inspectors, was in frequent communication with Markham. Two days later, Smith wrote again to tell Markham of Delevingne's scheme, which was similar to the chief inspector's but better, she said, because "he is definitely prepared to put the man under the woman as well as the woman under the man."[6]

With these alternatives in mind, the committee met to consider the evidence. Most of the senior women, including Hilda Martindale, supported continuing the parallel organization and increasing the number of women's districts. Henrietta Escreet, who had joined the department in 1908 and was working under Martindale in Birmingham, said that, "in spite of a

kind of modern and fictitious equality," she and her colleagues thought that "under a system of fusion, women would be less, not more, free."[7] In her opinion, women should be trained and supervised by women to preserve the point of view of women workers, because, she said, "the standards of men and women differ." Rose Squire envisioned women and men inspectors working together closely, but she told the committee she still believed that junior women should report to women and that matters concerning women workers should be dealt with by women.[8] Adelaide Anderson recommended more districts and greater cooperation between men and women inspectors. Despite the women inspectors' wide-ranging wartime activities, she believed that for the time being they should specialize in questions concerning women, sanitation, mess rooms, and first aid, while men continued to concentrate on chemical and engineering questions. She pleaded for gradual change: "We confer and jointly inspect and report and this can be greatly developed without assertion that we can both be experts in every side of the work. Assimilation will grow if the pace is not forced."[9] But she also asked for the addition of women medical inspectors, and by doing so, she seemed to be reinforcing separation rather than looking forward to assimilation.

The viewpoint of the men inspectors was presented by John Law and W. B. Lauder. They expressed their fear that fusion might make fewer places for men and their view that the women were not qualified to deal with the full range of industrial problems. To them, a satisfactory arrangement would be one where the women were securely tucked in under the authority of the district superintending inspector and strictly confined to issues relating to women workers.

Contrary to the impression conveyed by Escreet, the women themselves were far from unanimous. When Isabel Taylor, who, like Escreet, had joined the department in 1908, polled the staff asking whether they wanted to "continue as a separate branch or work under men," the younger women complained to Constance Smith that "this is hardly putting the case fairly & that there is a great deal 'more to it' than that." These women of the new generation who were beginning careers were afraid that "the present anomalous arrangement would injure their standing as compared with

that of women in other departments." They resented being pushed to agree with their seniors. "After all," one of them pointed out to Smith, "it is we who would have to work under men, not the seniors—and if we are willing, for the sake of the future & of women in general, then why not?"[10]

"It would be a thousand times better to pull down the old crazy patched-up house and build new on a modern foundation," Constance Smith acknowledged in a letter to Markham.[11] But she saw that radical reform was impossible in view of the "hopeless obscurantism" of the men and the refusal of the senior women to be reconciled. Anderson, refusing to give up the cause, demanded total support from her staff. Even after the committee on reorganization had submitted its report, she pressed Constance Smith to change her stand. Smith refused as tactfully as she could. "I have been *very* careful, *very* courteous, and have not lost my temper at all, but I expect nonetheless to be treated as an outcast henceforward!" She thought Anderson's insistence on unity quite useless: "if I were weak & insincere enough to do her bidding, the only result would be to *weaken* her case with the Committee, as it must then be evident to them that she was gaining supporters under duress," she wrote to Markham.[12]

Anderson was fighting a lonely battle. Even her supporters among the senior women inspectors were not prepared to sacrifice their careers. Rose Squire, still on special assignment outside the Factory Department, and worried anyway that her long absence would hamper her career, called on one of the deputy chief inspectors, R. E. Graves. She was anxious to let him know that she would cooperate with amalgamation. She confessed that after her wide responsibilities as deputy principal lady inspector and in her current position, she thought her own authority would be diminished by a regional assignment that would "confine her attentions to a comparatively small part of the country" as a superintending inspector,[13] but she made it clear that her views were those of a loyal civil servant—she intended to stay on.

In its final report, the committee on reorganization concluded that "admirable though the work carried out by the Women's Branch had been, the system of parallel lines and duplication of staffs" could not continue as the department

grew bigger. The existing confusion of overlapping responsibility caused annoyance to employers as well as friction among the staff. Although the women's assignments gave them considerable freedom and, to the irritation of the men, more time "to concentrate on the more human and interesting side of the work," they carried less responsibility and lower status, and were not eligible for promotion through all the ranks of the department. Times had changed, and in postwar Britain, to continue to bar women from full participation "would be in opposition to the present movement in regard to the status of women." The committee predicted that the lines between men's and women's employment would increasingly be blurred. Women in the inspectorate had already demonstrated their competence through their work in laundries and the clothing trades, and could be expected in the future to deal with the whole range of factory work.[14]

The language of the final report bears a strong resemblance to that of Constance Smith's January memorandum to Violet Markham, and it seems clear that she influenced Delevingne's thinking. This may explain why, in spite of the frequent references in all the reports to the need for women with greater departmental experience, it was Smith, older in years but with far less time in the department than the other seniors, who became the first woman deputy chief inspector under the reorganization.

Undersecretary C. E. Troup, submitting the report to the Home secretary, Edward Shortt, affirmed that it "is in accordance with the latest developments of feminism—and w[oul]d be supported by Mrs. Tennant, Miss Tuckwell, & other women interested in factory work," but he acknowledged that "it is strongly opposed by Miss Anderson, the chief woman inspector who has built up the present system and its adoption would mean her retirement."[15]

The Home secretary accepted the recommendations for amalgamation and appointed a new committee to work out the details of reassigning staff: Adelaide Anderson, Chief Inspector Malcolm Robinson, and the two deputy chief inspectors, R. E. Graves and Gerald Bellhouse. Graves had risen through the ranks and had been superintending inspector in Glasgow. He was to succeed Robinson as chief inspector within a

few months. Bellhouse, a man of few words and excellent judgment, was a veteran of thirty years in the department and was known for his impartiality and fairness and his support of new ideas.[16] He became chief inspector when Graves retired in 1922. The task of redistricting demanded the long experience and the wisdom of these four. They had to take into account not only the opinions of the staff, but the views and relative political weight of industrialists and trade unions in various cities as well.

Anderson's last stand was an effort to get women superintending inspectors put in charge of important districts. She did not succeed in all that she requested, but two of the ten district superintending inspectors were women: Hilda Martindale in London, and Emily Slocock in Leicester. Five women were appointed deputy superintending inspectors, and seven were named district inspectors; one woman medical inspector was added. By 1923 there were, in addition, seventeen women inspectors. Rose Squire, who had been deputy to Anderson before her wartime special assignment, was passed over, and Constance Smith was appointed deputy chief inspector. Years later, in her memoirs, Squire quietly expressed what, for this able and ambitious woman, must have been a great disappointment. With uncharacteristic understatement, she stated her suspicion that her absence on special assignment had "militated against the fulfillment of some of my cherished hopes of promotion."[17]

The position of principal lady inspector was eliminated, and Adelaide Anderson was, in the euphemism of the civil service, "retired." One last indignity awaited her. The plan had been to tell her about the decision that she must retire and, at the same time, to inform her that she was to be made a Dame of the British Empire. The bureaucracy mishandled the gesture. "Very unfortunately," Sir Malcolm wrote in great dismay to Violet Markham, "Downing Street—instead of sending the intimation of her dignity through us, as arranged . . . sent it direct to her so that she heard of the honour first and the retirement afterwards—also they kept us waiting so long for a decision that she gets hardly three months notice." (She probably also got a reduced pension, since she "retired" eight years early at the age of fifty-seven.) "If you or Mrs. Tennant

can pour any balm it will be a work of charity," he added. "I wish she could be put in the way of some work, either official or other, but nothing has suggested itself so far."[18]

In this limp fashion, the department and the Home Office released the woman who had served as principal lady inspector for twenty-three years. Adelaide's friends were much upset about this elegant callousness and tried to put things right. They organized a large dinner in her honor at Princes Restaurant. Three hundred guests attended, most of them distinguished women, many in the civil service. Lady Rhondda, the founder of the political weekly journal *Time and Tide*, presided and presented Anderson with a gift from her friends and admirers—1000 pounds enclosed in an antique mother-of-pearl casket.[19]

One further aspect of the reorganization was a matter of concern for all women. On August 15, both Malcolm Delevingne and May Tennant wrote to Violet Markham. Malcolm Delevingne, in his small, tidy, round hand, confirmed the rumor that both women had heard. The proposal put forward by the department and approved by the Home secretary had been accepted by the Treasury with one exception: the Treasury had not approved the salary ranges proposed for women. The committee on reorganization, recognizing that the present staff of women could not match their male counterparts in training and years of experience, had tried to allow for the differences by starting women at the lower end of the salary range in each rank. The government, however, had "adopted the principle of a 'certain differentiation' in the salaries of men and women," Delevingne explained, "by which apparently they mean that even where the work is equal in all respects women are nevertheless to be paid on a lower scale." May Tennant, in her usual black, angular scrawl, wrote angrily to Violet Markham: "This sex differentiation is the settled policy of the Govt. (God forgive such a statement) for all Departments."[20]

This was Tennant's third letter to Markham on the subject within a few days. Between letters, May had visited Sir Malcolm Delevingne. She wondered whether it would be worth while to bring the issue of equal pay to the attention of the public and launch a fight over the principle, but

Delevingne had told her, as he wrote to Markham, that he was "very anxious . . . that the Factory Department should not become the 'body of Patroclus' round which the fight will rage."[21] Delevingne felt it was futile to argue the point, although he knew that "the differentiation is bound to give rise to a good deal of dissatisfaction and to come in for a good deal of outside criticism."[22] His caution was natural enough for a dedicated civil servant, and May Tennant also realized the risks of waging a public battle that would "mobilise all the equal pay equal work people"—but by accepting the Treasury decision without a fight an opportunity was lost. The inspectors—with their excellent history of serious work, high standards, and established professional reputation—probably had a better chance than any other women in the civil service to defend their right to equal pay, and the Home Office, by insisting on it, might have established a precedent for equal pay in all branches of the government.

Delevingne knew Markham would be angry about the unequal-pay decision. He told her that, as an "unofficial" member of the committee, she was not bound to accept responsibility for the altered scheme and was "perfectly free to express [her] opinions." He was deeply disappointed, however. The Treasury's decision spoiled the chance that the Factory Department reorganization would receive "hearty support and goodwill from the outside." He knew that feminists would not endorse a plan that included a fundamental inequality. He hoped, however, that if the department could avoid "unsettling" controversy, the salary question would take care of itself over time. Meanwhile, he pointed out to Markham, "The women are getting the chance of equal status and responsibility and . . . a very considerable improvement in their salaries."[23] This was true; Martindale's salary, for example, doubled when she became a superintending inspector. But through the salary differential policy and other regulations governing admission and conditions of service of women in the civil service, the government, as one historian has observed, "simply reasserted the status quo," and for women civil servants, the Sex Disqualification (Removal) Act became "a dead letter."[24]

In January 1921, the women's branch of the Factory Department was dissolved and a pioneering era ended. "The value of

the special contribution brought by Women Factory Inspectors to the regulation of factory life for women and girls is too well and authoritatively established to be, as it were, accidentally lost," Adelaide Anderson wrote. Still doubtful that amalgamation was a wise move, she added, "We have yet to learn whether in the face of the actualities of industrial life complete fusion of the functions and activities of Men and Women Inspectors can serve the many distinct needs of men and women in factories and workshops better than some degree of specialisation and co-ordination."[25]

19

New Challenges

The transition from separate branches to a single inspectorate for both men and women was not without friction. Other men besides the male factory inspectors resented having a woman oversee their work. The Home Office had to deal with complaints from employers and trade unions that women were not competent to inspect the work of men. When Miriam Pease was appointed district inspector for Nottingham in 1921, Delevingne, responding firmly to a complaint from the Federation of Lace and Embroidery Employers' Association, explained that under the new scheme Nottingham, with its large number of women workers, was thought an especially suitable post for a woman district inspector. He added unequivocally:

> The Secretary of State is quite unable to agree with a view expressed in your letter that the main portion of the work of a Factory Inspector cannot be efficiently and properly performed by a woman. On the contrary he is advised that while there are certain matters relating to men's employment which can be best dealt with by men inspectors—and arrangements have been made at Nottingham as in other districts placed under a woman Inspector, for inspection by a male Inspector where necessary—the main work of factory inspection can (given the necessary training in the Department) be dealt with as well by women Inspectors as by men.[1]

He reminded the association that women inspectors had been

dealing with machines and machine fencing for a long time. With the same firm tones, the Home Office later notified the secretary of the Nottingham branch of the National Federation of Building Trades Operatives that under most circumstances, the woman district inspector would conduct all inspections of factories, although special arrangements for inspection by a male inspector could be made if unusual circumstances warranted it.[2]

Advocates for women workers had now to operate within the broader framework of the labor movement rather than outside it. Women workers themselves were merging their interests with those of men. The Women's Trade Union League was absorbed into the Trades Union Congress in 1921. Gertrude Tuckwell, Violet Markham, and other "allies" had long since been declared ineligible to hold office in the Trades Union Congress on the grounds that they were not trade unionists. But Tuckwell, still skeptical, speaking as a delegate at an annual meeting of the League, warned that women workers still needed special help "for their own sakes and to maintain the living standards of the working class."[3]

Hilda Martindale, as a superintending inspector, spent more time in meetings than she had in the less bureaucratic framework of the women's branch; the new trend in dealing with labor problems was to work in conference. She met with industrial councils, where employers and workers were represented equally, and with welfare supervisors. But the essence of routine inspection did not change very much. Alice Crosthwaite began work as a factory inspector in 1931, when a number of women were hired in an effort to make the proportion of women inspectors equivalent to the proportion (one-third) of women in the work force. Crosthwaite remembers checking up on overtime work and time-cribbing, investigating accidents—scalpings in machining works, loss of hands in a shell factory—and scrupulously following up on each complaint, no matter how trivial it appeared.

In an interview in 1982, Crosthwaite recalled adventures very like those of the lady inspectors of the 1890s. On one occasion she visited a factory in Manchester after the husband of a worker complained that the management required his wife to work on Sunday. She knocked at the factory entrance and,

receiving no answer, banged on the door with the heel of her shoe, as she had been taught to do. Still there was no response. Spotting a policeman nearby, she asked him to help her. She had to overcome his reluctance by showing him her copy of the Factory Acts. He got her inside, but she still had to coax the equally reluctant workers to give statements that they had worked on Sunday.

Women inspectors were still, in Crosthwaite's day, "more intellectual"—she herself was a graduate of Girton College, Cambridge—than the men, and highly conscientious, but, like Rose Squire, she found that her friends did not regard factory inspection as a highly respected profession.[4]

Of the first group of lady inspectors, only Hilda Martindale remained in the Factory Department when Crosthwaite began her career in 1931. As superintending inspector for the Southern Division, Martindale supervised seven districts in South-West London as well as the counties surrounding London and the seaport city of Southampton from an office in Queen's Gate. Her staff included seventeen men and five women. Luckily, Martindale's deputy, a man who had been in the department longer than she, "told me quite soon that I could count on his loyalty." Others were not so gracious. "I am in the horrible position of having to work under a woman—yourself," one man said to her. But just as Martindale had found that the least well-organized employers were those who objected to regulation of hours, so she believed that "opposition to working with women on equal terms seldom came from the man who was first class at his work" (H.M., p.175). She was pleased (but surely not surprised) to find that her women colleagues had no trouble understanding the intricacies of machinery, even though few of them had studied engineering. To the young women inspectors of Crosthwaite's generation, Martindale was a highly respected, if somewhat intimidating figure. When, shortly after the war, a new society was formed that became the Council of Women Civil Servants, Martindale was its treasurer and later its chairman.

After four years as superintending inspector, in 1925 Martindale succeeded Constance Smith as deputy chief inspector. The men inspectors had tried to use the opportunity of Smith's retirement to eliminate the provision for a woman

deputy, arguing that the place should be given to one of the men who had seniority. They opposed the supervision of senior men by women with fewer years of experience. Once again, Delevingne had had to intervene. As usual, his arguments were practical and virtually irrefutable. He advised the Home secretary that it would be a grave mistake to go back on this commitment, a move that would be sure to draw criticism from the women inspectors and their supporters outside the department. In any case, he added, Martindale had twenty-four years of experience and, at fifty, was the right age to take on the job; anyone much older than she would be too close to retirement. At his suggestion, the Home secretary denied the men's request for an interview, and Martindale was appointed.

By the time Gerald Bellhouse retired in 1932, Martindale was the senior deputy chief inspector. If she had been a man, as a loyal veteran of some thirty years, she would almost certainly have become chief inspector of factories, but this did not occur. In 1933, she was invited to apply for a new position in the Treasury as director of women establishments. She declined. She had been an advocate of equality of women with men in the Factory Department during the fusion battle; she now opposed the concept of separate treatment of women's civil service work. Besides, she observed, the directorship was merely an advisory office "with no certainty that the advice proffered would be acted upon." and the director's limited responsibility precluded further promotion. When, in spite of her reluctance, she was summoned for an interview, she did not hesitate to state her views on equal pay, removal of the "marriage bar," and the importance of women's work. Her frank objections got her the job; the board, convinced that she was the best candidate, somehow persuaded her to accept the position. As she had throughout her entire career, she accepted the challenge and used her position skillfully to achieve her aims.

Her first office had been a trunk in her room at the North Stafford Hotel at Stoke-on-Trent. Now she had a spacious paneled room at the Treasury, overlooking the passage leading to 10 Downing Street. The floor was covered with "a lovely blue silk carpet which had been made from some of that used in Westminster Abbey at the Coronation

of Edward VII. In it was interwoven the rose, the thistle, the shamrock and the leek" (H.M., pp.188–89).

With her customary determination, Martindale used her new post to survey the position of women in the whole range of civil service offices, compare the situation to that in other large institutions, and work toward eliminating inequalities and opening up career paths for women. Her efforts were successful; in time, special government posts for women were discontinued and her own job became obsolete. She retired from government in 1937, but she continued to serve on boards and committees where her knowledge and experience were valuable.

The other women who pioneered as factory inspectors continued in long careers of involvement with workers and working conditions. After her unhappy departure from the government, Adelaide Anderson found a channel for her energy and abilities by becoming an internationally recognized expert on labor conditions. She traveled to South Africa, Australia, and New Zealand. She visited China soon after she left the Factory Department, and began a long connection with that country. Until the outbreak of the war between China and Japan in 1933, she served on committees on child labor and factory inspection there, representing first the YWCA and later the Foreign Office and the International Labour Office. She also advised the Chinese government on the organization of a factory department. At home, she published her observations in a weekly column on China for the *Manchester Guardian* and wrote a book, *Humanity and Labour in China*.

When an English tourist brought back to the British office of the International Association for Social Progress a report of shocking labor conditions in Egypt in 1930, the association asked Anderson to make "an impartial enquiry" into that situation. "I had never known her as the formidable Principal Lady Inspector of Factories," recalled the association officer who asked her assistance, but she was "always gentle and always ready to help." Ignoring the admonitions of friends who suggested that, in her sixties, she was too old for such a venture, "she came with the inevitable umbrella and the bag bulging with papers and letters." She immediately began to work out ways and means of going. She solicited

official support from the YWCA and other organizations, arranged for introductions, and planned to write a series of articles about her experiences to finance the trip. Her work led eventually to Egypt's entry into full membership in the International Labour Organization.[5]

When Anderson died in 1936 at the age of seventy-two, the Chinese embassy sent a wreath to her funeral. May Tennant, Lucy Deane Streatfeild, and Gertrude Tuckwell were there, as were representatives from the International Labour Organisation, the YWCA, the Union of General and Municipal Workers, the Central Committee for Women's Training and Employment, and the International Association for Labour Legislation. Three women factory inspectors represented the Home Office. In the softening haze of bereavement, May Tennant described her old colleague to a newspaper reporter as "always equable, and to the end . . . absolutely happy."[6] Perhaps a more accurate sense of the woman came from an officer of the International Association for Social Progress, who told the obituary writer for *Social Justice* that "it is her gallantry which I shall chiefly remember. It is impossible to believe that she will never again walk in with umbrella and bulging bag, and perhaps a couple of books, and that I shall never again say to her: 'Just back, Dame Adelaide? And what are you going to do now?'"[7]

May Abraham Tennant continued her active interest in women's work as a member of the Central Committee on Women's Employment until 1939. She also worked on committees concerned with maternal mortality, tuberculosis, and other medical questions. Tennant raised five children and lost one son in the war. Like many women so bereaved, she took up spiritualism. When, after a long illness, she died in 1946, *The Times* reminded its readers that "She was a leading figure in public social work for half a century, in the course of which she had an important influence on social legislation."[8] Her old friend Violet Markham wrote that "Her keen sense of humour and her delight in a joke were matched by passionate earnestness for justice and right."[9]

Lucy Deane, like May Tennant, had left the Factory Department long before the amalgamation; extended illness forced her to resign from her position in 1908 after many sick leaves. Three years later she married a man she had known for years,

Granville Streatfeild, and went on to a long and active life pursuing the issues that had concerned her as a factory inspector. She served on various trade boards and was a member of the Royal Commission on the Civil Service. When the National Health Insurance plan went into effect in 1911, she was the first woman organizing officer in London. During World War I, she joined the executive committee of the Women's Land Army in her home county of Kent and, with Violet Markham, went to France on a Commission of Enquiry into the Conditions of the WAAC (Women's Auxiliary Army Corps). In 1918 she was made a Commander of the British Empire. She was Vice Chairman of the Kent Council of Social Service and one of the first women justices of the peace.

Mary Paterson continued as National Health Insurance commissioner from 1912 until 1919, though she left that position temporarily during the war to organize the National Service movement in Scotland. She was justice of the peace in Edinburgh, vice chairman of the Scottish Justices and Magistrates Association, chairman of the District Nursing Association, and an active member of the Edinburgh Women Citizens Association and the League of Nations Union.[10] In her will, detailed with the same precision she had long ago employed as a factory inspector, she directed her trustees

> to hold the silver Flower Stand and Spoons presented to me when I retired from Home Office service for the liferent use of my sister Agnes Paterson or Young, and upon the death of my said sister Agnes Paterson or Young for delivery to my niece Annie Muirhead Mathams . . . I wish my Trustees to allow my said sister the use and enjoyment of the said silver Flower Stand and Spoons in exchange for a suitable acknowledgement and undertaking by her that they will be returned on her death for delivery to my said niece Annie Muirhead Mathams . . . my said sister . . . shall not be responsible for the loss of the said silver Flower Stand and Spoons by fire or burglary.[14]

When Rose Squire moved from the Factory Department to the Industrial Division of the Home Office, she became, with some regret, a desk-bound administrator. Like Martindale, she must have missed the active life of inspections and

prosecutions, and she showed considerably less boldness in this job than she had displayed earlier in her career. She became involved in policy planning and administration, especially on the introduction of the two-shift system for women factory workers, on lighting in factories, and on a new field for her, working conditions in retail shops. In 1926, after thirty years at the Home Office, she retired. "I ended as I had begun," she wrote proudly, "as 'a pioneer,' for no woman had previously occupied a position in administrative work at the Home Office." A newspaper report of the dinner given in her honor referred to her avid reading of endless government reports in the headline, "Woman Who loved Blue Books." Squire observed with satisfaction that the guests included not only Miss Mason, who had been appointed inspector of poor law children in 1883, but also the newest woman factory inspector, who had gained her position by "successfully competing in the examination open for the first time to women on the same terms as men."[12]

Conclusion

Rose Squire entered the civil service in 1896 as one of a handful of women; by 1926 there were more than three hundred.[1] The intent of the lady inspectors had been to help women industrial workers achieve at least a minimum of decent and safe conditions at work, in the hope that, with that guarantee, they would become strong enough and skilled enough to take care of themselves. The women inspectors' greatest successes were in the areas of hours and welfare. In the 1890s, when the women's branch of the Factory Department was established, few industrialists saw any value in conserving the strength and energy of their employees; workers were regarded as an expendable resource that could easily be replaced. After years of patient instruction, the inspectors found in wartime exigencies the instrument that forced employers to listen: the forty-eight hour week was widely accepted, decent facilities for meals and cleanliness became widespread, and the kind of counsel the inspectors had provided on their infrequent peripatetic visits was permanently available from resident welfare supervisors employed by management in many factories.

The inspectors saw, too, the results of their work in marked reductions in accidents and industrial poisoning. Controversy continues even today, however, on poisoning by asbestos and lead (substances well known to be dangerous when the lady inspectors first began work) as well as newer chemical hazards in the workplace. These battles, it seems, remain to be fought perpetually. Employers still resist changing their methods or risking their profits to save the health and lives of their workers.

Sweatshops, the object of so much of the women inspectors' most painstaking detective work, still spring up in run-down sections of cities, behind shuttered windows and locked doors. They employ unorganized, often immigrant workers at substandard wages in unhealthful surroundings, and inspectors still ferret them out through constant vigilance. In rural areas, women work at home by choice or necessity, and the risk of exploitation still makes this a hotly debated issue.

Was the intervention of the government a benefit or a liability for women workers? It is hard to see how they might have pulled themselves up by their own bootstraps. While some skilled women, notably in textile mills, were strong and secure enough to unite, most women industrial workers were doubly oppressed, both by exploitative employers and by fellow workers – men who feared competition for jobs and reduction of wages. Many women were also doubly burdened, by jobs and family responsibilities. "Protection" – protective legislation and its enforcement – worked against women in some ways, but it also saved lives. An underlying question implicit in the continuing debate about protection has to do with the family and the division of responsibility – we still confront the concept that women are responsible for housekeeping and child rearing, and men for financial support.

The achievement of the lady inspectors in establishing a professional field for women is clear. Alice Crosthwaite recalls that Lillian Knowles, an economist at the London School of Economics, believed that factory inspection was the best profession open to women in the early days, because it offered the greatest independence and responsibility.[2] The pioneers gave the women's branch of the inspectorate its particular character. After it became amalgamated with the rest of the department, some of them left to find new challenge, still with a sense of mission to assist workers in defending themselves in a hard world; others stayed in the civil service, consolidating gains to some extent but succumbing to the compromises of governmental bureaucracy more than the admirers of their early achievements might have wished. But all of them had made their mark. Brave, intelligent, and competent, they performed well and enjoyed the satisfaction of accomplishing things in the public arena,

and they demonstrated to a disbelieving world that women could do as well as men, or better. The dissolution of the women's branch was, in that sense, the mark of its success.

Notes

Abbreviations Used in Notes

BM Add. Ms. British Museum, Additional Manuscripts
BLPES British Library of Political and Economic Science
C., Cd., Cmd. Command paper
P.P. Parliamentary Papers
PRO Public Record Office (Kew)

Chapter 1

1. Irene Whitworth, quoted in Adelaide Mary Anderson, *Women in the Factory: An Administrative Adventure, 1893 to 1921* (New York: Dutton, 1922), p. 221.
2. Rose E. Squire, *Thirty Years in the Public Service, an Industrial Retrospect* (London: Nisbet, 1927), p. 151.
3. The Home secretary's cabinet position as director of the Home Office included responsibility for the Department of Factories and Workshops, as well as other domestic concerns.

Chapter 2

1. *Thom's Irish Almanac and Official Directory*, Dublin, 1885, p. 512.
2. Stephen Gwynn and Gertrude Tuckwell, *Life of Sir Charles Dilke*, vol. 2 (London: John Murray, 1917), p. 230.
3. Violet R. Markham, *May Tennant, a Portrait* (London: Falcon Press, 1949), pp. 15–16.
4. Betty Askwith, *Lady Dilke, a Biography* (London: Chatto & Windus, 1969), p. 184.
5. George W. Abraham, *The Law and Practice of Lunacy in Ireland* (Dublin, 1886), cited in Mark Finnane, *Insanity and the Insane in Post-Famine Ireland* (London: Croom Helm, 1981), p. 125.
6. Askwith, *Lady Dilke*, p. 65.
7. *Annual Report of the Chief Inspector of Factories and Workshops for the Year 1879*, p. 98, quoted in Adelaide Mary Anderson, *Women in the Factories: An Administrative Adventure, 1893 to 1921* (New York: Dutton, 1922), p. 190.
8. Emilie Holyoake to the Rt. Honorable Henry Matthews, 5 March 1890. London, PRO, HO45/9818/B8031.

9. Godfrey Lushington, transmittal note dated June 1890, on letter of Emilie Holyoake to Home Secretary, 5 March 1890, PRO, HO45/9818/B8031; A. Redgrave, transmittal note dated 24 April 1890, on letter from E. Holyoake to Home Secretary Matthews dated 5 March 1890, PRO, HO45/9818/B8031.
10. Emilia Dilke to Miss Field, 6 December 1889, Dilke Papers, BM Add. Ms. 43908, f. 180.
11. Iona [pseud.], "Our Woman's Outlook," *Labour Leader*, 5 July 1907, p. 29.
12. The Victoria Press was founded by Emilia Boucherett and Helen Blackburn of the Society for the Employment of Women. It was staffed by women typesetters.
13. Emily Faithful to the editor, *The Times*, 19 February 1891.
14. Sidney Webb, Preface to B. L. Hutchins and A. Harrison, *A History of Factory Legislation* (1930; reprint, New York: Burt Franklin, 1970), p. vii.
15. Royal Commission on Labour, *The Employment of Women*, P.P. 1893–94, XXIII, C. 6894, p. 75.
16. Ibid., p. 87.
17. Women's Trade Union Association, *How Women Work. I. Being Extracts from Evidence Given before Group C of the Labour Commission in Regard to Women Working in the Ropemaking and Other Trades in London*, (London: Women's Trade Union League, n.d.), p. 3.
18. Home Office memorandum, unsigned, July 1891. PRO, HO45/9818/B8031.
19. Ibid.
20. *Parliamentary Debates*, 4th series, vol. 5 (1892), col. 643–46 (9 June 1892).
21. Sir Charles Dilke, Diary, 29 January 1893, quoted in Gwynn and Tuckwell, *Sir Charles Dilke*, 2:287.
22. Roy Jenkins, *Asquith: Portrait of a Man and an Era* (New York: Chilmark Press, 1964), p. 85.
23. Royal Commission on Labour, 5th Report, *P.P.*, 1894, XXXV, C. 7421, pp. 127–46.
24. Evelyne Bayes, assistant secretary, Women's Liberal Federation, to Home Secretary, 2 December 1892, PRO, HO45/9818/B8031.
25. Herbert Gladstone to Gordon Crowe, Montrose & District United Trades Council, 25 January 1893, PRO, HO87/10, p. 246; Godfrey Lushington to Glasgow United Trades Council, 13 February 1893, PRO, HO87/10, p. 216.
26. Herbert Henry Asquith, first Earl of Oxford and Asquith, *Memories and Reflections, 1852–1927*, 2 vols. (Boston: Little, Brown, 1928), 1:299.

27. International Labour Office, *Factory Inspection: Historical Development and Present Organisation in Certain Countries* (Geneva: International Labour Office, 1923), p. 7.
28. Diary of Lucy Deane, entry for 3 January 1894, Lucy A. E. Deane Streatfeild Papers, Modern Records Centre, University of Warwick, Mss. 69.
29. Norbert C. Soldon, *Women in British Trade Unions, 1874–1976* (Dublin: Gill and Macmillan, 1978), p. 35.
30. Markham, *May Tennant*, p. 18.

Chapter 3

1. Markham, *May Tennant*, p. 25.
2. Obituary of May Tennant, *The Times*, 12 July 1946.
3. *Annual Report of the Chief Inspector of Factories and Workshops for the Year 1893*, P.P., 1894, XXI, C. 7368, p. 11.
4. Ibid., pp.6, 16.
5. *The Liberal Magazine* 1 (October 1893):13.
6. *Annual Report of the Chief Inspector, 1893*, p. 12.
7. Anderson, *Women in the Factory*, p. 11.
8. Godfrey Lushington to May Abraham, 17 August 1893; Godfrey Lushington to P. Richmond, Esq., H.M. Inspector of Factories, 17 August 1893, PRO, HO87/10, pp. 606–09.
9. Anderson, *Women in the Factory*, pp. 11–12.
10. R. E. Sprague Oram to Godfrey Lushington, 19 December 1894, PR, HO45/9772.

Chapter 4

1. Markham, p. 25; Diary of Lucy Deane, entry for 5 November 1893, Mss. 69. Hereafter, all references to Lucy Deane's diary are cited in the text.
2. Godfrey Lushington to Civil Service Commission, 21 February 1894, PRO, HO87/11, p. 280.
3. "Dame Adelaide Anderson," *Social Justice* 1(3), September-October 1936.
4. *Labour Leader*, 5 May 1894, p. 2.
5. "Return of the Names and Previous Occupations or Professions of Factory Inspectors," House of Commons Accounts and Papers, P.P. 1907, vol. 76, p. 319.

Chapter 5

1. R. E. Sprague Oram to Godfrey Lushington, 21 November 1893, PRO, HO45/9877/B15295; Anderson, *Women in the Factory*, p. 201.

178 Notes to pages 34–54

2. Anderson, *Women in the Factory*, p. 203.
3. *The Liberal Magazine* 1 (October 1893): 13.
4. Squire, *Thirty Years*, pp. 22–23.
5. *Report of the Chief Inspector of Factories and Workshops for the Year 1896*, P.P., 1897, XVII, C. 8561, p. 59.
6. *Report of the Chief Inspector of Factories and Workshops for the Year 1895*, P.P., 1896, XIX, C. 8067, p. 122.
7. Squire, *Thirty Years*, pp. 25–6; B. L. Hutchins and A. Harrison, *A History of Factory Legislation* (1903; reprint, New York: Burt Franklin, 1970), p. 195.
8. Anderson, *Women in the Factory*, p. 141.
9. Ibid.
10. *Annual Report of the Chief Inspector of Factories and Workshops for the Year 1904*, P.P., 1905, X, Cd. 2569, p. 250.
11. Squire, *Thirty Years*, p. 33.
12. Ibid., pp. 17–18.
13. "Pioneer Woman in Civil Service," *Manchester Guardian*, 2 February 1926.

Chapter 6

1. Mary Paterson's letter, mentioned by Deane, has not been found, but is mentioned in Lucy Deane's diary, March 3, 1896.
2. K. E. Digby to Secretary to the Treasury, 16 March 1896, PRO, HO87/13.
3. Henry Conynghame to Chief Inspector, 2 April 1896, PRO, HO87/13.
4. Jane M.E. Brownlow, *Women and Factory Legislation* (London Women's Emancipation Union, 1896), p. 6.
5. Squire, *Thirty Years*, p. 54.

Chapter 7

1. Rose Squire, quoted in "Woman Who Loved Blue Books," *Evening Standard (London)*, 2 February 1926.
2. Squire, *Thirty Years*, pp. 72–3.
3. Ibid., pp. 67–68.
4. "Obituary: Sir Arthur Whitelegge, K.C.B., M.D., F.R.C.P. Lond., D.H.P.," *The Lancet*, 6 May 1933, p. 990.
5. *Annual Report of the Chief Inspector*, p. 73; *Annual Report of the Chief Inspector*, p. 57.
6. "Children and the Factory Act," *Pall Mall Gazette*, 27 February 1896, p. 8.
7. *Leeds Evening Express*, 1 December 1896, p. 3.

8. "Factory Act Offences," *Leeds Weekly Express*, 12 December 1896, p. 5.
9. Standish Meacham, *A Life Apart* (London: Thames & Hudson 1977), p. 111.
10. *Annual Report of the Chief Inspector*, p. 57
11. Squire, *Thirty Years*, pp. 66–67.
12. May E. Abraham, *The Law Relating to Factories and Workshops (including laundries and docks)* (London: Eyre and Spottiswoode, 1896).
13. "To Factory Owners and Workers," *Daily Chronicle* (London), 27 January 1896, p. 3.
14. Clementina Black, "The Rhyme of the Factory Acts," reprinted in Ellen Mappen, *Helping Women at Work: The Women's Industrial Council 1889–1914* (London: Hutchinson, 1985), pp. 123–28.

Chapter 8

1. Gertrude Tuckwell, quoted in Markham, *Tennant*, pp. 33–34.
2. May Tennant, "the Women's Factory Department," *The Fortnightly*, n.s. 64 (July–December 1898): 150–51.
3. Ibid., pp. 153–56.

Chapter 9

1. Arnold Bennett, *The Old Wives' Tale* (1908; reprint, New York: Doubleday, 1911), p. 5. The area known as the Five Towns, or the Potteries, the china-manufacturing area of Staffordshire, in west central England, actually includes six towns: Burslem, Hanley, Longton, Stoke-on-Trent, Fenton, and Tunstall.
2. Alice Hamilton, *Exploring the Dangerous Trades: The Autobiography of Alice Hamilton, M.D.* (Boston: Little, Brown 1943), p. 122.
3. Anderson, *Women in the Factory*, p. 104.
4. *Parliamentary Debates*, 4th series, vol.51 (1897), col. 1156.
5. Ibid., col. 1157.
6. *St. James's Gazette* (London), 18 May 1898.
7. Ibid., 23 May 1898.
8. Notes of deputation from North Staffordshire Pottery Trade, Subject: Lead Poisoning, 19 May 1898, PRO, HO45/9983/B26610.
9. *St. James's Gazette*, 20 May 1898.
10. Ibid., 19 April 1898; Petition, PRO, HO45/9983/B26610.
11. C. E. Troup to Chief Inspector of Factories, transmittal note accompanying Petition, 20 April 1898, PRO, HO45/9933/B26610.
12. *Parliamentary Debates*, 4th series, vol. 54, col. 478.
13. H. J. Tennant to the editor of *The Times*, 20 May 1898.

14. *Daily News*, 21 May 1898; *Daily Chronicle*, 25 May 1898; *St. James's Gazette*, 23 May 1898.
15. *Parliamentary Debates*, 4th series, vol. 54, 1898, cols. 515–16.
16. *Daily Chronicle*, 3, 10 August 1898.
17. Thomas Oliver and T. E. Thorpe, "Report to Her Majesty's Principal Secretary of State for the Home Department on the Employment of Compounds of Lead in the Manufacture of Pottery . . ." C. 9207 (1899).
18. C. E. Troup, Minute, 6 August 1898, HO45/10117/B12393P.
19. *In Arbitration*, Thursday the 7th November, 1901 . . . at the North Stafford Hotel, Stoke-on-Trent, before the Rt. Hon. Lord James of Hereford, Umpire . . . pp. 62–70, PRO, HO45/10120/B123293P.
20. Adelaide Anderson to B. A. Whitelegge, 28 May 1900, HO45/10118/ B12393P.
21. Adelaide Anderson, Memorandum on the amendments to the draft Home Office Rules proposed by the Joint Committee of Manufacturers, September 1900, 4 October 1900, HO45/10119/B12393P.
22. Ibid.
23. Deane, at this time, was a member of a commission headed by Millicent Garrett Fawcett investigating conditions in concentration camps where the British were holding wives and children of Boer guerrillas.
24. *In Arbitration*, pp. 71–78. HO45/10120/B12393P.
25. Ibid., pp. 62–70.
26. The Truck Acts regulated payment for piecework.
27. Hilda Martindale, *From One Generation to Another, 1839–1944* (London: George Allen & Unwin, 1944), p. 84.
28. *Daily News*, 12 February 1904.

Chapter 10

1. *Annual Report of the Chief Inspector of Factories and Workshops for the Year 1897, P.P.*, 1898, XIV, C. 9281, p. 103.
2. *The Times*, 18 March 1905.
3. Desmond Murphy, *Kerry, Donegal and Modern Ulster, 1790–1921* (Londonderry: Ailech Press, 1981), pp. 222–24.
4. *Annual Report of the Chief Inspector, 1897*, p. 109.
5. "Regulations as to the use of cycles," n.d. (1896), PRO HO87/13, p. 269B.
6. *Annual Report of the Chief Inspector, 1897*, p. 109.
7. "Gombeen man" originally meant "moneylender" or "usurer," but the term came to be used to describe the shopkeeper who

Notes to pages 82–94 181

bound local people to him through a system of store credit and payment in goods.
8. *Annual Report of the Chief Inspector, 1897*, p. 103.
9. *Annual Report of the Chief Inspector of Factories and Workshops for the Year 1899, P.P.*, 1900, XI, Cd. 223, p. 248.
10. H. A. Piehler, *Ireland for Everyman* (London: J. M. Dent, 1938), p. 178.
11. Squire, *Thirty Years*, p. 86.
12. Ibid., pp. 77–98 passim.
13. Ibid., p. 275.
14. Ibid., p. 90.
15. *Annual Report of the Chief Inspector, 1899*, p. 248.
16. Ibid.
17. Squire, *Thirty Years*, pp. 90–91.
18. Ibid., p. 91.

Chapter 11

1. *Annual Report of the Chief Inspector, 1899*, pp. 238, 233, 248.
2. John Sweeney, testimony, Truck Committee of 1908, *P.P..* 1908, LIX, Cd. 4444, p. 25.
3. *Donegal Vindicator*, 29 June 1900.
4. Sweeney testimony, p. 20.
5. Squire, *Thirty Years*, p. 94.
6. *Squire v. Sweeney*, High Court of Justice in Ireland (Queen's Bench Division), 16 January 1900; *Irish Weekly Law Reports*, 30 January 1900.
7. Squire, *Thirty Years*, pp. 95–96.
8. Sweeney testimony, p. 20.
9. *Parliamentary Debates*, 4th series, vol. 85, col. 958, 959.
10. *Annual Report of the Chief Inspector of Factories and Workshops for the Year 1900, P.P.*, 1901, X, Cd. 668, p. 359.
11. *Parliamentary Debates*, 4th series, vol. 93, col. 429.
12. *Squire v. Midland Lace*, Truck Committee of 1908, Appendix, p. 130.
13. *Parliamentary Debates*, 4th series, 5 August 1901, vol. 98, cols. 1333–34; 5 June 1902, vol. 108, col. 1548.
14. Hilda Martindale, *From One Generation to Another, 1839–1944* (London: George Allen & Unwin, 1944), pp. 89–90; *Parliamentary Debates*, 4th series, vol. 148, cols. 533–34, 29 June 1905.

Chapter 12

1. Martindale, *From One Generation*, p.42. Hereafter cited in the text.

182 Notes to pages 94–116

2. Diary of Louisa Martindale, "People we met on World Tour," 7 June 1900–29 May 1901. Wellcome Institute for the History of Medicine Library (London).
3. *Parliamentary Debates*, 4th series, vol. 129 (1904), col. 1495.
4. Nicholas Mansergh, *The Irish Question 1840–1921*. (London: George Allen and Unwin, 1975), pp. 236–37.
5. Adelaide Anderson to Chief Inspector, 13 September 1905, HO45/10327/132951 035145.
6. Unsigned letter to Herbert Gladstone, October 1906, HO45/14995 035390.
7. Malcolm Delevingne to Chief Inspector of Factories, 1 July 1907, HO45 10327/132951 035145. The horse leech is an exceptionally large and tenacious variety of the bloodsucking insect.

Chapter 13

1. H. V. Emy, *Liberals, Radicals and Social Policy 1892–1914* (Cambridge, England: Cambridge University Press, 1973), p. 216.
2. "Women and Child Wage Slaves." *The Voice of Labour*, 27 July 1907, p. 47.
3. John Turner, "Votes for Wealthy Women," *The Voice of Labour*, 23 February 1907, p. 44.
4. E. J. Hobsbawm, *Industry and Empire* (Harmondsworth: Penguin, 1969), p. 239.
5. Kenneth O. Morgan, ed., *The Oxford Illustrated History of Britain* (Oxford: Oxford University Press, 1984), p. 517.
6. Martin Wright, letter to author, 21 November 1982. Martin Wright is a cousin of Lucy Deane.
7. *Annual Report of the Chief Inspector*, 1900, p. 350.
8. *The Times*, 10 December 1908.
9. Malcolm Delevingne, Arthur Whitelegge, George H. Tripp, Confidential Report to the Right Honorable Herbert J. Gladstone, M.P., 23 December 1907, PRO, LAB14/330 035950.
10. Hobsbawm, *Industry and Empire*, pp. 167–68.
11. Adelaide Anderson to Herbert J. Gladstone, BM. Add. Ms. 46065, f. 185.
12. *Women's Industrial News*, October 1910.
13. Arthur Whitelegge to C. E. Troup, memorandum, minutes, PRO, HO45/10553/164207, folder 9.
14. C. E. Troup to H.M. Chief Inspector of Factories and Workshops, 1908, PRO, HO87/21, p. 255; *Annual Report of the Chief Inspector of Factories and Workshops for the Year 1908*, P.P., 1909, XXI, Cd. 4664, p. 120; H. M. Robinson, Deputy Chief Inspector, memorandum, 11 January 1909, PRO, HO45/10553, 164207/9.

15. Senior Lady Inspectors to Herbert Gladstone, 18 July 1908, PRO, HO45/10553/164207.
16. *Annual Report of the Chief Inspector, 1908*, p. 120.

Chapter 14

1. Adelaide Anderson to Chief Inspector, 10 April 1908, PRO, HO45/10553/164207.
2. Adelaide Anderson to Chief Factory Inspector, memorandum, 12 November 1908, PRO, HO45/10553/164207.
3. Unsigned memorandum to Secretary, H.M. Office of Works, 5 December 1907, PRO, H087/20 B20,087/48, p. 596.
4. Adelaide Anderson, "Memorandum on Divisional Localisation and additional instructions to Senior Lady Inspectors," 12 November 1908, PRO, H045/10553/164207.
5. Arthur Whitelegge to C. E. Troup, 25 November 1908, PRO, H045/10553/164207/9.
6. C. E. Troup, memorandum, 16 December 1908, PRO, H045/10553/164207/9.
7. Adelaide Anderson to Herbert Gladstone, 17 February 1909, BM Add. Ms. 46066, f. 258.
8. *Annual Report of the Chief Inspector of Factories and Workshops for the Year 1910*, P.P. 1911, XXII, Cd. 5693, p. 110.
9. Squire, *Thirty Years*, p. 126.
10. *Women's Trade Union Review*, October 1911, pp. 3–4; Soldon, *Women in British Trade Unions*, pp. 70–1.
11. Edith J. Macrosty, "'The Awakening': Women and Industrial Rights. Recent Progress," *The Standard*, 6 July 1912, clipping, Gertrude Tuckwell Papers, Trades Union Congress Library, London, 22/23.
12. Malcolm Delevingne and Arthur Whitelegge, "Confidential Report on the Question of an Increase in Staff of Factory Department," p. 15, PRO, LAB 14/182.
13. Gertrude Tuckwell, *Constance Smith: A Short Memoir* (London: Duckworth, 1931), 48 pp., passim.
14. *Annual Report of the Chief Inspector of Factories and Workshops for the Year 1914*, P.P., 1915, XXI, Cd. 8051, p. 32.
15. H. H. Asquith, quoted in C. E. Troup to the Undersecretary of State, Home Office, memorandum, 17 January 1914, PRO, LAB14/182.

Chapter 15

1. Squire, *Thirty Years*, p. 169.

2. Ibid., p. 170.
3. David Mitchell, *Women on the Warpath: The Story of the Women of the First World War* (London: Jonathan Cape, 1966), p. 256.
4. *Annual Report of the Chief Inspector, 1914*, p. 46.
5. Gail Braybon, *Women Workers in the First World War* (London: Croom Helm, 1981) p. 44.
6. *Annual Report of the Chief Inspector*, p. 45.
7. Squire, *Thirty Years*, p. 171.
8. *Annual Report of the Chief Inspector, 1914*, p. 34.
9. Ibid., p. 37.
10. Ibid., p. 33.
11. Barbara Drake, *Women in Trade Unions* (London: Labour Research Department and George Allen and Unwin, 1920), p. 74.
12. *Annual Report of the Chief Inspector of Factories and Workshops for the Year 1915, P.P.*, 1916, IX, Cd. 8276, p. 14.
13. Squire, *Thirty Years*, p. 172.
14. John Stevenson, *British Society 1914–1945* (London: Allen Lane, 1984), p. 66.
15. Braybon, *Women Workers*, pp. 47–49.
16. Anderson, *Women in the Factory*, p. 239; Braybon, *Women Workers*, pp. 48–49.
17. Drake, *Women in Trade Unions*, p. 73; Anderson, *Women in the Factory*, p. 248.
18. R.J.Q. Adams, *Arms and the Wizard: Lloyd George and the Ministry of Munitions, 1915–1916* (College Station: Texas A&M University Press, 1978), p. 118.
19. Braybon, *Women Workers*, pp. 50–59.
20. Drake, *Women in Trade Unions*, p. 77.
21. Ibid., pp. 101–02.
22. Adams, *Arms and the Wizard*, p. 122.
23. Adam W. Kirkaldy, *Industry and Finance: War Expedients and Reconstruction* (London: Pitman, 1917), p. 129.
24. *Annual Report of the Chief Inspector, 1914*, p. 33.

Chapter 16

1. Violet Markham, *Return Passage: The Autobiography of Violet R. Markham, C. H.* (London: Oxford University Press, 1953), pp. 89, 150–53.
2. Squire, *Thirty Years*, pp. 177, 178.
3. Ibid., p. 179.
4. Ibid., p. 180.
5. Ibid., pp. 182–83.

6. Vera Brittain, *Testament of Youth* (1933; reprint, New York: Seaview, 1980), p. 321.
7. Squire, *Thirty Years,* p.183; Braybon, *Women Workers,* p. 114.
8. Caroline Rennles, interview, Imperial War Museum, London, Department of Sound Records, Oral History: "War Work 1914–1918," reels 4, 6.
9. Braybon, *Women Workers,* p. 145.
10. Kirkaldy, *Industry and Finance,* pp. 50–51.
11. Drake, *Women in Trade Unions,* pp. 102–03.
12. Ibid., p. 103.
13. Soldon, *Women in British Trade Unions,* p. 98.
14. *Report of the Chief Inspector, 1915,* p. 15.
15. Stevenson, *British Society,* p. 65.
16. Anna Davin, "Imperialism and Motherhood," *History Workshop* 5(1978):9–65; Adelaide Mary Anderson, quoted in Braybon, *Women Workers,* p. 118.
17. Health of Munitions Workers' Committee, Memo, No. 7, quoted in Kirkaldy, *Industry and Finance,* p. 55.
18. Committee on the Organisation of the Factory Inspectorate to Secretary of State for Home, December 1918, Violet Markham Papers, BLPES, 5/2.
19. Kirkaldy, *Industry and Finance,* p. 82.
20. Anderson, *Women in the Factory,* p. 286.
21. B. Seebohm Rowntree, "Home Problems after the War," *Contemporary Review* 108 (October 1915): 32–45.
22. N. Adler, "Women's Industry during and after the War," *Contemporary Review,* 108 (December 1915): 780–88; Clement Kinloch-Cooke, "Women and the Reconstruction of Industry," *The Nineteenth Century,* December 1915, pp. 1396–1416.

Chapter 17

1. David Mitchell, *Women on the Warpath,* p. 266.
2. Squire, *Thirty Years,* pp. 190–91.
3. *Annual Report of the Chief Inspector of Factories and Workshops for the Year 1919,* P.P. 1920, XVI, Cmd. 941, pp.10, 11.
4. Ibid., p. 9.
5. Ibid., pp. 15–16.
6. Ibid., p. 12.
7. *Annual Report of the Chief Inspector of Factories and Workshops for the Year 1920,* P.P., 1921, XII, Cmd. 1403, p. 16.
8. Squire, *Thirty Years,* p. 193.
9. Stevenson, *British Society,* p. 132.

186 Notes to pages 150–160

10. Squire, *Thirty Years*, p. 189.
11. Ibid., p. 193.
12. Braybon, *Women Workers*, pp. 181–82.
13. Sean Glynn and John Oxborrow, *Interwar Britain: A Social and Economic History* (New York, Barnes and Noble, 1976), pp. 250–52.
14. Squire, *Thirty Years*, p. 196.
15. *Annual Report of the Chief Inspector, 1919*, pp. 49, 50, 74.
16. *Annual Report of the Chief Inspector, 1920*, pp. 86, 94–95.

Chapter 18

1. Malcolm Delevingne to Violet Markham, 15 July 1919, Violet Markham Papers, BLPES, 5/1.
2. Constance Smith, "Factory Department: Notes on position in future of the Women's Branch," confidential memorandum to Violet Markham, accompanied by letter dated 16 January 1920, Violet Markham Papers, BLPES, 5/1.
3. Ibid.
4. Ibid., pp. 7–8.
5. Constance Smith to Violet Markham, 18 January 1920, Violet Markham Papers, BLPES, 5/1.
6. Ibid.
7. H. C. Escreet, Memorandum of Evidence, Committee on Re-organisation of the Factory Inspectorate, 22 January 1920, Violet Markham Papers, BLPES, 5/2.
8. Rose Squire, Statement for the Factory Committee, Violet Markham Papers, BLPES, 5/2.
9. Adelaide Anderson, Evidence to Factory Committee, Violet Markham Papers, BLPES. 5/2.
10. Constance Smith to Violet Markham, 27 January 1920, Violet Markham Papers, BLPES, 5/1.
11. Constance Smith to Violet Markham, 30 January 1920, Violet Markham Papers, BLPES, 5/1.
12. Constance Smith to Violet Markham, "Sunday 21st" [21 March 1920], Violet Markham Papers, BLPES, 5/1.
13. R. E. Graves to Malcolm Delevingne, 1 April 1920, PRO, LAB14/333 035950.
14. Committee on the Organisation of the Factory Inspectorate, Report, PRO, LAB14/333 035950, pp. 12–15.
15. C. E. Troup to Secretary of State, 25 February 1920, PRO, LAB14/333.
16. Hilda Martindale, "A Civil Servant of Great Integrity: Sir Gerald Bellhouse, C.B.E.," *Some Victorian Portraits* (London, George Allen & Unwin, 1948), pp. 40–45.

Notes to pages 160–171 187

17. Squire, *Thirty Years*, p. 179.
18. Malcolm Delevingne to Violet Markham, 16 May [1920], Violet Markham Papers, BLPES, 5/1.
19. *The Times*, 22 December 1921.
20. Malcolm Delevingne to Violet Markham, 15 August 1920, Violet Markham Papers, BLPES, 5/1; May Tennant to Violet Markham, 15 August 1920, Violet Markham Papers, BLPES, 5/1.
21. Delevingne to Markham, 15 August 1920.
22. Malcolm Delevingne, minute accompanying Treasury reply to Home Office, "Factory Inspectorate: Organization & Pay" 12 July 1920, PRO, LAB14/333 035950.
23. Delevingne to Markham, 15 August 1920.
24. Meta Zimmeck, "Strategies and Stratagems for the Employment of Women in the British Civil Service 1919–1939," *Historical Journal* 27 (1984): 908–09.
25. Anderson, *Women in the Factory*, pp. 17–18.

Chapter 19

1. Malcolm Delevingne for Secretary of State to Secretary, Federation of Lace and Embroidery Employers' Association, Nottingham, 15 December 1921, PRO, H087/52.
2. Malcolm Delevingne for Secretary of State to Secretary, National Federation of Building Trades Operatives (Local Branch), Nottingham, 3 October 1921, PRO, H087/52.
3. Sheila Lewenhak, *Women and Trade Unions, an Outline History of Women in the British Trade Union Movement* (London: Ernest Benn, 1977, p. 175.
4. Alice Crosthwaite, interview with author, London, 19 November 1982.
5. "Dame Adelaide Anderson," *Social Justice*.
6. *Manchester Guardian*, 31 August, 2 September 1936.
7. "Dame Adelaide Anderson," *Social Justice*.
8. "Mrs. H. J. Tennant: Public Social Work," *The Times*, 12 July 1946.
9. Violet Markham, "Mrs. H. J. Tennant," *The Times*, 16 July 1946.
10. "Obituary: Distinguished Scotswoman, Mary M. Paterson, C.B.E.," *Glasgow Herald*, 11 June 1941.
11. Will of Mary Muirhead Paterson, Edinburgh, 28 June 1941, Scottish Record Office, record 5134, folio 173–76.
12. Squire, *Thirty Years*, p. 231.

Conclusion

1. Squire, *Thirty Years*, p. 233.
2. Alice Crosthwaite, interview.

Select Bibliography

Archival Sources

Anderson, Adelaide, and Violet Markham. "Report on Industrial Welfare Conditions in Coventry in November, 1916." Typescript. Violet Markham Papers, 3/33, BLPES.

Collet, Clara. Papers. Coventry. Modern Records Centre, University of Warwick, Mss.29.

Deane, Lucy. Diary. Lucy A. E. Deane Streatfeild Papers. Coventry. Modern Records Centre, University of Warwick. Mss. 69.

Dilke, Charles and Emilia. Papers. British Museum Additional Manuscripts 43908.

Kew. Public Record Office. Home Office Papers. HO45 and HO87.

Kew. Public Record Office. Labour Office Papers. LAB 14.

Lawrence Collection (photographs). Dublin. National Library of Ireland.

London. Imperial War Museum. Department of Sound Records. Oral History: "War Work 1914–1918" (tapes).

Martindale, Louisa. Diary, "People We Met on World Tour, 7 June 1900–29 May 1901." London. Wellcome Institute.

Violet Markham Papers. London. British Library of Political and Economic Science.

Parliamentary Papers

Great Britain. Home Office. *Annual Report of the Chief Inspector of Factories and Workshops*, 1890–1922.

Great Britain. Ministry of Reconstruction. Report of the Women's Employment Committee. Cd. 9239 (1919).

Great Britain. Royal Commission on Labour. Reports. First,

Group C. C.6708(1892). Second, Group C. C. 6795(1892). Third, Group C. C.6894(1892–94). Fourth, Group C. C.7063(1893–94). Fifth, Group C. C. 7421(1894).

Great Britain, Royal Commission on Labour. "The Employment of Women, Reports by Miss Eliza Orme, Miss Clara E. Collett, Miss May Abraham, and Miss Margaret H. Irwin, Lady Assistant Commissioners, on the Conditions of Work in Various Industries in England, Wales, Scotland, and Ireland." C. 6894 (1892–94).

Newspapers and Periodicals

Contemporary Review
Daily Chronicle
Daily News
Donegal Vindicator
Economic Journal
Englishwomen's Review
Fortnightly
Labour Leader
Manchester Guardian
St. James's Gazette
The Times
The Voice of Labour
Women's Industrial News
Women's Trade Union Review

Contemporary Works and Autobiographies

Abraham, May E. *The Law Relating to Factories and Workshops (including laundries and docks)*. London: Eyre and Spottiswoode, 1896.

Adler, N. "Women's Industry during and after the War." *Contemporary Review* 108 (December 1915):28–88.

Anderson, Adelaide Mary. *Women in the Factory: An Administrative Adventure, 1893 to 1921*. New York: Dutton, 1922.

Black, Clementina. "The Coming Factory Act." *Contemporary Review* 59(1891):710–17.

Black, Clementina, ed. *Married Women's Work*. 1915; reprint London: Virago Press, 1983.

Booth, Charles, *Life and Labour of the People of London.* 17 vols. London: Macmillan, 1892-1903.
Boucherett, E. Jessie. "Lead Poisoning in Pottery Work." *Englishwomen's Review* 30(15 April 1899):98–102.
Boucherett, E. Jessie, and Helen Blackburn, eds. *The Condition of Working Women and the Factory Acts.* London: Elliot Stock, 1896.
Bradby, L. Barbara, and Anne Black. "Women Compositors and the Factory Acts." *Economic Journal* 9(1899):260–66.
Brownlow, Jane M. E. *Women and Factory Legislation.* London: Women's Emancipation Union, 1896.
Butler, Harold. *Confident Morning.* London: Faber & Faber, 1950.
Byles, Mrs. W. P. "The Work of Women Inspectors." In *Women in Professions, being the Professional Section of the International Congress of Women.* London: T. Fisher Unwin, 1900.
Cadbury, Edward, M. Cecile Matheson, and George Shann. *Women's Work and Wages: A Phase of Life in an Industrial City.* London: T. Fisher Unwin, 1906.
Chilston, Eric Alexander Akers-Douglas, 3rd viscount. *Chief Whip: The Political Life and Times of Aretas Akers-Douglas, 1st Viscount Chilston.* Toronto: University of Toronto Press, 1962.
Crabtree, John Henry. *A Guide for Students Preparing for the Examination for an Appointment as Inspector of Factories and Workshops.* London: Eyre and Spottiswoode, 1898.
Dilke, Emilia F. S. *The Industrial Position of Women.* London: Women's Trade Union League, n.d.
Dunckley, Henry. "Child Labour: II, The Half-Timers," *Contemporary Review* 59(June 1891):798–802.
Ford, Isabella O. *Women as Factory Inspectors and Certifying Surgeons.* Investigation Papers, no. 4. Manchester, Women's Co-operative Guild, 1898.
Haslam, James. "Female Labour in the Potteries." *Englishwoman* 3(July-September 1909):61–73.
Haslam, James. "Seating in the Irish Linen Industry." *Englishwoman* 9(January-March 1911):137–46.
Harrison, Amy. "The Inspection of Women's Workshops in London: A Study in Factory Legislation." *Economic Review(London)*, January 1901, n.p.

Hutchins, B. Leigh. *Home Work and Sweating*. Fabian Tract no. 130. London: Fabian Society, 1907.

Hutchins, B. Leigh. *Women in Modern Industry*. London: G. Bell, 1915.

Hutchins, B. Leigh, and Amy Harrison. *A History of Factory Legislation*. 1903; reprint, New York: Burt Franklin, 1970.

Kinlock-Cooke, Clement. "Women and the Reconstruction of Industry." *The Nineteenth Century*. December 1915, pp. 1396–1416.

Kirkaldy, Adam W. *Industry and Finance: War Expedients and Reconstruction*. London: Pitman, 1917.

"Law and the Laundry," Part 1. "Commercial Laundries," by Mrs. Bernard Bosanquet, Mrs Creighton, and Mrs Sidney Webb. Part 2. "Laundries in Religious Houses," by Lucy C. F. Cavendish. *Nineteenth Century* 41(January-June 1897):224–35.

Life in the Laundry. Fabian Tract no. 112. London: Fabian Society, 1902.

Liverpool Women's Industrial Council. *Report on Home Work in Liverpool*. Liverpool: The Council, 1908.

Lyttleton, Edith. *Warp and Woof, a Play*. London: T. Fisher Unwin, 1908.

Manning, Henry Edward. "Child Labour I: The Minimum Age for Labour of Children." *Contemporary Review* 59(June 1891):794–97.

Markham, Violet R. *Return Passage: The Autobiography of Violet R. Markham, C. H.* London: Oxford University Press, 1953.

Martindale, Hilda. *From One Generation to Another, 1839–1944*. London: George Allen & Unwin, 1944.

Martindale, Hilda. *Women Servants of the State, 1870–1938: A History of Women in the Civil Service*. London: George Allen & Unwin, 1938.

Nash, Rosalind. *Life and Death in the Potteries*. Manchester (England): Women's Co-operative Guild, 1898.

Oliver, Thomas, ed. *Dangerous Trades: The Historical, Social and Legal Aspects of Industrial Occupations as Affecting Health, By a Number of Experts*. New York: Dutton, 1902.

Oliver, Thomas, and T. E. Thorpe. *Report to Her Majesty's Principal Secretary of State for the Home Department on the Employment of Compounds of Lead in the Manufacture of Pottery.* . . . C. 9207 (1899). Reprint, *British Parliamentary Papers: Industrial Revolution: Factories*, vol. 31. Shannon: Irish University Press, 1971.

Oxford and Asquith, Herbert Henry Asquith, 1st earl of, *Memories and Reflections, 1852–1927.* Boston: Little, Brown, 1928.

Rowntree, B. Seebohm. "Home Problems after the War." *Contemporary Review* 108(October 1915): 432–45.

Samuel, Herbert. *Grooves of Change.* Indianapolis: Bobbs-Merrill, 1945.

Squire, Rose. *Thirty Years in the Public Service, an Industrial Retrospect.* London: Nisbet 1927.

Tennant, May. "The Women's Factory Department." *Fortnightly*, n.s.64(July-December 1898):148–56.

Tuckwell, Gertrude M., and Constance Smith. *The Worker's Handbook.* London: Duckworth, 1908.

Vesselitsky, V. de. *The Homeworker and the Outlook: A Descriptive Study of Tailoresses and Boxmakers.* London: G. Bell, 1916.

Vynne, Nora, and Helen Blackburn. *Women under the Factory Act.* London: Williams & Norgate, 1903.

Webb, Beatrice. *The Diary of Beatrice Webb.* Vol. 3. "The Power to Alter Things: 1905–1924." Norman and Jeanne MacKenzie, eds. Cambridge: Belknap/Harvard University Press, 1984.

Webb, Beatrice. "To Your Tents, O Israel." *Fortnightly Review*, n.s. 54(November 1893):569–89.

"Women Inspectors: Discussion." *Women in Professions, being the Professional Section of the International Congress of Women, London, July, 1899.* London: T. Fisher Unwin, 1900, pp.108–14.

Women's Trade Union League. *How Women Work, Being Extracts from Evidence Given before Group C of the Labour Commission in Regard to Women Working in the Ropemaking and Other Trades in London.* London: Women's Trade Union League, n.d.

Secondary Sources

Adams, R.J.Q. *Arms and the Wizard: Lloyd George and the Ministry of Munitions, 1915–1916.* College Station: Texas A&M University Press, 1978.

Askwith, Betty. *Lady Dilke, a Biography.* London: Chatto & Windus, 1969.

Bartrip, P.W.J. "British Government Inspection, 1821–1875: Some Observations." *Historical Journal* 25(1982): 605–26.

Boston, Sarah. *Women Workers and the Trade Unions.* London: Davis-Poynter, 1980.

Brand, Jeanne L. *Doctors and the State: The British Medical Profession and Government Action in Public Health, 1870–1912.* Baltimore: John Hopkins University Press, 1965.

Braybon, Gail. *Women Workers in the First World War.* London: Croom Helm, 1981.

Brebner, J. B. "Laissez Faire and State Intervention in Nineteenth Century Britain." *Journal of Economic History*, Supplement 7, 1948.

Briggs, Asa. *The Age of Improvement.* London: Longman, Green, 1959.

Briggs, Asa. *A Social History of England.* New York: Viking, 1983.

Bythell, Duncan. *The Sweated Trades: Outwork in Nineteenth-Century Britain.* New York: St. Martin's Press, 1978.

Clarke, Peter. *Lancashire and the New Liberalism.* Cambridge, England: Cambridge University Press, 1971.

Clarke, Peter. "The Progressive Movement in England." *Transactions of the Royal Historical Society* 24(1974): 159–81.

Clegg, H. A., Alan Fox, and A. F. Thompson. *A History of British Trade Unions Since 1889.* Vol. 1, 1889–1910. Oxford: Clarendon Press, 1964.

Clokie, H. M., and J. W. Robinson. *Royal Commissions of Inquiry.* Stanford: Stanford University Press, 1937.

Davin, Anna, "Imperialism and Motherhood," *History Workshop Journal* 5(1978):9–65.

Djang, T. K. *Factory Inspection in Great Britain.* Studies in Political Science and Sociology, 2. London: George Allen & Unwin, 1942.

Drake, Barbara. *Women in Trade Unions.* London: Labour

Research Department and George Allen & Unwin, 1920.
Emy, H. V. *Liberals, Radicals and Social Policy 1892–1914*. Cambridge, England: Cambridge University Press, 1973.
Evans, Dorothy. *Women and the Civil Service: A History of the Development of the Employment of Women in the Civil Service, and a Guide to Present-day Opportunities*. London: Pitman, 1934.
Ford, Percy. *Social Theory and Social Practice: An Exploration of Experience*. Shannon: Irish University Press, 1968.
Fussell, Paul. *The Great War and Modern Memory*. London: Oxford University Press, 1975.
Glynn, Sean, and John Oxborrow. *Interwar Britain: A Social and Economic History*. New York: Barnes & Noble, 1976.
Gwynn, Stephen, and Gertrude Tuckwell. *Life of Sir Charles Dilke*. 2 vols. London: John Murray, 1917.
Hamer, David Alan. "The Irish Question and Liberal Politics 1880–94." *Historical Journal* 12(1969):511–32.
Hamer, David Alan. *Liberal Politics in the Age of Gladstone and Rosebery: A Study in Leadership and Policy*. Oxford: Clarendon Press, 1972.
Havighurst, Alfred F. *Britain in Transition: The Twentieth Century*. Chicago: University of Chicago Press, 1979.
Hay, J. R. "Employers' Attitudes to Social Policy." In *The Origins of British Social Policy*, ed. Pat Thane. London: Croom Helm, 1978, pp. 107–25.
Hewitt, Margaret. *Wives and Mothers in Victorian Industry*. London: Rockcliff, 1958.
Hobsbawm, E. J. *Industry and Empire*. The Pelican Economic History of Britain, vol. 3. Harmondsworth: Penguin Books, 1969.
Holcombe, Lee. *Victorian Ladies at Work: Middle-Class Working Women in England and Wales 1850–1914*. Hamden, Conn.:Archon Books, 1973.
International Labour Office. *Factory Inspection: Historical Development and Present Organisation in Certain Countries*. Geneva: International Labour Office, 1923.
Jenkins, Roy. *Asquith: Portrait of a Man and an Era*. New York: Chilmark Press, 1964.
Jenkins, Roy. *Sir Charles Dilke: A Victorian Tragedy*. Rev. ed. London: Collins, 1965.
John, Angela, ed. *Unequal Opportunities: Women's Employment

in England 1800–1918. Oxford: Basil Blackwell, 1986.
Joyce, Patrick. *Work, Society and Politics: The Culture of the Factory in Later Victorian England.* Brighton: Harvester Press, 1980.
Koss, Stephen. *Asquith.* London: A. Lane, 1976.
Lewenhak, Sheila. *Women and Trade Unions.* London: Ernst Benn, 1977.
Lewis, Jane, ed. *Labour & Love: Women's Experience of Home and Family 1850–1940.* London: Basil Blackwell, 1986.
Liddington, Jill, and Jill Norris. *One Hand Tied behind Us: The Rise of the Women's Suffrage Movement.* London: Virago, 1978.
Lloyd, T. O. *Empire to Welfare State: English History 1906–1976.* 2d ed. Oxford: Oxford University Press, 1979.
Mansergh, Nicholas. *The Irish Question 1840–1921.* London: George Allen & Unwin, 1975.
Mappen, Ellen. *Helping Women at Work: The Women's Industrial Council 1889–1914.* London: Hutchinson, 1985.
Markham, Violet R. *May Tennant, a Portrait.* London: Falcon Press, 1949.
Martindale, Hilda. *Some Victorian Portraits and Others.* London: George Allen & Unwin, 1948.
Marwick, Arthur. *Britain in the Century of Total War: War, Peace and Social Change 1900–1967.* London: Bodley Head, 1968.
Meacham, Standish. *A Life Apart.* London: Thames & Hudson, 1977.
Mess, H. A. *Factory Legislation and Its Administration 1891–1924.* London: 1926.
Mitchell, David. *Women on the Warpath: The Story of the Women of the First World War.* London: Jonathan Cape, 1966.
Parris, Henry. *Constitutional Bureaucracy: The Development of British Central Administration Since the Eighteenth Century.* New York: Augustus M. Kelley, 1969.
Parris, Henry. "The Nineteenth-Century Revolution in Government: A Reappraisal Reappraised." *Historical Journal* 3(1960):17–37.
Pellew, Jill. *The Home Office, 1948–1918: From Clerks to Bureaucrats.* Rutherford, N.J.: Fairleigh Dickinson University Press, 1982.
Rhodes, Gerald. *Inspectorates in British Government: Law Enforcement and Standards of Efficiency.* London: George Allen & Unwin, 1981.

Soldon, Norbert C. *Women in British Trade Unions 1874–1976*. Dublin: Gill and Macmillan, 1978.
Stearns, Peter. *Lives of Labor: Work in a Maturing Industrial Society*. New York: Holmes & Meier, 1975.
Stearns, Peter. "Working-Class Women in Britain, 1890–1914." In *Suffer and Be Still: Women in the Victorian Age*. Martha Vicinus, ed. Bloomington: Indiana University Press, 1973. Pp. 100–20.
Stevenson, John. *British Society 1914–45*. London: Allen Lane, 1984.
Thane, Pat, ed. *The Origins of British Social Policy*. London: Croom Helm, 1978.
Thane, Pat. "The Working Class and State 'Welfare' in Britain, 1880–1914." *Historical Journal* 27(1984):877–900.
Troup, Sir Edward. *The Home Office*. New York: Putnam's 1925.
Tuckwell, Gertrude. *Constance Smith: A Short Memoir*. London: Duckworth, 1931.
Wedeen, Richard P. *Poison in the Pot: The Legacy of Lead*. Carbondale: Southern Illinois University Press, 1984.
Vicinus, Martha. *Independent Women: Work & Community for Single Women 1850–1920*. Chicago: University of Chicago Press, 1985.
Vicinus, Martha, ed. *Suffer and Be Still: Women in the Victorian Age*. Bloomington: Indiana University Press, 1973.
Vicinus, Martha, ed. *A Widening Sphere: Changing Roles of Victorian Women*. Bloomington: Indiana University Press, 1977.
"Women and the Labour Movement," *North West Labour History Society Bulletin* no. 7(1980–81).
Zimmeck, Meta. "Strategies and Stratagems for the Employment of Women in the British Civil Service 1919–1939." *Historical Journal* 27(1984):901–24.

Index

Aberdeen, Lady 13–77
Abraham, May, *see* Tennant, May Abraham
accidents, 2; in laundries, 37; records of, 39–40; in war industries, 139
Akers-Douglas, Aretas, 74
Anderson, Adelaide, 20, 25, 54–5, 95, 148–9; appointed principal lady inspector, 60; objections to 1921 amalgamation, 155, 157, 158; and reorganization of 1908, 114, 118–20; retirement, 160–61, 168–9
Ardara, 78–82
Asquith, H.H., 3–4, 13, 14, 18, 20–1, 23, 24, 25, 42, 124
Asquith, Margot, 23

Barker, Lilian, 150
Barnett, Henrietta, 94
Belfast, 76, 78, 97, 99, 104
Bellhouse, Gerald, 159–60, 167
Bennet, Sarah, 30, 69
Bevan, W.F., 28–9
bicycles, 79
Birmingham Works Morality Committee, 143–4
Black, Clementina, 57
Bondfield, Margaret, 93, 150
Boyle, Teresa, 79–80

Cadbury, Edward, 140
canary girls, 139–40
Cavendish, Lady Frederick, 49
Central Committee for Women's Training and Employment, 126
Chamberlain, Neville, 136–7
Chemical Works, Committee of Enquiry as to, 20
child workers, 3, 105–6, 134
Churchill, Winston, 110, 138
civil service, 14, 19–20
Collis, Dr. Edgar, 138
Congested Districts Board (Ireland), 77
Congress of Irish Workers, 91
Cooke-Taylor, H.W., 31
Coventry, 32
Cramp, W.D., 31
Crosthwaite, Alice, 165–6
credit, payment in, 79–80, 99

Dangerous Trades, Committee on, 20, 66
Deane, Lucy, 22–5, 28–33, 59, 111–12, 115, 170–1; in Donegal, 78–82; investigation in potteries, 65–8; as prosecutor, 34–5, 53–5, 82; training, 27–32; as witness at inquest, 70–1
Delevingne, Malcolm, 42, 98–9, 113, 114, 154–5, 162–3, 165–6
Department of Demobilisation and Resettlement, *see* Women's Training Branch
Digby, Kenelm, 46, 60
Dilke, Charles, 5, 7, 13, 90, 91
Dilke, Emilia, 4, 6–8, 14, 17–18, 23
dilution of labor, 130
Donegal, 76–91; *see also* Ardara, Dungloe
dressmakers, 17, 19
Dungloe, 83–6, 87–90

Edward VII, 111
Employer's Liability Bill, 67
employers, 19, 52–3, 64–5, 73–4, 101–3, 120, 126–7

Factory Acts, 10, 17, 40, 56–7, 67, 127, 132; abstracts, 27; of 1833, 14; of 1895, 39, 41
Factory Department, reorganization, 1907–08, 113–17; reorganization, postwar, 154–61; staff, statistics, 113
Factory Department, women's branch 44–7; decentralization, 108, 113–17; dissolution, 163–4
Factory inspectors, salaries, 114, 162–3
Factory inspectors, men, 28–31, 46–7, 158
Factory inspectors, women; duties, 16–17, 19–21; examinations, 24, 25–6, 41; as investigators, 20, 36–40, 63–8; objections to, 8–9, 12–13; office hours for workers, 55–6; as prosecutors, 34–5, 50–5, 82; public support for, 10–11, 13–15; salaries, 25, 114, 161–2; senior, 116–17; supervision of, 44–6; training, 27–8, 118–19; travels, 27–32, 76–81, 83–6; as wartime advisers, 126–7
Faithfull, Emily, 10, 11
fines and deductions, 11
fisheries, 3, 88, 125

George V, 111
Gladstone, Herbert, 98, 116
gombeen men, 80, 84–5, 99
Graves, R.E., 158, 159–60

hazards, industrial, 2, 17, 18, 140–1; *see also* lead poisoning
Hicks, Amie, 12
Hoare, C.C.W., 30
Holyoake, Emilie, 8–9
Home Office, 8–9, 45–6, 60, 142
home work, 91; in Ireland, 77–82, 84–5

Industrial Law Committee, 104
Ireland, 87, 96–107; resident woman inspector for, 78, 91–2; *see also* Belfast, Donegal, Dublin
Irish Trade Union Congress, 91

jam factories, 2

Kensington, 22, 38, 41
Knowles, Lillian, 173

labor exchanges, 110, 136–7
Labour party, 110
Labour Supply Committee, 130
laundresses, 9, 36–9
laundries, 17, 22, 36–9; accidents in, 40–1; included under Factory Acts, 39; institutional, 100–1
lead, 23–4; in china manufacture, 63–5, 71; special rules on, 72–4
lead poisoning, 23–4, 64–8, 70–1, 73; victims, deputation to Home Office, 68

Index

Liberal party, social legislation, 110
Lloyd George, David, 130, 136, 143
London, 1–2, 17, 27, 42, 51, 130; West London special district, 40–1, 111–12
London Women's Trades Council, 8–9
Lushington, Godfrey, 8–9

Macarthur, Mary, 126, 130, 150
McKenna, Reginald, 70
Martindale, Hilda, 93–5, 115, 118–19, 144–5, 161, 166, 167–9; assigned to Ireland, 92, 96–107; assigned to potteries, 74–5, 95–6; and postwar workers, 149
Martindale, Louisa, 93–4
Martindale, Louisa Spicer, 93–4, 98
Mary, Queen, 126
Matthews, Henry, 8–9, 12–13
minimum wage, 110
Ministry of Labour, 136
Ministry of Munitions, 137
Mooney, Annie, 79

nail and chain makers, 9–10, 32–3
Nannetti, Joseph Patrick, 91
National Federation of Women Workers, 122
National Health Society, 22, 24, 25
National Service Department, 136–7
Nottingham, 29

Oliver, Thomas, 67–8, 70, 71
Oram, R.E. Sprague, 16–17, 20–1, 26–7, 28, 30, 42–3, 44, 46
Order of the British Empire, 144
Orme, Eliza, 26
overtime, 1–2, 12–13, 17–18, 52, 131–3

Pankhurst, Emmeline, 130
Pankhurst, Sylvia, 126
Paterson, Emma, 3–5
Paterson, Mary, 15, 17–21, 42, 59, 71, 82, 115, 119, 122, 171
Pease, Miriam, 165
plumbism, see lead poisoning
potteries, 63–5, 71–5, 95–6
potter's rot, 63
pottery workers, 64–6, 69, 70–1, 72–3
prosecutions, 16–17, 28, 34–6, 50–5, 102–4
publicity, 47–9, 53, 104–5

Queen Mary's Work for Women Fund, 126

Redgrave, Alexander, 8, 9, 12, 23
Rennles, Caroline, 140
Ridley, Matthew White, 46, 60, 67, 68, 90
Ritchie, Charles, 91
Robinson, Malcolm, 156
Rowntree, Seebohm, 138–9, 146–7
Royal Commission on Labour, 10–12, 13
Royal Commission on the Poor Law, 115
Royal Irish Industries Association, 77

Sadler, Emily, 112, 115
Samuel, Herbert, 99
sanitation, 2, 11, 52, 103
Sedgwick, G., 30–1
Sex Disqualification (Removal) Act of 1919, 155
Shortt, Edward, 160
Slocock, Emily, 161
Smith, Constance, 123, 154–6, 159–60, 161
Snape, G.B., 77, 79

social investigation, 109
Squire, Rose, 38–9, 41–2, 115, 157, 160, 170–1; and demobilization of workers, 149–51; in Ireland, 83–6, 88–90; as prosecutor, 50–3; wartime activities, 138–40
Squire v. Fuller, 51, 53
Squire v. Midland Lace Company, 91
Staffordshire, 63–70
Stoke-on-Trent, 29–30, 65–6
Stourbridge, 32–3
straw-hat manufacturers, 53–4
Streatfeild, Lucy Deane, see Deane, Lucy
strikes, 1910–12, 121–2
sweated industries, 9–10
Sweeney, John, 88–90

tailors, 1–2
Taylor, Isabel, 157
Tennant, H.J., 20, 23–4, 58–9, 67, 69, 91
Tennant, May Abraham, 5–10, 14–21, 27, 60–1, 66, 67, 78, 169; book about Factory Acts, 56–7; *Fortnightly* article, 61; on investigating committees, 20; as lady assistant commissioner, Royal Commission on Labour, 11; as lady superintending inspector, 46–7; marriage, 58–60; opposes resident inspector for Ireland, 78; views on inspectors' salaries, 161–2; wartime activities, 136–8; and Women's Trade Union League, 7–9
textile factories, 10, 101–2
Textile Operatives Society, Belfast, 78, 97, 104
Tierney, Miss, teacher, 79
TNT, 139–40
Tracey, Anna, 115
trade unions, women members, 10, 121, 122
Trades Union Congress, 4, 165
Troup, C.E., 69, 71, 159
Truck Acts, 17, 90, 99–100, 103
Tuckwell, Gertrude, 6, 15, 26, 49, 69, 165
Tuckwell, Marian, 54

unemployment, 110, 126, 145–6, 151

Vines, Mabel, 116

Wagstaff, Henry, inquest, 70–1
Walmsley, J.H., 29, 65, 70, 75
Webb, Beatrice, 49, 58, 115
Webb, Sidney, 10
welfare provisions in factories, 105, 146, 149, 152–3
welfare supervisors, 141–3
Whitelegge, Dr. Arthur, 46, 52, 60–1, 66, 120
Whitley Committee, 146
Whitworth, Irene, 1, 115, 139
Women's Emancipation Union, 48
Women's Liberal Federation, 13
Women's National Liberation Association, 68
Women's Trade Union League, 3–4, 7–8, 9, 10, 13, 122, 128, 166
Women's Training Branch, 151–2
Women's Work Society, 48
workers' complaints, 19, 56
workers, women, 11–12, 14, 35, 55–6, 101; postwar, 148–50; and trade unions, 10, 110; in war industries, 129–33, 144–5
workmen's compensation, 67
World War I, 125–46
workshops, 1–2, 12–13, 31–32, 35